Painterly Plants

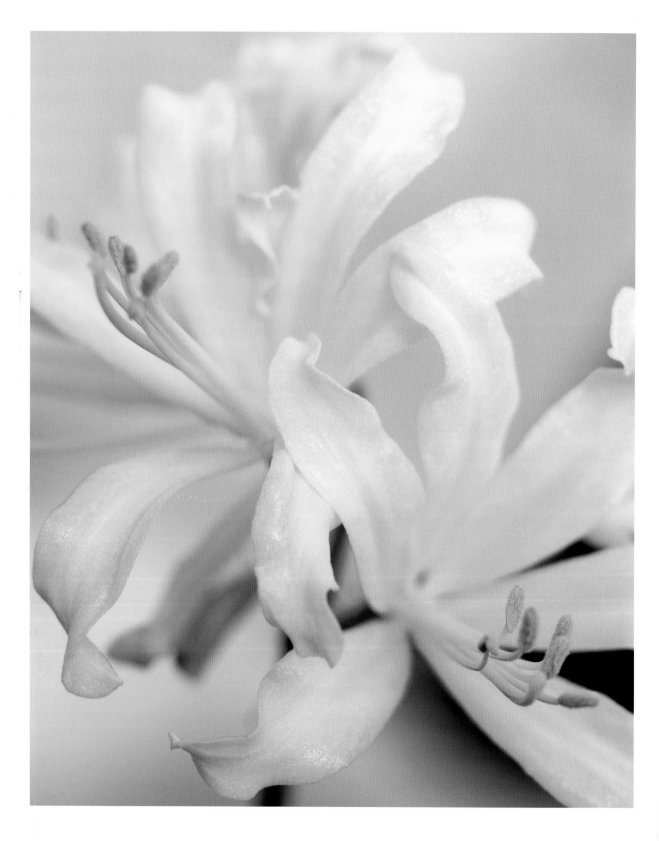

Introduction

There are some flowers whose intricacy and beauty demand a closer look, drawing us in with colours and patterning so exquisite that we marvel at nature's ability to produce such artistry. These, above all others, are the plants that have been the artist's muse throughout history, their forms depicted both with the clarity of botanical accuracy and with the broad sweep of an impressionistic brush. Not surprisingly, these are also the plants that arouse a strange and passionate obsession among gardeners, leading some to go to extraordinary lengths to create or obtain new specimens: Thomas Fairchild, for instance, who behind closed doors made the first deliberate hybrid between a carnation and sweet William, going against everything Christianity had ever taught him; or those swept up in the mad moments of tulipomania in seventeenth-century Holland, prepared to risk an entire fortune for a single bulb. Throughout history, people have travelled the globe to find new plants to introduce to their own shores, broadening the ever-expanding palette of plants that can be cultivated in our gardens. Each plant, therefore, has an intriguing tale to tell, and a history that often stretches back thousands of years, from the ancient use of plants in medicine to man's overriding desire to create improved forms through hybridization.

As I researched my list of painterly plants for a series that originally appeared in *House & Garden*, I realized what an invaluable role art had to play in telling these stories.

Throughout history, plants have been sketched, painted, sculpted and embroidered to leave us with a wealth of images that tell us things even the written word cannot. These images, as well as being utterly beautiful to behold, provide us with crucial evidence of a plant's complex evolution as hybridization changes its appearance and character. In the early years of plant acquisition from foreign shores, European botanists were often wrong about the provenance or naming of plants, but artists painted what they saw — as true a record as you can get in the vast and complicated world of plants. Often, a painting is the first tangible documentation of a plant: the 3500-year-old wall paintings of the rose at Knossos in Crete, for instance, or the remarkable *Codex Aniciae Julianae*, a sixth-century version of the Greek physician Pedanius Dioscorides's famous first-century herbal *De Materia Medica* (*Regarding Medical Materials*), which is one of the world's earliest surviving collections of botanical images. A painting can also provide an invaluable record of a variety that is no longer in cultivation.

Through the medium of art, history comes alive. Whether we are studying a medieval tapestry or one of the great still-life paintings of the Dutch masters, these images show us which plants were fashionable in a particular era. The earliest flower drawings were made to help people identify medicinal plants, and crude line drawings soon turned into more naturalistic portraits, reproduced as woodcuts in the sixteenth- and

Pierre-Joseph Redouté
(1759–1840)
Paeonia Moutan, c. 1799
Hand-coloured engraving

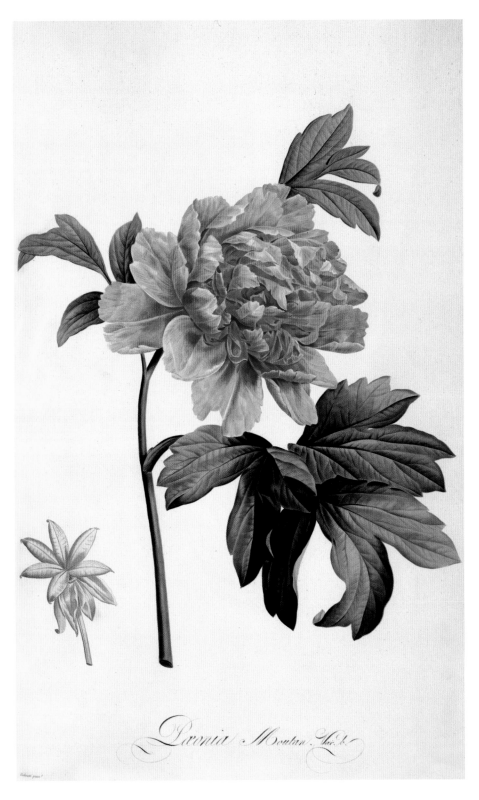

seventeenth-century herbals. Later, as new plants flooded into Europe, the florilegium was born — a lavish, expensive publication commissioned by wealthy patrons to document their prized plant collections. The eighteenth century was the great age of the botanical artist, with such luminaries as Georg Dionysius Ehret and Pierre-Joseph Redouté dominating the stage, while the nineteenth century saw the rise of the garden periodical, containing images of the newest and most exciting plants. And this is not to mention the role of more conventional artists in documenting the history of these plants: Claude Monet, Charles Rennie Mackintosh, Georgia O'Keeffe and many, many more have been drawn to the living form of the flower, adding their perspective to the already richly complex narrative.

What I aim to do in this book is simply to make people look at plants in a different way. Knowing a little about the history of a plant may make you reassess a flower as familiar as the tulip, while seeing a Redouté painting of a rose you know and love may send you out into the garden to scrutinize one of your own blooms. Sabina Rüber's exquisite photographs, works of art in themselves, truly capture the essence of what makes each of these plants so special, encouraging you to look — really look — at each one. After all, nature and art are inextricably intertwined; indeed, as such artists as Edward Steichen have demonstrated, creating hybrids can itself be seen as a form of art. I leave you with a quotation that seems as relevant today as it did 500 years ago, from the painter Albrecht Dürer: 'Study nature diligently', he urged other artists. 'Be guided by nature and do not depart from it, thinking you can do better yourself. You will be misguided, for truly art is hidden in nature and he who can draw it out possesses it.'

Paeonia lactiflora 'Gazelle'.

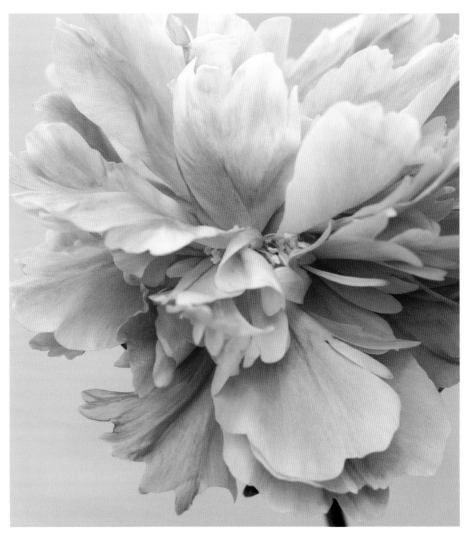

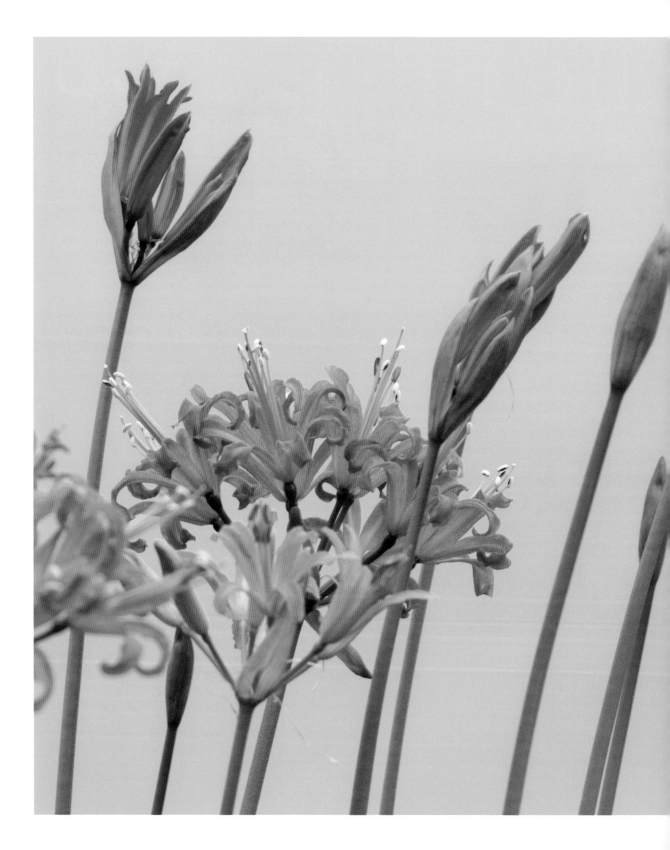

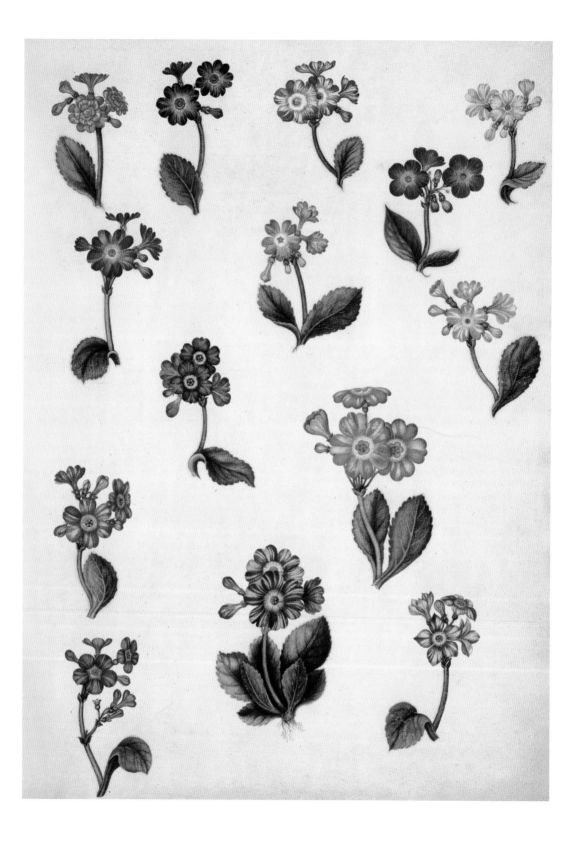

Auricula

Vita Sackville-West (1892–1962) summed up the curiously ersatz appearance of the auricula when she wrote: 'It is indeed one of those flowers which looks more like the invention of a miniaturist or of a designer of embroidery, than like a thing which will grow easily and contentedly in one's own garden' (*Some Flowers*, 1937). She was right: auriculas look unreal, but that is part of their peculiar charm. They are collectors' items, perfectly designed for exhibiting, to show off their individual markings and jewel colours, and they lend themselves to competitions and shows, where their finest assets can be proudly displayed.

To grow auriculas is to join an exclusive club with a long history. It may not be apparent from their highly bred appearance, but auriculas derive from two very humble Alpine plants: the delicate yellow *Primula auricula* and the striking pink *P. hirsuta*, both of which grow wild in the mountains of Austria and Switzerland. The first hint of interest in the Alpine primula as a cultivated plant is not in a written text but in a colour illustration of *P. auricula* made in about 1550 for the botanic manuscript of Pietro Antonio Michiel (1510–1576), who was for some years director of the botanic garden in Padua. Three decades later, in the version of his manuscript *Rariorum Plantarum Historia* (*A History of Rare Plants*) dating from 1583, the botanist Charles de l'Écluse (1526–1609; better known by the Latinized version of his name, Carolus Clusius) described two distinct forms of the plant he called 'auricula ursi' because of the leaf's resemblance

to a bear's ear: one with yellow flowers and another with red, the latter of which would almost certainly have been a hybrid between the two wild species, *P. auricula* and *P. hirsuta*. Clusius grew these plants in the botanic garden of Leiden in The Netherlands, where he was director, and played a pivotal part in distributing these and many other species of plant throughout Europe.

The auricula arrives in Britain

It is thought that auriculas came to Britain with the first wave of Huguenot refugees in the latter part of the sixteenth century, but there is no written evidence to substantiate this. Certainly the plant was associated with the Huguenot silk-weavers and lacemakers, who worked from home in small cottages where the diminutive size of these jewel-like flowers would have been an advantage. However the plants found their way to England, they were mentioned and illustrated in 1597 by John Gerard (1545–1612), physician, gardener and herbalist, and author of one of the first major herbals in the English language, now generally known as *Gerard's Herbal*. Referring to the auriculas as 'Beares eares or Mountaine Cowslips', Gerard listed six different varieties distinguished by their colour: yellow, purple, red, scarlet, bright red and 'blush'. These coloured, but plain, auriculas were the ancestors of the modern multicoloured confections. The simple black-and-white

All photographs in this chapter
show cultivars of *Primula auricula*.
Top row, from left: 'Stardust';
'Howard Telford'; 'Freya'.
Middle row, from left: 'Renata';
'Monk'; 'Zorro'. Bottom row,
from left: 'Pageboy'; 'Boy Blue';
'Blue Yonder'.

woodcut illustrations in Gerard's herbal do not show the plants in any great botanical detail, but it is clear that they are still very close to their wild ancestors, with flowers more akin to those of the wild British primrose than to the hybrids we know today. His description of the plants, however, emphasizes the point that even at this early stage in their development auriculas were occurring in a variety of colours because of their natural tendency to hybridize: 'There are divers varieties of their floures, and the chiefe differences arise either from the leaves or floures; from their leaves, which are either smooth and greene or else gray and hoary, againe they are smooth about the edges, or snipt more or lesse. The floures some are fairer than othersome, and their colours are so various, that it is hard to find words to expresse them.'

Gerard also drew attention to a characteristic that has been paramount in the decorative development of this plant: the 'gray and hoary' farinaceous leaves. The wild yellow *P. auricula* has silvery grey, felty leaves covered in a white powdery meal known as 'farina', its function in the wild to protect the plant from sun damage. This farina, over centuries of hybridization, has made its way into the flowers of some auriculas, giving them their distinctive 'mealy' appearance. Despite imparting unique patterns and textures to the flower, the presence of the farina can itself add to the complexities of growing auriculas, as it makes them susceptible to rain damage – the colouring and markings

can literally run – meaning that any auricula with elements of farina should be grown under cover.

Seventeenth-century striped and double auriculas

After Gerard's initial description in 1597, interest in the auricula accelerated swiftly, and it became a plant that transcended all sectors of society, popular with working men and gentry alike. By 1629 John Parkinson (1566/67–1650), apothecary to Charles I, listed twenty 'beares ears' in his *Paradisi in Sole Paradisus Terrestris* (*Park-in-Sun's Terrestrial Paradise*), and just two years later auriculas were among the rich-list of plants exhibited at the first Florists' Feast. The modern usage of the word 'florist', one who arranges and sells cut flowers, is very different from the seventeenth-century meaning. At that time florists were men devoted to growing and exhibiting particular flowers for their beauty alone. Societies were established all over England, and members would meet several times a year for Florists' Feasts. These were by all accounts very convivial affairs, with societies gathering to share large amounts of good food and ale, listen to poetry readings or plays and, of course, exhibit their prize plant specimens.

Once the auricula had been accepted into the inner circle of the florists' societies, a frenzy of hybridization began, starting in Belgium. The florists of Liège produced wonderful varieties with bright, sometimes dual colours,

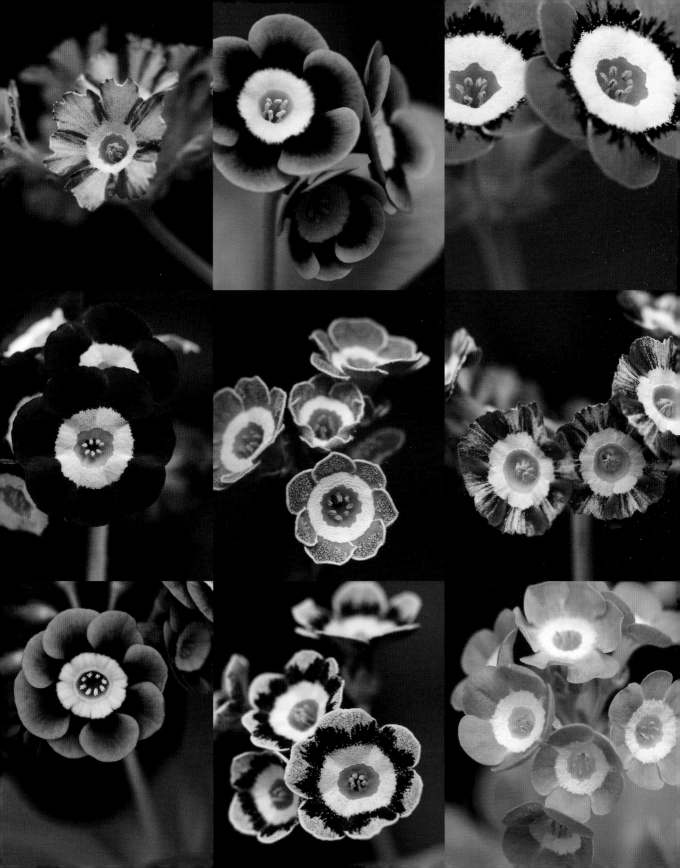

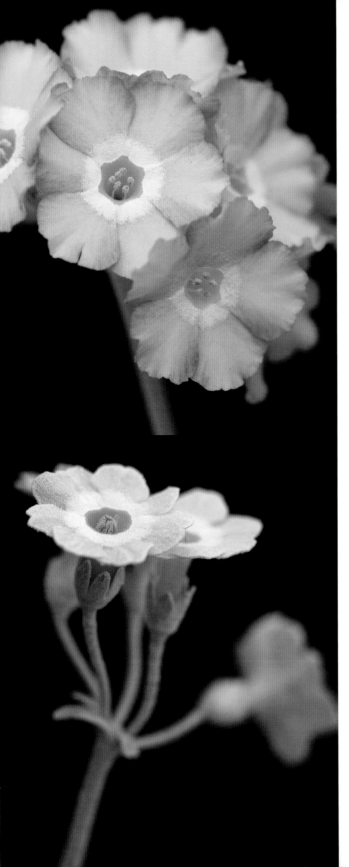

'Icon' (top); 'Twiggy' (bottom).

and soon new characteristics were appearing, in flamboyant striped and double forms that were documented in paintings of the time. In 1640 the French artist Jacques Linard painted auriculas of various colours, including a double, while a collection of fourteen striped auriculas appears in a mid-seventeenth-century painting by the British gardener and artist Alexander Marshal (c. 1620–1682; p. 12). Marshal, who was part of a distinguished circle of gentlemen gardeners in London, painted 'merely for his Amusement', and his flower albums, in the form of two rare folio volumes now held in the Royal Library at Windsor Castle, contained beautifully executed botanical studies of more than 1000 different flowers. His delicate auriculas are painted in rich tones of gold, orange and purple–red, some showing the characteristic white ring of farina around the central eye that is integral to today's show auriculas, and in the top left-hand corner of the painting is a double-striped flower, which would have been an expensive rarity in Marshal's day. These works of art proved an invaluable record, as both the striped and the double auriculas disappeared completely in the nineteenth century, to be reintroduced only in the latter half of the twentieth.

The eighteenth-century edged auricula

Striped auriculas were still the most popular type at the beginning of the eighteenth century, but some time in

'Wincha'.

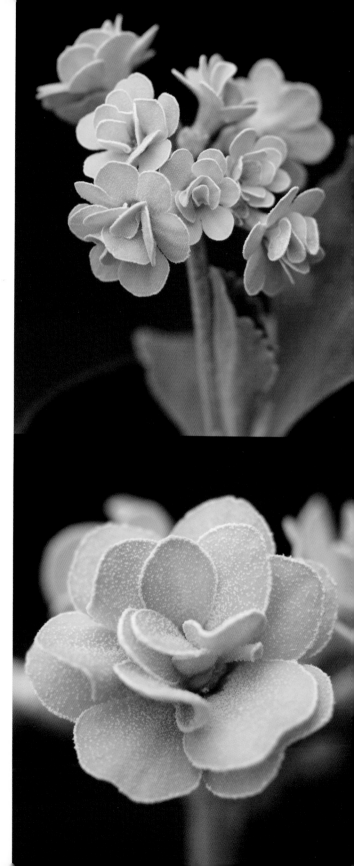

the middle of the century the fashion changed and a new type evolved: the edged auricula, with flowers of extraordinary detail and beauty. Each petal was delicately edged in green, grey or white around a band of base colour, which itself surrounded a central eye of pure-white farina (known as the 'paste' because of its resemblance to unglazed porcelain). Known at the time as 'English', the edged auriculas quickly became all the rage, and wealthy gardeners built special wooden theatres in which to display their treasured specimens.

The science behind this evolutionary twist is fascinating. A natural mutation made the outer part of the flower take on the cell character of the leaf. That event explains the presence of the farina, which originally covered only the leaves and calyx of the wild *P. auricula*, and also the green, grey or white colouration at the edge: green from the leaf, grey from a light covering of farina and white from a dense covering of farina. Exactly when this change occurred is unknown, but in the 1980s an exciting discovery altered the widely held belief that edged auriculas had not appeared until the nineteenth century. In 1987 Sotheby's brought to auction a hitherto unknown painting by Christopher Steele (1733–1768) entitled *Portrait of Martha Rodes*, in which Martha poses next to a large terracotta pot of what are undeniably grey-edged auriculas. The flowers play a prominent part in the composition, with the girl reaching out to hold a stem of the plant, and the grey edging of the flowers is mirrored in the silver silk of her

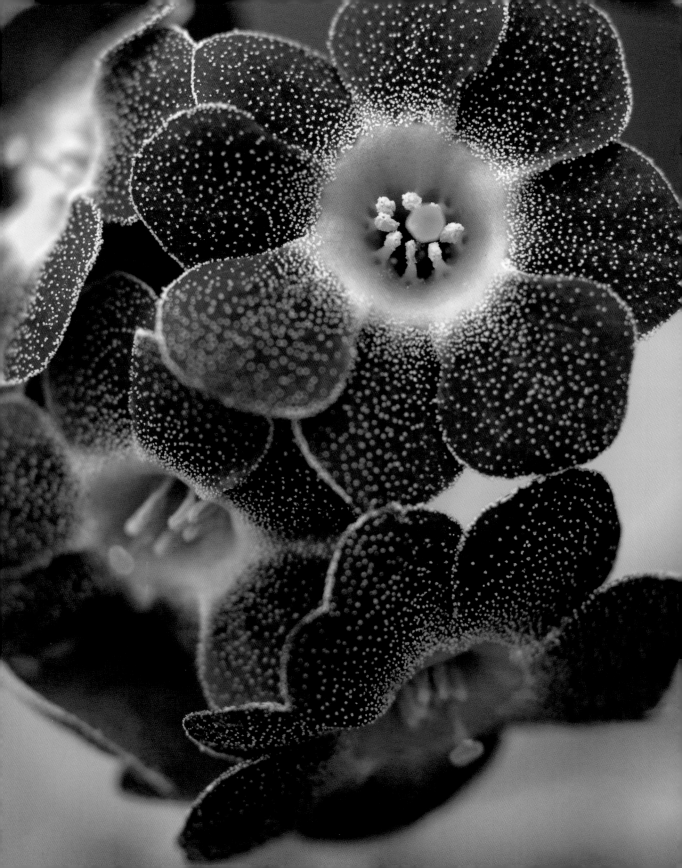

elegant dress. The painting, which is dated 1750, is firm proof that the new edged auriculas had made their debut some time in the first half of the eighteenth century, decades earlier than had been originally thought.

Green-edged auriculas were also known from about this time, although none seems to have been illustrated until the beginning of the nineteenth century. In 1810 the botanical artist Sydenham Teast Edwards (1768–1819) produced a portrait of the bizarrely named 'Cockup's Eclipse', a beautiful plant similar to some of the modern edged varieties, with a pure-white central paste surrounded by a ring of black and a crimped pure-green edge that reflects the green of the leaves. This auricula is also illustrated in Dr Robert John Thornton's famous florilegium, *The Temple of Flora*, a hugely extravagant publication that first appeared in 1812, and which almost reduced its creator to bankruptcy. Thornton (1768–1837) was a naturalist and botanist, and, although not himself an artist, commissioned some of the country's most talented illustrators to produce the colour plates to accompany his text, uniquely portraying the plants against naturalistic landscape backdrops. In the 1820s and 1830s green-edged auriculas were firmly in fashion, and dozens were illustrated in a series of periodicals devised by the gardener and botanist Robert Sweet (1783–1835). The *Florist's Guide and Cultivator's Directory*, published in monthly editions between 1827 and 1832, contained full-colour, if sometimes gaudy, prints based on originals by Edwin

Dalton Smith (1800–1866), depicting some of 'the choicest flowers cultivated by florists'.

The nineteenth-century Alpine auriculas

In the latter part of the nineteenth century, the development of the auricula took yet another turn. With the advent of industrialization and a move towards the cities, auricula-growing became much more of a specialist occupation. Increasingly long hours of work and smaller gardens meant that most people had neither the time nor the space to devote to such labour-intensive flowers, and interest in them dwindled. More specialist societies and shows sprang up, however, and in 1873 the National Auricula Society was established. Perhaps as a response to this, breeding now focused on the easier-going Alpine auriculas, which needed less cosseting than the edged and striped varieties. The result was a rush of new, bright colours. The Alpines were (and still are) distinguished by their gold or cream centres and brightly coloured, flat, round blooms. Often seen as the poor cousins of the show auriculas, they were easier to grow outside because of their lack of farina, and did not need the costly paraphernalia associated with the edged or striped varieties.

If industrialization started the slow decline of the auricula, then the two world wars almost finished it off. In the early twentieth century auricula-growing was still very much a male-dominated occupation, and when the

First World War struck the traditional florists' societies lost all but a few of their members. The Second World War dealt a double blow, as people turned to the land to grow not flowers but food. Not surprisingly, auricula-growing sank into near-oblivion. Through these dark years a handful of breeders kept the heart of the genus beating, but it was not until the 1950s and 1960s that the true revival began. Such nurserymen as Fred Buckley from Macclesfield, Cheshire, led the way in the 1950s by breeding new edged auriculas from old varieties. A decade later the doubles that had completely disappeared from cultivation began to make a comeback, followed by the striped auriculas, after one breeder successfully re-created an old striped variety, 'Glory of Chilton', that he had seen in an old painting.

Auriculas today

There are now hundreds of auricula varieties to choose from, thanks to continued work by both amateur enthusiasts and nurserymen. Modern auriculas come in a mind-boggling range of colours and forms, grouped — for the purpose of exhibiting by present-day 'florists' — into four categories: Show, Alpine, Double and Border. The most flamboyant are the Show auriculas, characterized by the presence of farina in the central paste and, in some cases, around the edge or scattered across the entire bloom. The Shows are divided into several subcategories:

Edged, Self, Striped and Fancy. The Selfs are the most velvety-looking auriculas, with the central white paste surrounded by petals of a single pure colour, from the brightest vermilion to the deepest purple–black. The Striped and recently introduced Double Striped varieties are real curiosities, with perhaps the most artificial-looking blooms of all. The Fancies are a small group of rogue varieties that do not fall into any of the other categories. Traditionally grown in three-inch terracotta pots for display, Show auriculas can be tricky creatures to grow, needing protection under glass in winter and shade in summer. They hate having damp feet (their roots will rot if the compost remains soggy), so a free-draining, gritty compost is essential — yet in summer they will need watering little and often to ensure they do not dry out. The ideal way to display them when in flower is in a traditional wooden auricula theatre.

Alpine auriculas, which flower in mid-spring, are easier and less time-consuming than the Show varieties, and can be planted in the garden rather than in pots because they have no farina to be damaged by rain. Similarly, Double auriculas can make good border plants. Resembling miniature posies, they are not to everyone's taste, as their opulent, frilly forms are far removed from the standard auricula, but their flowers come in a wide spectrum of colours, from the cinnamon tones of *P. auricula* 'Trouble' to the rich-red *P. auricula* 'Crimson Glow', and they make extremely attractive plants. The last

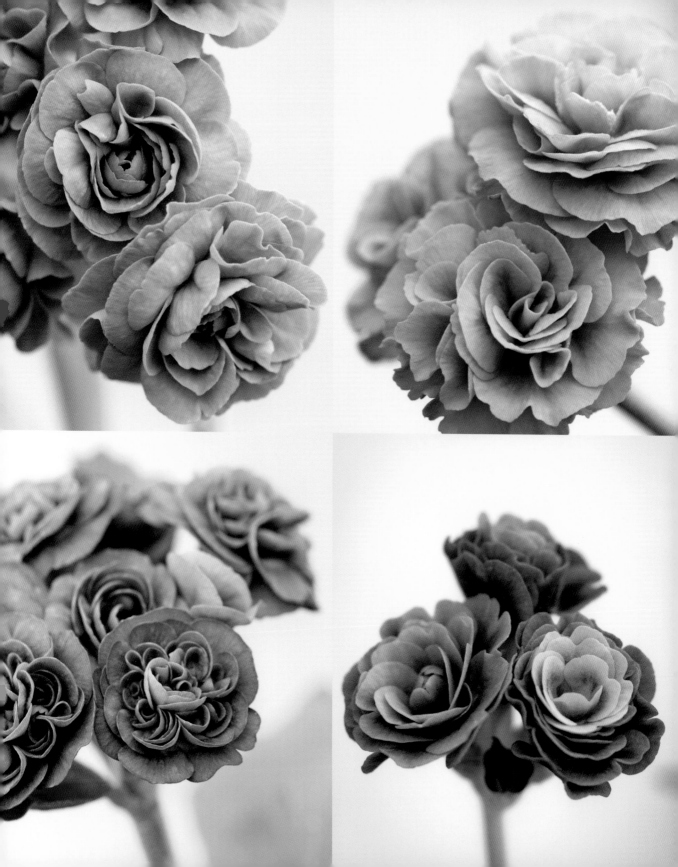

From top: 'Snowy Ridge';
'Moonshadow'.

Opposite: 'Grey Ladywood'.

group, Border auriculas, contains plants more akin to the native British primrose; these auriculas are often overlooked in favour of other varieties because they do not have the excitement of the Show auriculas. However, recent arrivals in the Border group have perked this category up, and now such curiosities as *P. auricula* 'Starling' (p. 18), which sports slate-purple flowers speckled with farina, are becoming more popular.

From humble mountain primula to elaborate, showy hybrid, the auricula has come a long way. A plant naturally suited to the show bench (and the collector's mentality), it is all too often dismissed by ordinary gardeners as 'too difficult' or 'too specialist', but it must also be one of the most richly satisfying plants to grow and display, especially in the context of its long, colourful history. These lines from Letter VIII of George Crabbe's long poem *The Borough* (1810) sum up the enduring prestige and attraction of this extraordinary plant:

> *These brilliant hues are all distinct and clean,*
> *No kindred tint, no blending streaks between;*
> *This is no shaded, run-off, pin-eyed thing,*
> *A king of flowers, a flower for England's king.*

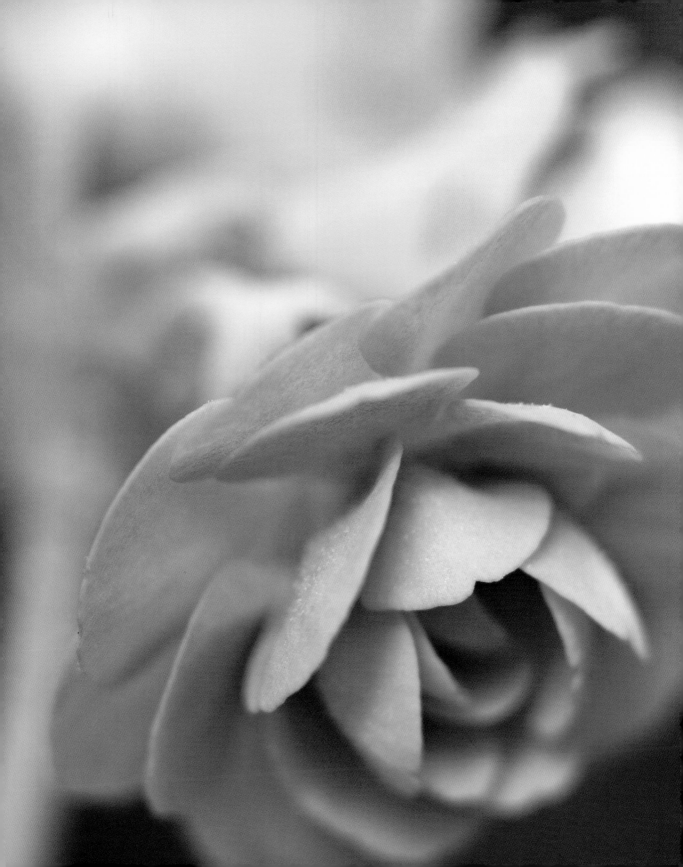

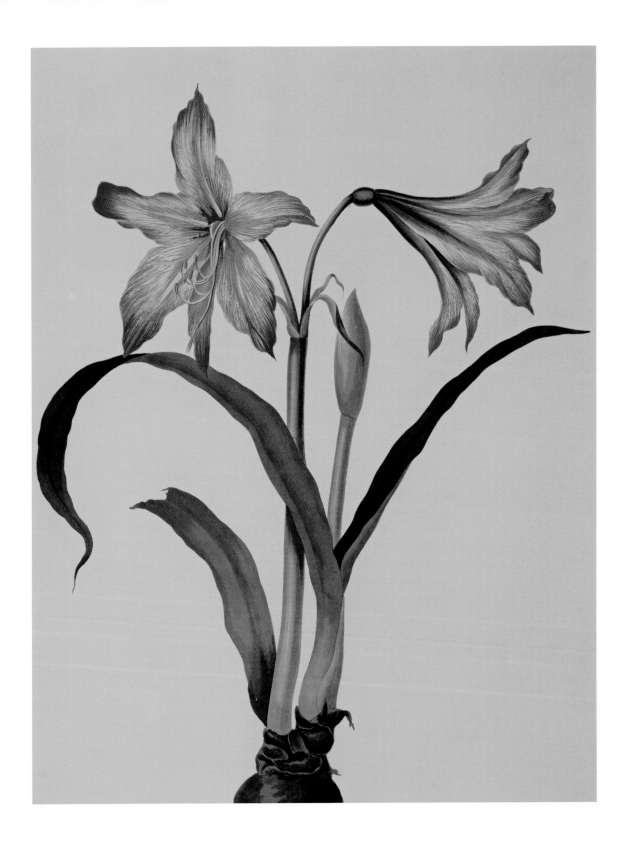

Hippeastrum

The South American hippeastrum, or 'amaryllis', as it is commonly known, is fast taking over from the poinsettia as the most popular Christmas plant. Forced for indoor cultivation in the winter, it grows from the most unpromising-looking bulb, throwing up spikes of exotic, eye-catching flowers that unfurl from their buds like a giant butterfly emerging from a chrysalis. In rich colours ranging from deepest blood-red to delicately veined white, the classic large-flowered single form with its trumpet-shaped blooms is the most widely grown; but in the twenty-first century an increasing range of hybrids has widened the choice, and there are now sumptuous doubles and bi-colours as well as the sculptural, spidery forms of *Hippeastrum cybister*. It is these last, smaller-flowered forms that are finding favour today.

The 'Lilionarcissus': a glamorous new arrival

The general view is that the hippeastrum reached Europe from South America in the late seventeenth century, when the first official descriptions were published. In fact, it had been known in Europe since the beginning of that century, and although no records exist to document its exact journey from New World to Old World, it is possible from the first Western illustrations to say roughly when it arrived. One of the earliest images of the hippeastrum appeared in 1624 in a book of engravings by Pierre Vallet, the first botanical painter in the seventeenth-century French court. The book, *Le Jardin du roy très chrestien Loys XIII* (*The Garden of the Most Holy King Louis XIII*), was the second version of one of the very first florilegia, recording the rare and unusual plants growing in the king's garden. The first, *Le Jardin du roy très chrestien Henri IV* (1608), did not include the hippeastrum, so it must have been sent to the new king a few years afterwards with such other New World plants as the passion flower, which was introduced in about 1612. Described as *Lilionarcissus rubeus indicus*, the hippeastrum appeared again in 1625, in a similar florilegium in Italy.

The plant was also sent to Holland some time in the seventeenth century, although exactly when and by whom remain a mystery. It was first described in 1698 in *Paradisus Batavus*, a record by the German botanist Paul Hermann of the collection of plants in the famous Leiden Botanic Garden. Hermann described the plant that had been sent to him rather long-windedly as '*Lilum americanum puniceo flore Bella Donna dictum*' ('the American lily with scarlet flowers called Belladonna'). The 'belladonna' epithet was to be hugely significant in the enduring botanical muddle over the name, as we shall see later.

A similar plant with striking crimson flowers was painted in 1705 by the artist Maria Sibylla Merian (see p. 128) after a trip to Surinam. 'This lily comes from a white bulb which grows wild in the countryside', she wrote. 'Its leaves – which are green – have a satiny lustre … They have this in the gardens of Holland, where they bear blossoms before their leaves appear.' It is likely that the

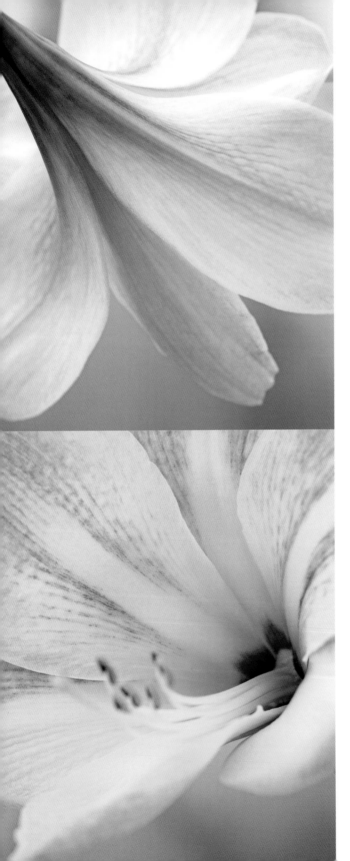

plant recorded by these early botanists and artists was the species now known as *Hippeastrum puniceum*, the Barbados lily.

Amaryllis or hippeastrum?

From this point onwards, various species of hippeastrum began to arrive in Europe, and botanists sought to classify the plant. Thus started what can be described only as a botanical shambles over the naming of the genus; it has never been ironed out. The reason for the name change was the gradual realization of a fundamental nomenclatural error that had led to two superficially similar plants from completely different parts of the world being given the same name. *Amaryllis belladonna* was (and is still) used to describe a tall, pink, multi-flowered plant from South Africa; by mistake, the same name was used for a similar but crimson-flowered plant from the West Indies (the forerunner of the hippeastrum hybrids we grow today). The state of affairs became hugely complex, but the finger can be pointed at none other than Carl Linnaeus (1707–1778), who had used Hermann's name for the plant, Belladonna. As far as one can make out, he must have mixed up the description of the Cape flower with that of the South American one, basing his name (*Amaryllis belladonna*) on the African flower while describing the American one. Even the 'father of botany', it turns out, was fallible.

Confusion reigned for many years. In the nineteenth century the cleric and botanist William Herbert

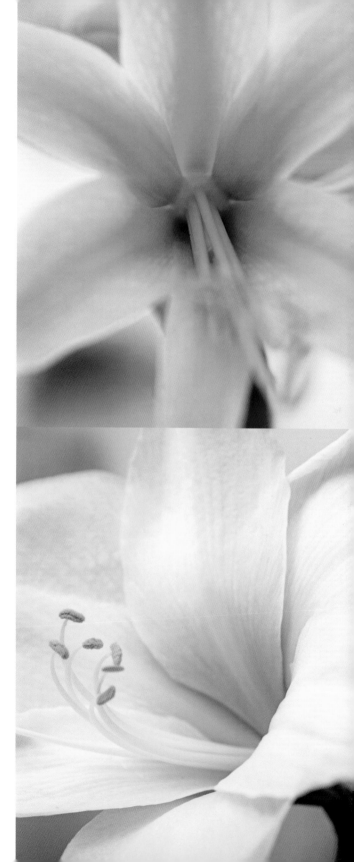

Opposite, from top: *Hippeastrum*
'Apricot'; 'Apple Blossom'.

Right, from top: 'Evergreen';
'Matterhorn'.

(1778–1847), who had an interest in all the amaryllids, took matters into his own hands and, after extensive research, reclassified the American amaryllis as 'hippeastrum', from the Greek *hippos* (horse) and *astrum* (star). Opposition to the new nomenclature was fierce, because, as the eminent Victorian horticulturist Harry Veitch (1840–1924) summed up, people simply preferred the sound and connotations of the word 'amaryllis': 'Are we wrong', Veitch wrote in the *Journal of the Royal Horticultural Society* in 1890, 'in continuing to call these grand flowers after the name of the Virgilian nymph, and should we therefore drop the pleasing appellative with which they have been almost indissolubly connected from our earliest memory, and substitute the rougher Hippeastrum for the softer Amaryllis?' To this day opinion is divided on what the name of the genus should be, and many believe that it should never have been changed; bulb producers persist in using the common name Amaryllis, and the debate continues.

Oblivious to all this confusion, amateur growers in Britain were receiving new species of hippeastrum with open arms. *H. reginae* was introduced from Mexico in 1728 and *H. vittatum* from Peru in 1769, followed by others at the beginning of the nineteenth century. *H. psittacinum*, with its crimson-edged flowers and finely striped markings, was introduced in 1814 and illustrated two years later by Sydenham Teast Edwards in his *Botanical Register*. William Hooker (1785–1865), first director of the Royal

'Chico'.

Botanic Gardens, Kew, was effusive about this new species when it first flowered there: 'My expectations have been fully realized, and I think it may fairly be pronounced the most splendid individual of this splendid genus' (*Curtis's Botanical Magazine*, 1836). Inevitably, people began to see the potential of cross-breeding this showy plant, and the quest for improvement began.

The first hippeastrum hybrids

The first hybrid was made in 1799 between *H. reginae* and *H. vittatum*, by an amateur enthusiast named Arthur Johnson, a clockmaker from Preston in Lancashire. The cultivar was universally appreciated for its clear crimson petals, each with a narrow stripe of white, and indeed it still exists, under the name *H. × johnsonii*. One of the most striking contemporary engravings of this cultivar appeared in an extraordinary publication called *Hexandrian Plants* by the botanical artist Priscilla Susan Bury (1799–1872), published in parts between 1831 and 1834. Mrs Bury (see p. 24) was an amateur artist who started painting specimens at the Liverpool botanic garden as a hobby. Encouraged by friends, as she reports in the preface to the collection, she began to make a collection of amaryllid drawings as 'an endeavour to preserve some memorial of the brilliant and fugitive beauties, of a particularly splendid and elegant tribe of plants'. The plate portraying Johnson's hybrid is given pride of place as the first in the volume, and her notes on the plant accompany the illustration: 'This lily is sufficiently worthy of distinction from its splendid appearance, but still more so, as being the first hybrid on record', she wrote. The book was produced in an impressively large format and contained hand-coloured engravings of some fifty amaryllids, including plants that we know now as nerines, crinum and sprekelia, in addition to eighteen hippeastrum, giving an idea of how many species had been introduced in a relatively short period of time.

After Johnson's hybrid, other breeders in Britain, Holland and Belgium followed suit, producing many new forms throughout the nineteenth century. Meanwhile, new species of hippeastrum were being actively sought and sent back from South America. One British plant-hunter who played a significant role in the history of the genus is Richard Pearce (*c.* 1835–1867), who was employed by Veitch's nursery to seek out new plant material in South America. Pearce carried out two three-year expeditions between 1858 and 1867 to explore Chile, Peru, Bolivia, Ecuador and Argentina, discovering dozens of new species, including several begonias and two hippeastrums, *H. pardinum* and *H. leopoldii*. The latter, with its shorter, open-faced flower, was used to create the first Leopoldii hybrids, which have influenced the development of modern large-flowered hybrids. The *Floral Magazine* of 1870 contained a colour illustration of *H. leopoldii*, depicting its huge, 20-centimetre-diameter

(8 in.) flowers, along with this description, revealing how it had been named:

> *Hippeastrum Leopoldi* [sic] *was obtained from the same habitat, Peru [as* H. pardinum, *which was illustrated in an earlier volume], by Mr R. Pearce, and he always considered it a most valuable species. It did not flower until the present year, when it fully confirmed all that he had said of it; and when, on the occasion of the visit of his Majesty the King of the Belgians to London last autumn, an exhibition was rapidly got together at the Royal Horticultural Society's Gardens in his honour, the Messrs Veitch exhibited, and requested that it might be named Leopoldi, a permission which was at once courteously granted.*

Tragically, Richard Pearce died at about the age of thirty after contracting yellow fever from a mosquito bite on a third trip to South America.

The twentieth century to today

Throughout the second half of the nineteenth century and the first half of the twentieth, demand for new hippeastrums remained high, and hybridization continued in Britain, The Netherlands, Belgium and the United States. Various milestones can be noted in the form of the most successful named cultivars of the day: 'Empress of India', raised in Holland, was the first hippeastrum to boast multiple flowers rather than only two or three, while 'Snowdon' was the first pure-white Leopoldii hybrid,

created in 1904 by Charles Fielder, head gardener at North Mymms Park in Hertfordshire. When the First World War forced British breeders to discontinue their work, the Americans took over, and the hippeastrum became hugely fashionable in the United States, a fact borne out by the establishment in 1933 of the American Amaryllis Society.

Although interest dwindled in the middle of the twentieth century, it has been rekindled with renewed vigour since the 1970s, as yet more species are discovered in South America, showing how enormous and seemingly limitless the genus is. Breeding continues in the United States and The Netherlands, as well as in Australia, Japan and — ironically — South Africa, whose native *Amaryllis belladonna* was confused with the hippeastrum in the eighteenth century.

Despite the Victorian craze for the plant, now long forgotten, hippeastrums fell out of favour in Britain for many years, but recently they have suddenly become popular again. In addition to the well-known cultivars 'Red Lion' and 'Apple Blossom' (p. 26), a range of more exciting varieties is becoming available to satisfy the enthusiasts. Red is the most popular colour by far: 'Benfica' and 'Royal Velvet' are two of the loveliest, in darker, more sophisticated shades than 'Red Lion'; 'Rapido' (p. 32) is a modern small-flowered hybrid, subtler than some, but more beautiful for it. At the other end of the colour spectrum are the whites and greens, including 'Matterhorn' (p. 27), a good Dutch cultivar

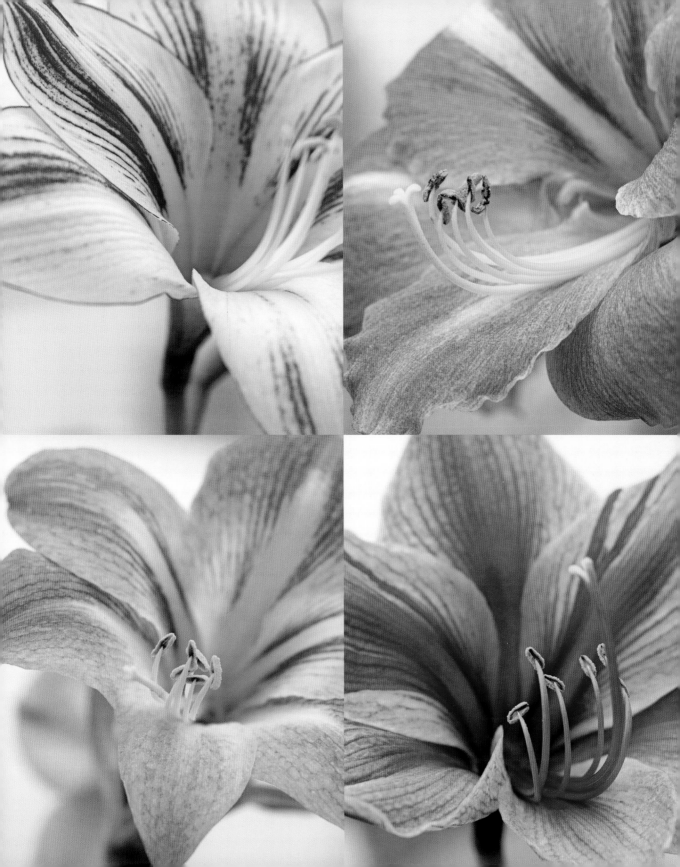

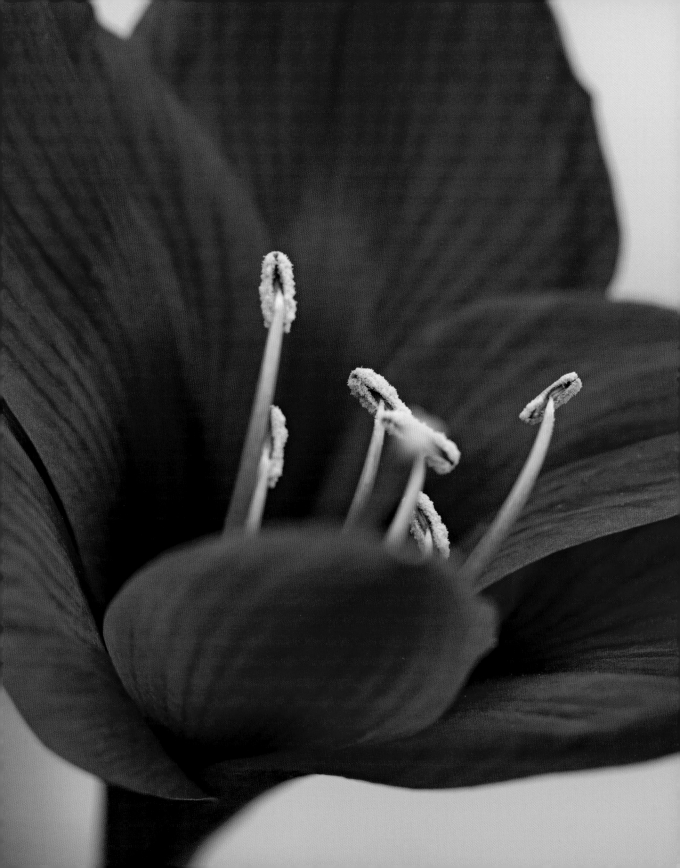

Opposite: 'Rapido'.

Right, from top: 'Santos';
'Bogota'.

sporting huge single flowers with lime-green throats, and
'White Peacock', a flamboyant double with snow-white
blooms. Some hippeastrums are bi-coloured, with
striped, veined or picoteed edges; others, particularly
the cybister types, have narrow, twisting petals, giving
them an ethereal quality.

 What many people may not realize is that hippeastrum
bulbs are extremely easy to grow: all that is needed is a
light windowsill and a warm room, and the plant will do
the rest. Bear in mind, too, that these are not one-hit
wonders; if treated well, they will go on blooming for
decades. After flowering, the plant will continue to
produce leaves; it should be watered throughout spring
and summer, and placed in a warm greenhouse or on a
sunny windowsill. In autumn watering can stop, and the
plant should be kept at a temperature of around 13 degrees
Celsius, as the bulbs need a cool period for reliable repeat
flowering. After eight to ten weeks, old leaves should be
snipped off, the compost refreshed (by removing the top
5 centimetres/2 in. and replacing with new) and the pots
brought into a warm room for the cycle to begin again.

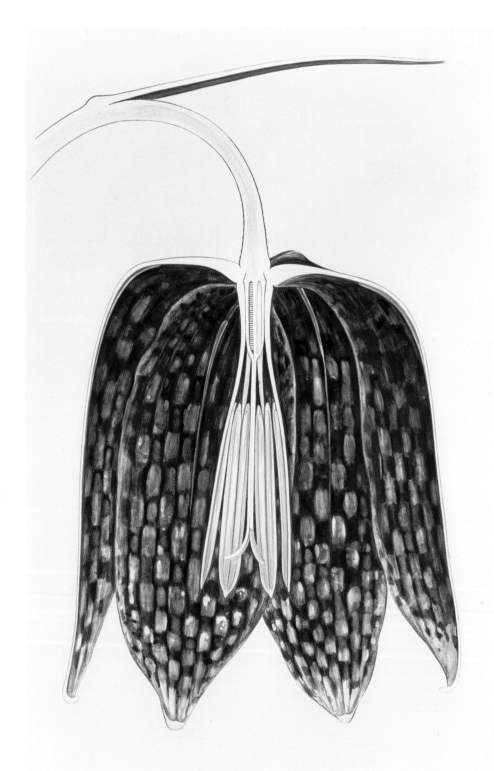

Fritillary

'Art is the flower, life is the green leaf. Let every artist strive to make his flower a beautiful living thing, something that will convince the world that there may be, there are, things more precious, more beautiful – more lasting than life itself.' So said Charles Rennie Mackintosh (1868–1928) in a lecture delivered in 1902. Nature was a strong influence on Mackintosh's work, and although he is better known for his architecture, textiles and jewellery, he also produced some fine botanical paintings, among which was his beautiful study of the snake's head fritillary, *Fritillaria meleagris*. If there was a flower that represented his entire œuvre it would be the fritillary, with its intricate and unusual chequered markings that look almost as if they have been printed on to silk and then overlaid on the petals. These markings, almost unique in the world of plants, make the snake's head fritillary one of the most distinctive of flowers. Like a rare jewel, it seems almost out of place alongside the humble buttercup and cowslip, but perhaps that is because these days it *is* so rare in the wild. One of the few places where fritillaries still thrive is in the water meadow at Magdalen College, Oxford, where in late April the emerald grass is studded with thousands of nodding mauve flowers that bob in the breeze like miniature lanterns – an ephemeral tableau that appears as if from nowhere and then disappears almost as mysteriously as it arrived.

Early European cultivation

The snake's head fritillary is thought of as a British wild flower, but its geographical spread covers a great swathe of Europe, so it may have been introduced to Britain from the Continent at some point and subsequently naturalized there. Its exact history is unknown, and undoubtedly stretches back thousands of years. Its first representation in Western art and literature, however, does not occur until the sixteenth century, perhaps because the genus had no known medicinal properties and was therefore excluded from the early Greek and Latin herbals. This fact was noted by John Gerard in his herbal of 1633: 'Of the facultie of these pleasant floures there is nothing set down in the ancient or later Writer, but [they] are greatly esteemed for the beautifying of our gardens, and the bosoms of the beautifull.' The ginny-hen (or guinea-hen) flower or chequered daffodil, as it was known then, was grown purely for its ornamental value, which Gerard described in effusive terms: 'Nature, or rather the Creator of all things, hath kept a very wonderful order, surpassing (as in all other things) the curiousest painting that Art can set down.' The name *Fritillaria* is derived from the Latin *fritillus*, a chequered dice box, and the species name, *meleagris*, comes from the Latin for guineafowl, the speckled markings of which the flower resembles.

One of the first botanical illustrations of the snake's head fritillary appears as a woodcut in *Plantarum*

seu Stirpium Icones (*Images of Plants*, 1581) by Mathias de L'Obel (1538–1616), a French botanist. L'Obel, or Lobelius, as he was known, also illustrated in this volume a fritillary that had been introduced only very recently from Turkey: the crown imperial (*Fritillaria imperialis*). A completely different creature from the dainty snake's head, this tall, sturdy plant bears gaudy yellow, orange or red flowers crowned with a topknot of spiky leaves. Although it was a new plant to Europeans when it arrived in 1576, it had been cultivated for centuries before that in Turkey and Iran.

The botanist Carolus Clusius, head of the Imperial Gardens in Vienna from 1573 to 1587, is credited with the fritillary's introduction to and distribution around Europe. He received and enthusiastically propagated many new plants, particularly bulbs, sent to him from the East by such travellers as the intrepid Ogier Ghiselin de Busbecq, perhaps better known for his role in the introduction of the tulip (see p. 83). Clusius illustrated four fritillaries in his *Rariorum Plantarum Historia* (1601) – *Fritillaria imperialis*, *F. persica*, *F. meleagris* and *F. aquitanica* (now known as *F. pyrenaica*) – although at the time they were thought of as being completely different plants, with the crown imperial and *F. persica* both classified as lilies.

The fashionable crown imperial

In Britain, the crown imperial was seized on with glee and was soon eliciting high praise. In his *Paradisi in Sole Paradisus Terrestris* of 1629, the botanist John Parkinson wrote: 'The Crowne Imperiall for all his stately beautifulness deserveth the first place in this our Garden of delight, to be entreated before all other Lillies.' The plant's status in the gardens of the well-to-do is clearly to be seen in a delightful seventeenth-century engraving entitled *Spring Garden*, in which the crown imperial takes centre stage in a perfect Tudor parterre, surrounded by such other recently introduced bulbs as tulips and lilies. The illustration is on an introductory page of *Hortus Floridus* (*A Garden of Flowers*, 1614), a collection of engravings of 'rather rare and less common flowers' by the Dutch publisher and engraver Crispijn de Passe and his son, also Crispijn. Later in the book the crown imperial appears as a single plate, its flowers large and showy, a lone bee buzzing underneath the petals. These enchanting images are somewhat different from the style of botanical illustration that had gone before. The dynamic, close-up portraits of each flower are more intricate than earlier woodcuts, and are brought to life by the presence of bees, butterflies and other insects that add movement and interest to each plate.

One of the most realistic and beautifully executed portraits of the crown imperial appeared in the florilegium of Dutch artist Pieter van Kouwenhoorn (1630; now in

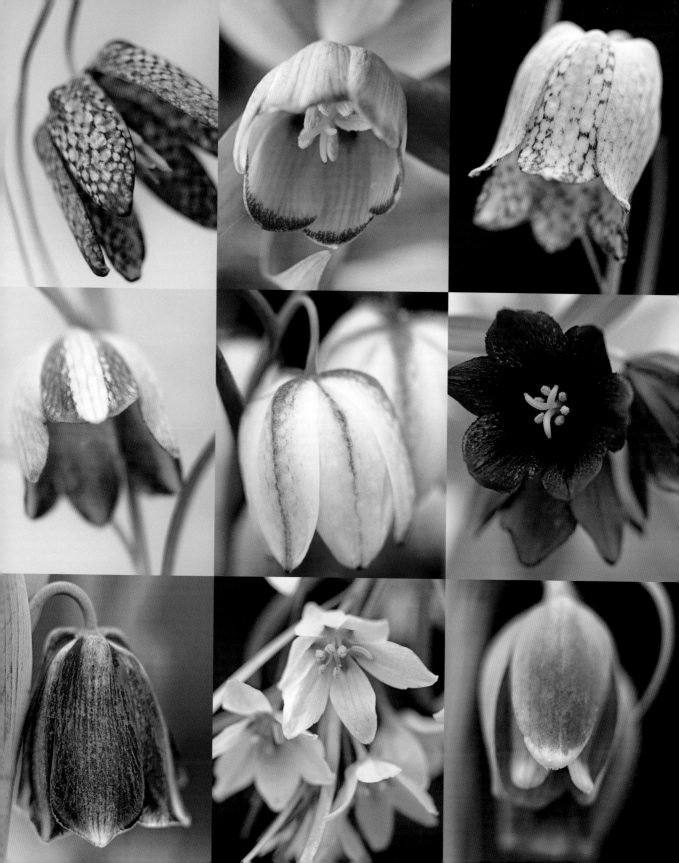

the Royal Horticultural Society's Lindley Library in London). Extravagant florilegia – bound collections of botanical watercolours – were highly popular in the seventeenth and eighteenth centuries, often commissioned by wealthy patrons as a record of what was growing in their own gardens. Another striking early seventeenth-century painting of the crown imperial appeared as part of the extraordinary *Paper Museum* of Cassiano dal Pozzo, now in the Royal Collection at Windsor Castle. This wonderful assemblage of more than 7000 watercolours, drawings and prints, brought together throughout the seventeenth century by dal Pozzo, an Italian patron and collector, documented the art, archaeology and natural history of the age, and included some fine botanical studies. The painting of the crown imperial is eye-catching and graphic, with the nodding burnt-orange flowers framed top and bottom by leaves.

Other species of fritillary were known and, to a lesser extent, cultivated during the seventeenth and eighteenth centuries, including *F. persica*, another flower of the East that arrived from Turkey at about the same time as the crown imperial. This dusky beauty stands about 1 metre (3 ft) tall and bears many delicate, bell-like, darkly burnished flowers that hang down like bunches of red grapes. Although it was illustrated in the early plant treatises, its more reserved beauty appears not to have caught the eye of many botanical artists, and in his herbal of 1597 John Gerard was politely rude about it: 'There

is not any thing knowne of the nature or virtues of this Persian Lily, esteemed as yet for his rarenesse and comely proportion; although (if I might be so bold with a stranger that has vouchsafed to travell so many hundreds of miles for our acquaintance) we have in our English fields many scores of floures in beauty far excelling it.'

The fritillary in the eighteenth and nineteenth centuries

Unlike many other flowers, the variability of which led to the creation of countless new forms, there is limited scope for hybridization with the fritillaries, so they have never risen to the levels of popularity of, say, the tulip or the carnation. But this very simplicity is their charm, and they are a breath of fresh air, an antidote to the overdone unnaturalness of many hybrids. The story of the genus therefore changes little from the seventeenth century onwards, and there is no notable progression recorded in the art of the day. Because of its showy countenance, the crown imperial continued to woo the great botanical painters of the eighteenth and nineteenth centuries, but other species were largely overlooked.

One exception is the fascinating anatomical portrait of *F. meleagris* made by Arthur Harry Church in 1906 (p. 34), which in typical Church style shows a dissection of the flower, allowing the viewer to see the inner stamens and sexual parts against the petals. Church, a botanist who

taught at Oxford University for some thirty-five years, had no background in art, but began to use his own meticulously executed watercolour studies of dissected flowers to demonstrate the mechanics of reproduction to his students. He produced an extraordinary body of work for his unfinished *Types of Floral Mechanism*, only one volume of which was ever published, in 1908. His exquisite paintings are as decorative as they are educational, and his fritillary is a particularly striking image.

A recent revival

Only very recently has interest in fritillaries broadened the availability of different species to gardeners. In total there are more than 100 species in the genus; most are comparable to *F. meleagris* in size and have muted but interesting colours, some with tessellated patterning, others with coloured edging to the petals. They can be grown in pots or rock gardens, and some can be naturalized in grass. Broadly speaking, fritillaries can be divided into two categories in terms of their cultivation requirements: those that need dry conditions, and those that need moisture to thrive. The snake's head fritillary comes into the second category, preferring damper habitats – such as the water meadows at Magdalen College – and this is the species to naturalize in grass if you have the right conditions. On the other hand, the crown imperial, *F. imperialis*, is best grown in a mixed border,

From top: *Fritillaria pallidiflora*;
F. imperialis.

and needs a well-drained, rich soil and full sun, as do
the dusky *F. persica* and its pale-green cultivar 'Ivory Bells',
and the delightful *F. verticillata*, which has flowers of the
palest green, hanging down like paper lanterns, delicately
chequered on the inside. Other, smaller fritillaries enjoy
the dry conditions of a rock garden or raised trough.
F. pyrenaica is one of the most versatile, with interesting
maroon–brown flowers tinged in yellow or green,
sometimes tessellated, and *F. hermonis* subsp. *amana* (p. 37)
is similarly easy, with attractive flowers striped in rusty
brown and lime-green.

These are not bold feature plants, but delicate
beauties to be appreciated from close quarters, and it is
this subtlety that Vita Sackville-West summed up when
she wrote on the fritillary: 'In order to appreciate its true
beauty, you will have to learn to know it intimately' (*Some
Flowers*, 1937). Such modern-day painters as Raymond
Booth (born 1929) and Rory McEwen (1932–1982) have
painted the range of fritillaries available today, capturing
the subtle details that give each species its distinctive
character. Surely the painter's or photographer's eye can
only encourage people to enjoy a more intimate view of
these fascinating flowers.

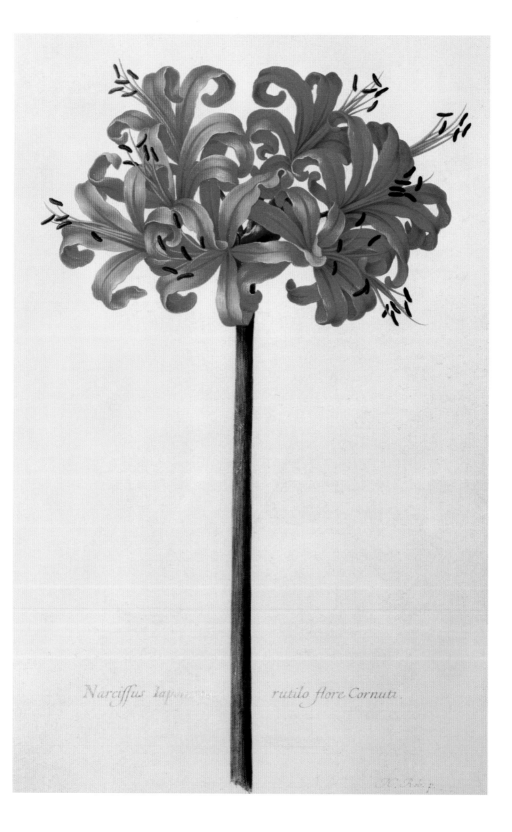

Narciffus Iapon̄ic̄us rutilo flore Cornuti.

Nerine

The story of the nerine is one of the most enjoyable in plant history, a dramatic tale of shipwrecks, mystery and intrigue that — even when unravelled — leaves plenty of unanswered questions. The handsome autumn-flowering South African bulb *Nerine sarniensis* made its way to Europe some time in the early seventeenth century; although we cannot be precise about the year it arrived, it seems to have reached France first, where it was initially described and illustrated in 1635. It appeared in the volume *Canadensium Plantarum* by the physician Jacques Philippe Cornut, with a beautifully detailed etching showing the bloom and the bulb, drawn from a plant that had flowered in the garden of nurseryman Jean Morin the previous year. The book, which was purportedly about North American plants, contained several South African bulbs, although their source may not have been known at the time. Indeed, the drawing of the nerine is labelled *Narcissus japonicus rutilo flore*, establishing the widely held belief that it had come from Japan. The most likely reason for this mistake — which was to cause confusion for most of the next 200 years — was that the bulbs had arrived on a Japanese ship, which would have stopped at the Cape on its way. Soon afterwards the botanical artist Nicolas Robert (1614–1685) engraved a single bloom of the plant (opposite) — a vivid, sculptural flower, which explodes outwards from its straight, stout stem — and the plant was launched in France.

It took another decade or so for the nerine to arrive in Britain, where, as far as records show, it was first grown by John Lambert (1619–1684), a Parliamentarian general during the Civil War. A keen gardener, 'Honest John' had acquired the nerine from Morin in Paris, and grew it in his garden in Wimbledon in the 1650s. One of his specimens was painted by Alexander Marshal in 1759 for his florilegium — the first ever British painting of the flower.

The Guernsey shipwreck

Despite being firm evidence that *Nerine sarniensis* had been introduced to Britain in the 1650s or before, this small episode in botanical history has been glossed over in favour of a much more intriguing tale that was perpetuated by many a learned horticulturist for years to come. The bulbs, it is said, came to Britain via Guernsey, where they had mysteriously arrived and were growing prolifically. How exactly they came to be growing there is still not known, but the story to which most people subscribed was that boxes of bulbs were cast off a sinking ship bound for Holland in about 1659, and that the bulbs subsequently established themselves in the sand dunes after being washed ashore. The story captured everyone's imagination, even prompting the poem 'The Guernsey Lily' by Hartley Coleridge (1796–1849):

Far in the East, and long to us unknown,
A lily bloom'd, of colours quaint and rare;
Not like our lilies, white, and dimly fair,
But clad like Eastern monarch on his throne.
A ship there was by stress of tempest blown,
And wreck'd on beach, all sandy, flat, and bare; —
The storm-god bated of his rage to spare
The queenly flower, foredoom'd to be our own.
The Guernsey fisher, seeking what the sea
Had stolen to aid his hungry poverty,
Starts to behold the stranger from afar,
And wonders what the gorgeous thing might be,
That like an unsphered and dejected star
Gleam'd in forlorn and mateless majesty.

But there is another, more likely explanation of the nerine's colonization of Guernsey. None other than 'Honest John' Lambert was exiled there in 1661, and it seems likely that he brought the first bulbs with him. Whether the first story was circulated as an elaborate cover-up by those who did not want the disgraced Lambert to get all the accolades for the nerine's introduction to the island (and indeed to Britain in the years before the Restoration) will never be proved. The plant was soon thriving in the benign climate of the Channel Islands, and has grown there ever since, its Linnaean name, *Amaryllis sarniensis*, taken from the Latin name for Guernsey, Sarnia.

The great Empress of the whole flowery world

In Britain, *Nerine sarniensis*, being too tender for general outdoor cultivation, was grown by only a handful of keen gardeners and botanists, and remained an exotic curiosity until the early eighteenth century, when the flowers began to be cultivated on a larger, more commercial scale in Guernsey. By 1725 the plant was sufficiently well known to have a book devoted to it: *Description of the Guernsey Lily* by James Douglas (1675–1742). Douglas, who was better known for his work as an obstetrician, wrote most enthusiastically:

> *Whoever will but give themselves the trouble to walk out to Hoxton in the months of September or October and view it in Mr Fairchild's garden, in its full prime and beauty, will readily agree that it richly deserves to be taken pains about ... I therefore heartily invite all lovers of flowers to the culture of the Guernsey Lilly, the great Empress of the whole flowery world, I am sure the noblest plant that England can boast of...*

He also provided an eloquent description of the flower, drawing attention to the unique sparkly sheen that distinguishes *N. sarniensis* from other plants: 'When we look upon the flower in full sunshine, each leaf appears to be studded with thousands of little diamonds, sparkling and glittering with a most surprising and agreeable lustre; but if we view the same by candlelight, these numerous specks or spangles look more like fine

gold dust.' Unfortunately his drawings of the plant in the book are in black and white, so do not convey the essence of these colourful, lustrous flowers, although – as one would expect from a medical man – they are anatomically precise, showing flower, roots and dissections. Douglas played his part in perpetuating the shipwreck myth, relating how the introduction of the species to Britain 'happened by a very singular melancholy accident'.

The confusion over the plant's origins continued throughout the eighteenth century. In his *Dictionary of Gardening* of 1768, Philip Miller wrote that the plant 'was supposed to come originally from Japan, but has been many years cultivated in the gardens of Guernsey and Jersey; in both [of] which places they seem to thrive as well as if it was their native country; and from those islands their roots are sent annually to the curious in most parts of Europe, and are commercially called Guernsey Lilies'. Even after nerines were found growing on Table Mountain by the plant-hunter Francis Masson in the 1770s, *Curtis's Botanical Magazine* (see pp. 139, 142) was getting it wrong. In volume 9 (1795), *N. sarniensis* was illustrated and described thus: 'The Guernsey Lily, as it is most commonly called, is originally a native of Japan; where it is described to grow by Kaempfer and Thunberg, who visited that island, the latter says on the hills about Nagasaki[;] from thence roots are said to have been introduced to the garden of Johannes

Morinus [Jean Morin] at Paris, in which it flowered, October 1634.' Either the botanists Engelbert Kaempfer and Carl Peter Thunberg were describing the Japanese native *Lycoris radiata*, which is similar in appearance to the nerine, or they really had found the nerine there, it having been previously introduced from South Africa.

Victorian heyday and twentieth-century collections

The nineteenth century saw a steady rise in the nerine's popularity, and Linnaeus's *Amaryllis sarniensis* was given a new name in 1820 by William Herbert, who spent many years working on classifying the Amaryllis and related genera (see pp. 26–27). He called the plant 'nerine' after the sea nymph of Greek mythology, again referring to the shipwreck theory. By this time a handful of other species had been introduced, including *N. humilis*, the 'salmon-coloured amaryllis', illustrated in *Curtis's Botanical Magazine* in 1808, and *N. undulata*, a delicate pale-pink species illustrated by Sydenham Teast Edwards in his *Botanical Register* in 1816. With this new material, Herbert created the first hybrids, and by 1837 there were seven recognized varieties. The general popularity of conservatory plants in Victorian times at last accelerated interest in nerines, and they became the height of fashion in 1888 when the society beauty and

mistress of Edward VII, Lillie Langtry, was painted
by John Everett Millais demurely holding a bloom of
N. sarniensis. By chance, Langtry hailed from Jersey and
became known as the Jersey Lily, further confusing
matters, since the plant was still known commonly as
the Guernsey Lily.

The most concentrated work on breeding *N. sarniensis*
was carried out at the beginning of the twentieth century
by Henry Elwes (1846–1922), who is better known for his
discovery of the snowdrop named after him, *Galanthus
elwesii*. Elwes, who was a bulb man, wrote a detailed
study of lilies, *Monograph of the Genus Lilium* (1880); he
also built up a renowned collection of bulbs in his
garden at Colesbourne Park in Gloucestershire. Elwes
commissioned the botanical artist Lilian Snelling
(1879–1972) to paint his collection of nerines, and
these paintings of long-lost cultivars are now held in the
Royal Horticultural Society's Lindley Library. Conjuring
up a different era, they seem to be named after either
relatives ('Miss Rosamund Elwes', for his daughter)
or well-to-do ladies. After Elwes's death, his nerine
collection passed into the hands of enthusiast Lionel
de Rothschild, who continued the breeding work from
his gardens at Exbury in Hampshire. The Exbury
collection, in turn, was acquired by the Conservative
politician Sir Peter Smithers in the 1970s, who had
loved nerines ever since buying his first plants as a
teenager. His rigorous selection techniques in breeding

new varieties included an annual 'beauty contest', when he would invite friends to his house in Switzerland to see his nerines beautifully displayed on a balcony, and ask them to rate each specimen. In 1995, in a pleasing example of horticultural continuity, Sir Peter met Nicholas de Rothschild, Lionel's grandson, and offered the collection to him, bringing it back to Exbury. Today the plants thrive in the glasshouses there, and are displayed each October in a special gallery to show off their brilliant colours, which range from the palest of pinks to the deepest crimson.

The *sarniensis* hybrids will thrive in pots, provided you have a conservatory or greenhouse where you can give them a minimum night-time temperature of 4 or 5 degrees Celsius in winter. They are sometimes called diamond or jewel lilies, and many have a beautiful iridescent quality with crystalline flecks that sparkle in the sunlight – a phenomenon the Victorians noted as 'gold or silver dusting'. As well as the vermilion of *N. sarniensis* itself, there are hybrids in rich shades of orange–red (*N. sarniensis* var. *corusca* 'Major'), delicate sugar-pink (*N.* 'Stephanie') and rich two-tone purple and pink (*N.* 'Cleopatra'; opposite).

The outdoor nerine

The story of the nerine, however, is not quite complete. If we wind the clock back to the beginning

of the twentieth century, we find that another species was introduced to Britain, bringing the nerine firmly within range of the gardener's radar. The shocking-pink *N. bowdenii* (p. 46) is hardy enough to grow outside in temperate climates, immediately broadening its appeal to those without conservatories or greenhouses. It was discovered by an Englishman, Athelstan Hall Cornish-Bowden (1871–1942), after whom the plant is named. Bowden travelled to South Africa as a government land surveyor, eventually rising to become surveyor-general of the Cape Colony, and from there sent bulbs of *N. bowdenii* to his mother, Elizabeth, in Devon. She grew them successfully in her garden, and in 1902 had the forethought to send a few of her bulbs to the Botanic Gardens at Kew, with a note requesting that they be named after her son. Today *N. bowdenii* is the most widely grown species in Britain, and its conspicuous bright-pink flowers bring a final burst of colour to the garden in autumn.

N. bowdenii and its cultivars should be grown in a warm, sunny spot outside, in very well-drained soil that is not too rich in nutrients. Given dry conditions, the plants should survive temperatures as low as -15 degrees Celsius. The different forms flower from September to November, and their large blooms on sturdy stems provide colour well into autumn; for those who cannot take strong pink, such recent cultivars as the pale-pink 'Marnie Rogerson' have broadened the colour range.

For me, the most enduring image of the nerine is one of the oldest: Nicolas Robert's timeless portrait of *N. sarniensis*, which dates from the seventeenth century. Interestingly, the image is well known today, and widely available on the Internet as a poster print. With the colour turned up a notch from the original subtle orange–red to a bright lipstick-pink, the poster image has a modernity that transcends history, and it remains as a tribute to the plant's first glory days in France, before all the myth, mystery and muddle began.

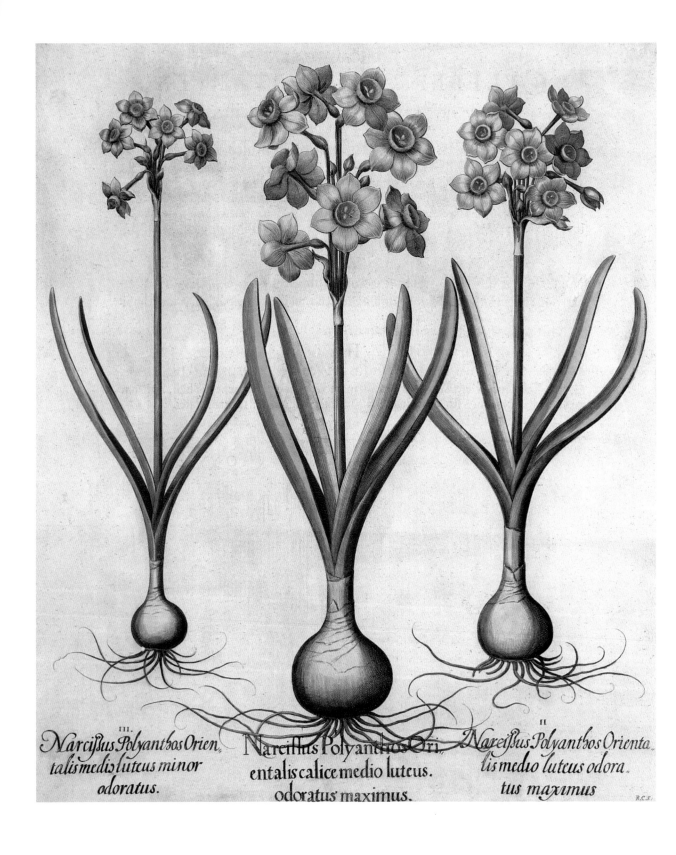

III.
Narcissus Polyanthos Orien
talis medio luteus minor
odoratus.

Narcissus Polyanthos Ori,
entalis calice medio luteus.
odoratus maximus.

II
Narcissus Polyanthos Orienta,
lis medio luteus odora,
tus maximus

R.C.S.

Narcissus

'I doubt whether any flower has a more interesting or romantic history than the Daffodil', wrote Peter Barr, known in Victorian times as the 'Daffodil King', quoted in an article in the *Daffodil Yearbook* of 1933. Barr was biased, of course, being so utterly obsessed with his adopted plant family that he devoted most of the latter part of his life to it, but his words ring true.

The story of this iconic flower begins thousands of years ago, when it was used in the funeral wreaths of the ancient Egyptians. The Greeks followed suit, weaving the flower into head garlands, as well as using the bulb and root in medicine. The first written records are from the Greek philosopher and botanist Theophrastus (*c.* 371–*c.* 287 BC), who referred in 300 BC to several different types of daffodil, most likely to be *Narcissus poeticus* (the pheasant's-eye daffodil) and *N. tazetta*, both of which are native to southern Europe. The philosopher, botanist and physician Pedanius Dioscorides (*c.* AD 40–90) described the narcissus as having white flowers with a saffron-yellow or sometimes purple centre and leaves similar to those of a leek, and wrote about various medicinal uses for the roots, while Homer wrote romantically about the flower in *Hymn to Demeter* (seventh century BC): 'The Narcissus wondrously glittering, a noble sight for all, whether immortal gods or mortal men; from whose root a hundred heads spring forth, and at the fragrant odour thereof all the broad heaven above and all the earth laughed, and the salt wave of the sea.' It is widely

believed that the plant was named after the mythical Greek character who was obsessed with his own reflection, but in his *Natural History* (*Naturalis Historia*, *c.* AD 77–79), Pliny the Elder stated very clearly that its name came from the word *narce*, meaning narcotic: 'It took the name in Greek, Narcissus, of Narce, which betokeneth nummednesse or dullness of sense, and not of the young boy Narcissus, as the Poets do feign and fable' (as translated by the British scholar Philemon Holland in 1601).

The narcissus in Britain

In the wild, daffodil species are found throughout Europe and North Africa, with the majority of species on the Iberian peninsula. Only one daffodil is truly native to Britain: *N. pseudonarcissus*, which in the seventeenth century was called the bastard or false daffodil because it was seen as secondary to the 'true' daffodils that had arrived from the Continent (many forms and species of which were known in Britain at the time, having criss-crossed Europe since Roman times). Also known as the Lent lily, it was to be found all over Britain, growing freely, as the botanist Clusius noted after a visit to England in the sixteenth century: '[It grows] in such profusion in the meadows close to London that in the crowded quarter commonly called Cheapside in March the country women offer blossoms in great abundance for sale, and all the taverns may be decked out with this flower.' Today the true wild

daffodil grows undisturbed in only a few pockets, although the colony that inspired Wordsworth's famous poem survives on the banks of Ullswater in the Lake District.

One of the first known illustrations of the daffodil is a crude depiction of what is probably *N. poeticus* in an eleventh-century copy of the *Herbarium of Apuleius Platonicus*, held in the Bodleian Library in Oxford (see pp. 135–36). Of even less use to the botanist or gardener is the bizarre illustration in the fifteenth-century herbal *Hortus Sanitatis* (*Garden of Health*), published by Jacob Meydenbach in 1491, a volume aptly described by the University of Sydney (which holds a copy) as 'a rich compendium of information and misinformation'. It contains a fascinating mishmash of botanical illustrations, some true to nature, others altogether more fanciful in character, such as the mythical mandrake with its human root, and the 'Tree of Knowledge' with Adam and Eve at its base. The daffodil is illustrated with two human figures emerging from the blooms, incorporating the mythological notion of Narcissus turning into a flower. In direct contrast, two sixteenth-century herbals published only a few decades after the *Hortus Sanitatis* contain infinitely more realistic portraits of daffodils. Otto Brunfels (1488–1534) and Leonhart Fuchs (1501–1566), both of whom are mentioned in other chapters (see pp. 106–107 and 125–26), prided themselves on depicting plants in as naturalistic a way as possible.

In Britain, the first botanical mention of the genus was in the herbal of William Turner (1509/10–1568),

who is often called 'the father of English botany' for his
pioneering work in classifying plants. From the time
Turner's herbal appeared, in the 1550s and 1560s,
interest in collecting different European forms of
daffodil must have suddenly soared; by 1629 John
Parkinson could name and illustrate in his *Paradisi in Sole
Paradisus Terrestris* more than seventy different forms, some
of which would later drop out of cultivation for many
years, only to be rediscovered in the nineteenth century.

This spike of interest was not to be sustained, however.
The humble daffodil was overshadowed by the hundreds of
rare, more interesting plants being collected from all over
the world, and interest in it soon died down. Daffodils
continued to be grown, certainly, and appeared in full
colour in many seventeenth-century florilegiums, including
the extravagant *Hortus Eystettensis* (*The Garden at Eichstätt*; p. 52),
compiled by Basilius Besler and published in 1613 (see
pp. 84, 86); they were also to be seen in the lavish still-life
arrangements of the Dutch School, and were frequently
mentioned in literature of all kinds, from Shakespeare to
Robert Herrick. But the lack of demand for new forms meant
that nobody was interested in creating hybrids, and it was
to be another 200 years before the genus flourished again.

A Victorian revival

At the beginning of the nineteenth century the most
famous French botanical painter of all, Pierre-Joseph

Redouté (1759–1840), produced a series of exquisite daffodil portraits for his work *Les Liliacées*, published between 1805 and 1816 and dedicated to his patron Josephine Bonaparte. A total of eighteen narcissi are illustrated in the volume, all of them slender, delicate creatures as yet unchanged by the hand of man. Redouté was not to know that over the next few decades a vast number of new forms would be unveiled, as horticulturists started creating hybrids, raising the status of this commonplace flower to something more desirable.

One of the pre-Victorian pioneers in narcissus hybridization was William Herbert, who was convinced that the previous way of classifying the narcissus was wrong, and that many of the forms described as species must be natural hybrids. He started making experimental crosses to prove his point, and soon realized the potential of the genus for hybridization. Six of the very first hybrids were illustrated in the twenty-ninth volume of the *Botanical Register* in 1843, along with Herbert's notes on how they had come about. 'It is desirable to call the attention of the humblest cultivator, of every labourer indeed,' he wrote, '... to the infinite variety of Narcissus that may be thus raised ... offering him a sense of harmless and interesting amusement, and perhaps a little profit and celebrity.'

Herbert's words certainly had a galvanizing effect. In the years that followed, others, such as Edward Leeds in Manchester and William Backhouse in Durham, continued the breeding work, raising sizeable collections that began

to change the nature of the garden daffodil. Backhouse,
a Darlington banker with a country house in Wolsingham,
County Durham, devoted all his spare time to collecting
and raising new daffodils. One of his most popular
cultivars, 'Weardale Perfection', which disappeared from
cultivation in the 1930s as other cultivars were introduced,
has recently been rediscovered in a garden in Wolsingham,
and its large, pale-yellow bi-coloured blooms can be seen
once more in the village churchyard.

The Daffodil King

It was the Covent Garden nurseryman Peter Barr
(1826–1909) who contributed most to the Victorian
revival of the plant. He made it his life's mission to collect
daffodils, buying various notable collections, including
Backhouse's, and scouring the country for lost species and
cultivars that he could save from extinction. At the age of
sixty-one, this tireless enthusiast embarked on a series of
journeys in France, northern Spain and Portugal in search
of wild daffodils, as 'he had long cherished the desire to
visit their native habitats, and to find, if possible, some
of the varieties described by Parkinson in 1629' (quoted
in *Daffodil Yearbook*, 1933). The text continues: 'Fortunately
he was endowed with a strong constitution and possessed
abundant energy and perseverance.'

Barr discovered many species that are still known and
grown today, including *N. cyclamineus* and *N. triandrus*, also

known as 'Angel's Tears' (so named because the boy
employed to help him traverse the mountains allegedly
shed tears when he could not keep up with the spritely
Barr). Both these diminutive species had been known
and illustrated in seventeenth-century France and may
also have been grown in Britain, but had subsequently
disappeared from cultivation until Barr reintroduced them.
He worked hard at classifying the genus and generally
whipped up a renewed interest in daffodils, organizing
a daffodil conference with the Royal Horticultural
Society (RHS) in 1884.

From this time the nature of the daffodil began
to change. Other figures, including George Herbert
Engleheart, focused on creating such blowsy, large-
flowered cultivars as 'King Alfred' (1899). Gradually
these took over from the dainty, more natural-looking
forms, and the modern daffodil was born.

Daffodils today

Daffodils are the easiest and most rewarding of bulbs
to grow and naturalize, and they are a symbolic sight of
a British spring. Almost no plant is less liable to disease
or threat from pests, as the leaves and bulb contain
needle-sharp crystals of calcium oxalate, which render it
indigestible and even poisonous to grazing animals. It is
generally thought that about fifty species grow in the wild,
so it is the cultivated varieties — all 24,000 of them — that

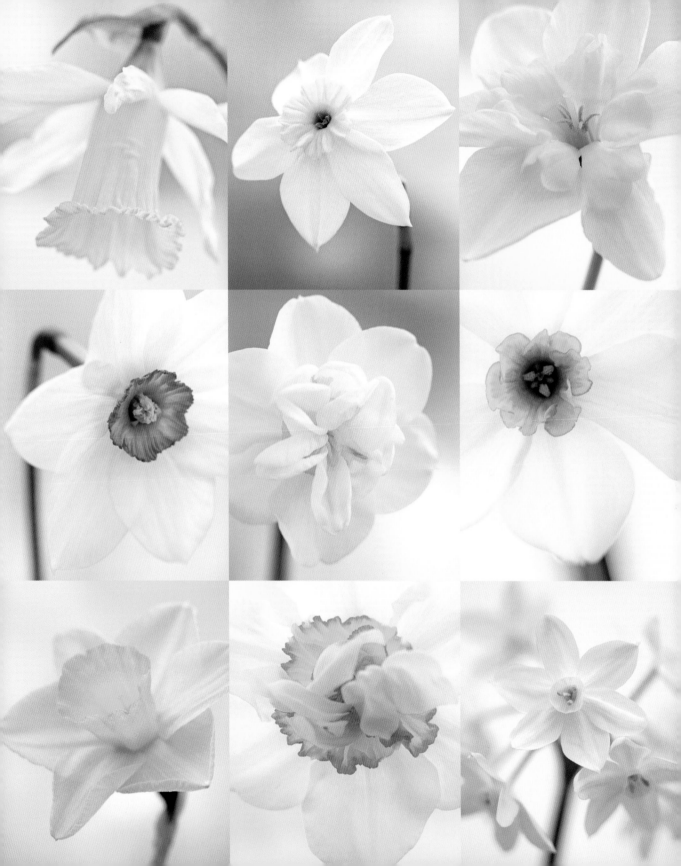

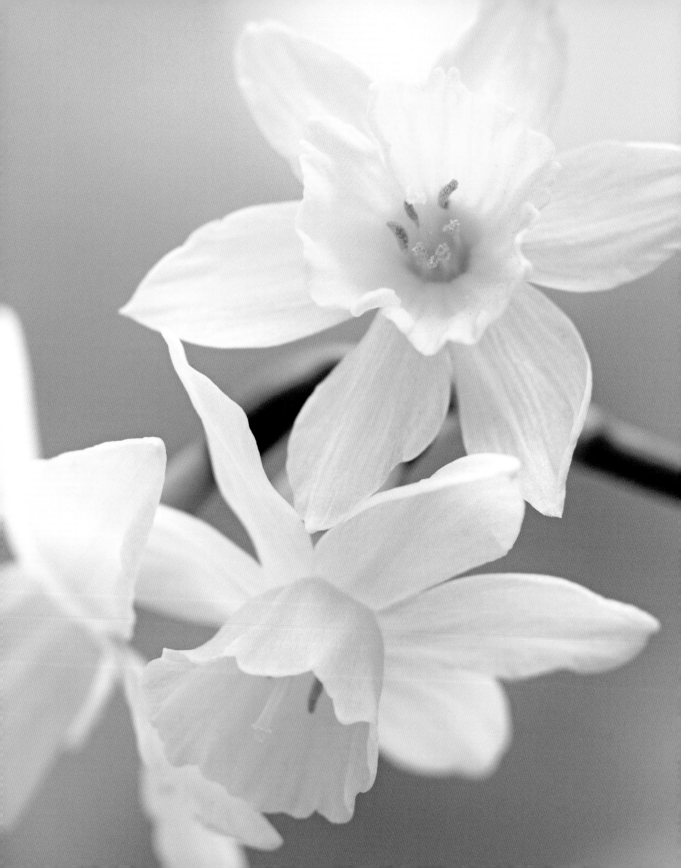

'Sailboat'.

make the most significant contribution to gardens. This unruly bunch is classified by the RHS into eleven groups according to the parent species: trumpet, large-cupped, small-cupped, double, triandrus, cyclamineus, jonquil, tazetta, poeticus, bulbocodium and split-corona.

Most daffodils are unfussy and easy to grow in a variety of soil types. Daffodils for naturalizing in grass should be planted in autumn in open, sunny conditions or on the edge of light woodland, with plenty of space between the bulbs to allow for movement. Ideally, the grass should be left unmown for six weeks after flowering while the foliage dies back. In beds and borders, daffodils should be planted 10–15 centimetres (4–6 in.) apart, and will need to be divided every two or three years to prevent overcrowding. Plant the bulbs at least 10 centimetres (4 in.) deep, or three times the height of the bulb; planting too shallowly can encourage the bulb to split into smaller divisions that will be weaker and shyer to flower.

With so many thousands of cultivars from which to choose, daffodils are in danger of losing their mystique. Recently, however, there has seemed to be a return to favour of the smaller, more delicate cultivars that are akin to the wild species, and these are better suited to a natural setting than some of the over-bred cultivars. *N. pseudonarcissus* and the Tenby daffodil, *N. obvallaris*, lend themselves to naturalizing in grass, as does the late-flowering pheasant's-eye daffodil, *N. poeticus* var. *recurvus*, or its larger-flowered cultivar, *N.* 'Actaea' (p. 54), which flowers earlier.

'Green Pearl' (p. 56) is an attractive sport of 'Actaea', with similar rounded white petals and a green eye. Another, smaller daffodil for naturalizing is the lovely 'W.P. Milner' (pp. 56, 58), a Victorian cultivar with pale-cream petals that sweep forwards over a lemon-yellow trumpet; while such miniature daffodils as 'Hawera' (p. 55), 'Petrel' and 'Segovia' (p. 58) offer a delicate alternative to some of the taller cultivars, and can be grown in pots and troughs or in the rock garden. With careful planning, you can have daffodils in bloom from January to May, with such early varieties as 'Rijnveld's Early Sensation' or 'February Gold' to start the season, and *N. poeticus* var. *recurvus* to round it off. The colour range of the daffodil may be limited, but after a long, grey winter these cheerful flowers epitomize the hope and promise of spring, and, as Herrick summed up in his seventeenth-century poem 'To Daffodils', we are sorry when they fade:

> *Fair Daffodils, we weep to see*
> *You haste away so soon,*
> *As yet the early-rising sun*
> *Has not attained his noon;*
> *Stay, stay*
> *Until the hastening day*
> *Has run*
> *But to the even-song;*
> *And, having pray'd together, we*
> *Will go with you along.*

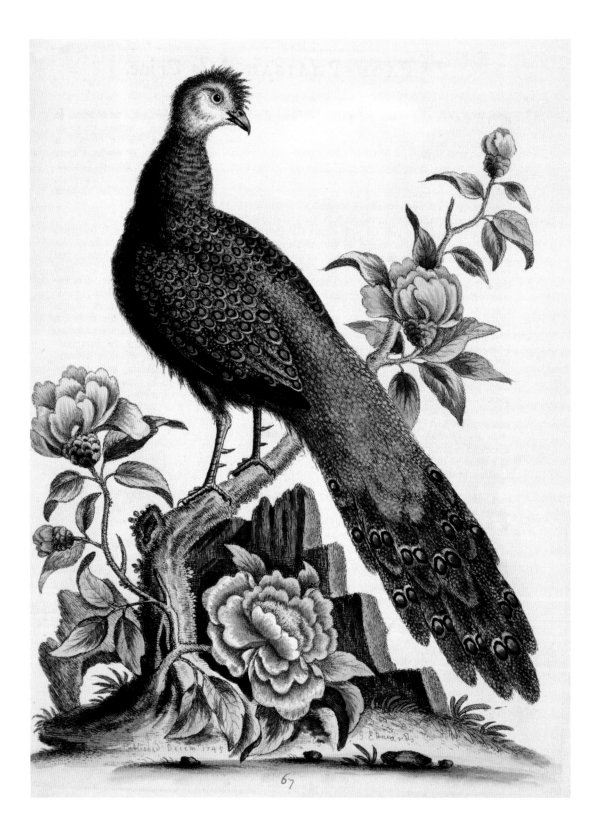

Published Decem.ʳ 1745

G. Edwards

Camellia

Originally from China and Japan, the camellia has a relatively short record of European cultivation, but its history in the East goes back centuries, even millennia, with the age-old habit of tea-drinking. Astonishingly for what people think of as such a British drink, tea has been made from the leaves of *Camellia sinensis* since about 2700 BC, when, as legend relates, the Chinese emperor Shen Nung discovered the drink by accident as leaves from a camellia tree fell into a pan of water boiling on an outdoor stove. The fascinating story of how tea subsequently spread to Europe is told elsewhere; here we focus on the ornamental camellias, which have been an integral part of Chinese and Japanese culture for almost as long as the tea plant, but which were introduced into Europe only from the eighteenth century. These beautiful, sensuous flowers, which might almost be the product of intricate origami, were first grown by Buddhist priests. Later the flower became popular with the gentry, and in Japan it was known as the Imperial flower. Its status was reflected in the literature and arts of the day, and its elegant flowers lent themselves to many forms of Eastern art, from priceless paintings to Ming vases.

The camellia arrives in Europe

The first ornamental camellias to reach Europe were forms of *C. japonica*, which grows wild in both China and Japan.

The exact date of their introduction to Britain is unclear, but their arrival coincided with a burst of interest in all things Chinese. Silks, furniture, paintings and porcelain were being imported by the shipload, destined for the homes of the fashionable rich, and this interest certainly boosted the fortunes of the camellia when it eventually arrived. The first European illustration and description of an ornamental camellia appeared in 1702 in *An Account of Part of a Collection of Curious Plants and Drugs ...* by the apothecary James Petiver, a fellow of the Royal Society and a collector of plants. But it was not until nearly forty years later that the plant began to be actively cultivated in Britain, with the first flowering specimen of *C. japonica* recorded in the garden (or, more correctly, stove house) of Lord Petrie of Thorndon Hall in Essex.

This particular plant must have generated a good deal of interest, as it found itself the subject of at least two paintings. The first, by the botanist and artist Georg Dionysius Ehret (1708–1770), is a delicate watercolour of a young plant with glossy red flowers, dated 1740 and now held in the archives of the Natural History Museum, London. Notes in Latin are scribbled on the illustration, including the correct botanical name (it had already been classified in Carl Linnaeus's *Systema Natura* of 1735) and the reference to its provenance 'in horto Lord Petri' ('in Lord Petrie's garden'). Five years later the same plant was immortalized once more in a painting by the artist and naturalist George Edwards in his *Natural History of Birds*

(1745). Entitled *Peacock Pheasant from China*, the illustration is accompanied by a text describing the plant as a 'Chinese Rose' raised by 'the late curious and noble Lord Petre/Petrie, in his Stoves at Thorndon Hall in Essex' (p. 62). The pheasant, another eighteenth-century import from China, is shown sitting primly on a branch of the camellia, now a much bigger plant than it had been when painted by Ehret.

For the next several decades, the cultivation of camellias was restricted to those in the know. Because of the perception that they were too tender to thrive outside, they were grown only by those wealthy enough to have a stove house or orangery, or by well-connected plantsmen in the inner circle of horticulture, who received plant material from those travelling abroad. Since the seventeenth century Britain had had a rich history of plant-hunting, driven by the desire for ever more exotic and interesting plants. There was no shortage of wealthy patrons to sponsor the men from all walks of life who risked life and limb to bring back new plants from far corners of the globe. From humble gardeners to qualified physicians, they were willing to explore uncharted and often dangerous territory in order to discover new plants and introduce them to fellow gardeners.

One eighteenth-century plant-hunter who travelled extensively in Japan was the Swedish botanist Carl Peter Thunberg (1743–1828). His first port of call was South Africa – where he almost drowned when his horse fell into a submerged hippopotamus pit – and in 1775 he went from there to Japan, where he spent three years exploring and collecting many plants before returning to Sweden, visiting London on the way to meet the naturalist and patron Joseph Banks. In his *Flora Japonica*, published in 1784, Thunberg described the camellia genus at length, and was the first European to describe and illustrate the winter-flowering *C. sasanqua*.

Towards the end of the eighteenth century, knowledge about plants and gardening was becoming available to a wider public through a host of new horticultural publications. One of the most successful of these was *Curtis's Botanical Magazine*, launched by the botanist William Curtis in 1787 (see pp. 139, 142). The early illustrations were hand-coloured engravings based on original watercolours by a notable array of artists, including Sydenham Teast Edwards and James Sowerby, and the magazine employed a team of thirty colourists who meticulously hand-painted the engravings. The first hand-coloured engraving of a camellia appeared in the magazine in 1788, accompanied by a text linking Thunberg to the plant:

Thunberg, in his Flora Japonica, *describes it as growing every where in the groves and gardens of Japan, where it becomes a prodigiously large and tall tree, highly esteemed by the natives for the elegance of its large and very variable blossoms, and its evergreen leaves: it is there found with single*

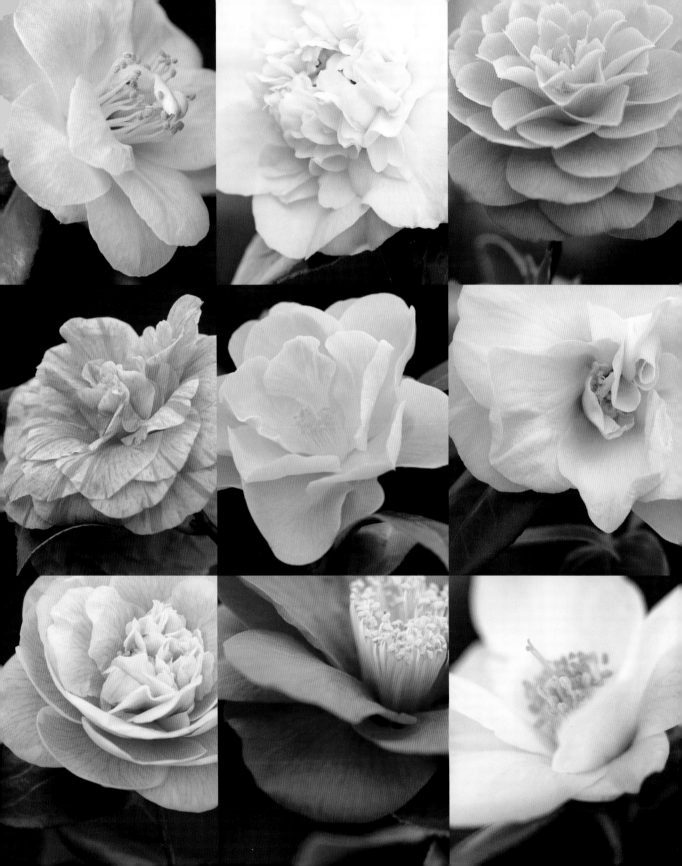

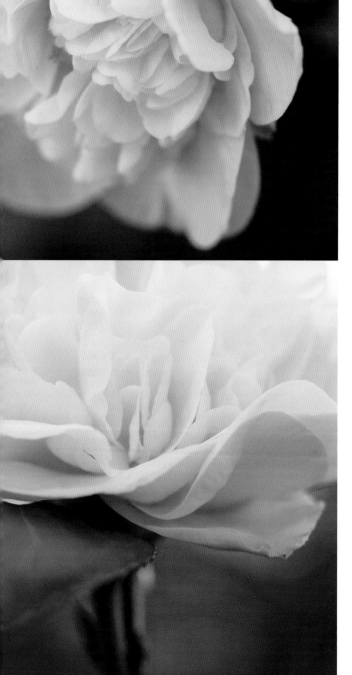

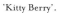

and double flowers, which also are white, red, and purple, and produced from April to October. Representations of this flower are frequently met with in Chinese paintings. With us, the Camellia is generally treated as a stove plant.

A Victorian icon

It was not until 1792 that the public imagination was really caught, with the arrival in Britain of the first double-flowered camellias, 'Alba Plena' and 'Variegata', both of which were illustrated in another horticultural periodical of the day, the *Botanical Repository*, compiled by Henry C. Andrews. Andrews certainly did his best to promote the two new cultivars, writing at length about 'Alba Plena' and mentioning a certain Mr Slater, who seems to have been instrumental in sponsoring expeditions to procure plants from China: 'This fine variety of the Camellia was first imported from China about the year 1793, by Captain Connor of the Carnatic East-indiaman, for the gardens of the late J. Slater Esq., a gentleman of most indefatigable spirit, for the introduction of new plants to this kingdom; indeed, it is to him we owe most of the plants received from China within these few years.' Word quickly spread about these new varieties, and there was a sudden burst of interest in the plant.

The Victorian age was the heyday of the camellia. Impressive camellia houses were built by the wealthy to

keep their growing collections, including two that survive today, at Chatsworth in Derbyshire and Chiswick House in west London, both designed by the architect Joseph Paxton. British nurserymen started to develop new hybrids to add to those that were arriving from the East. One of the first British varieties, raised by nurseryman Alfred Chandler of Vauxhall in 1825, was *C. japonica* 'Chandleri', a deep-red double that was illustrated in his glossy plant catalogue. This was followed later by the well-known *C. japonica* 'Elegans', a deep rose-pink anemone type, still available and widely grown today. By this time it was known that *C. japonica* and its cultivars were generally hardy enough for outdoor cultivation, thanks to the research and writings of Samuel Curtis (a cousin of William Curtis), published in *Curtis's Botanical Magazine* in July 1814: 'A variety of *C. japonica* with single red flowers', he wrote, '… is found to be hardy enough to bear being exposed during winter in the open air.'

Samuel went on to write a detailed study of the camellia, illustrated by the botanical artist Clara Maria Pope (1768–1838). His *Monograph on the Genus Camellia* (1819) was an exclusive and extravagant publication, a large leatherbound volume with five hand-coloured engravings by Pope, each showing two or three different varieties. Although grouped in a stylized way, the individual flowers are painted with a degree of realism and flair unusual for the time, and the engravings illustrate the range of camellias available in that year.

In addition to the single flowers, there were formal doubles, looser rose-type doubles and even an anemone-flowered variety, in colours ranging from white through pale pink to crimson.

But that was just the beginning: from this point, a flood of new varieties with fascinating new characteristics arrived on the scene, some from Japan and China, others developed in Britain and other parts of Europe, and yet others from as far afield as America and Australia. *C. japonica*, it was soon realized, produced an exciting variety of flower shapes, with petals sometimes arranged in intriguing spirals or tiers. Such varieties as the white 'Incarnata' and the almost artificial-looking 'Vergine di Colle Beato' were suddenly all the rage. The latter was described eloquently by the nineteenth-century Belgian horticulturist Ambroise Verschaffelt as having 'irreproachable form, its rare elegance and the centrifugal spiral arrangement of the petals; equal, round, mathematically imbricated at distances marked by a geometrician's compass, and of immaculate snowy whiteness'. Verschaffelt, a leading camellia-breeder of the day, published another monograph on the genus – much more ambitious than Curtis's – in monthly parts between 1848 and 1860. This *Nouvelle Iconographie du Genre Camellia*, illustrating some 600 varieties (as opposed to only twenty-nine in Britain at the time of Curtis's monograph forty years earlier), admirably demonstrates the rate at which new varieties were being launched, showing

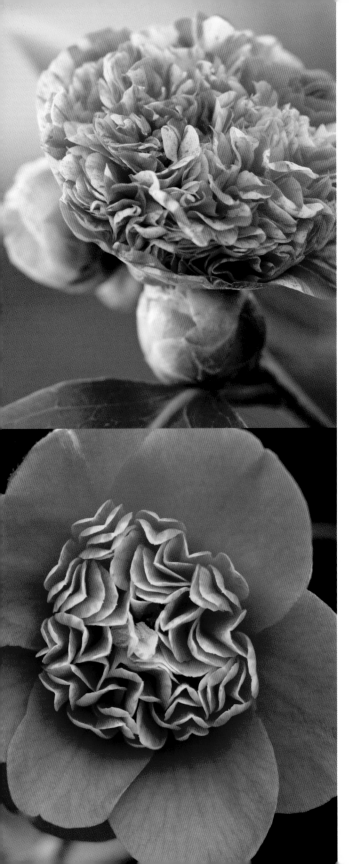

a veritable cornucopia of formal double flowers, many of them with a degree of striping on the petals.

The twentieth century onwards

As if the camellia symbolized a social era, the intense interest in the flower dwindled as the Victorian age came to an end at the turn of the twentieth century. Perhaps people had simply had too much of the formal double flowers that had been so fashionable for years: the endless variants of *C. japonica* that, in their proliferation, had lost the exclusiveness and originality that had drawn people to them in the first place. But with the end of the *japonica* era there started another, with the discovery of new species that were used to make new hybrids. The plant-hunter George Forrest (1873–1932) survived a notoriously perilous trip to Yunnan in China to bring back specimens of several species of camellia, including *C. saluenensis*, which was to be pivotal in the creation of the famous *williamsii* hybrids. Developed by John Charles Williams of Caerhays in Cornwall, this group of hardy hybrids was made by crossing *C. saluenensis* with *C. japonica*. Perhaps the most famous of these hybrids is *C.* × *williamsii* 'Donation', a superb semi-double with clear pink flowers, still one of the most popular camellias today.

While they have never again reached the peaks of popularity that they attained in Victorian times, camellias are today widely grown in many countries throughout

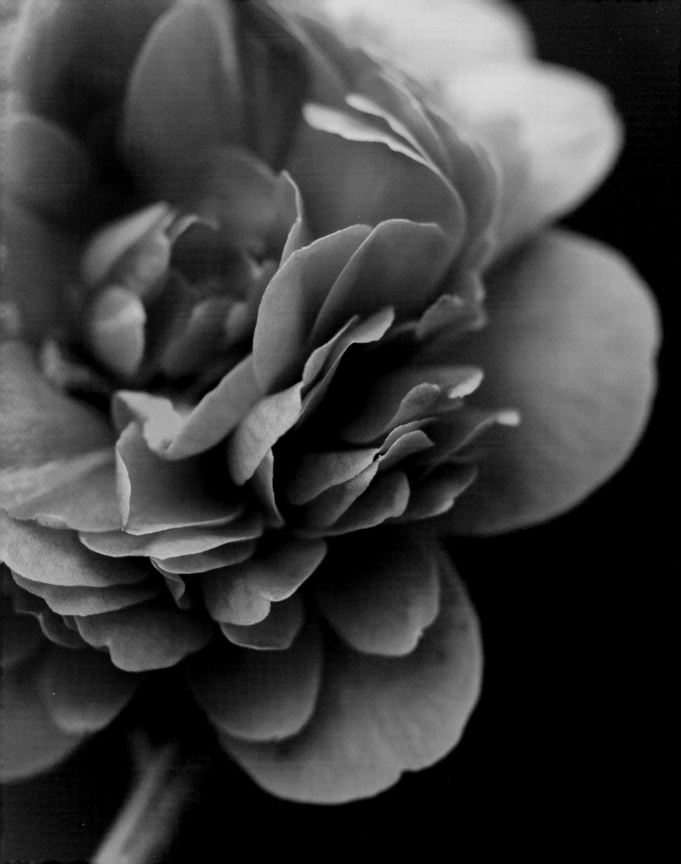

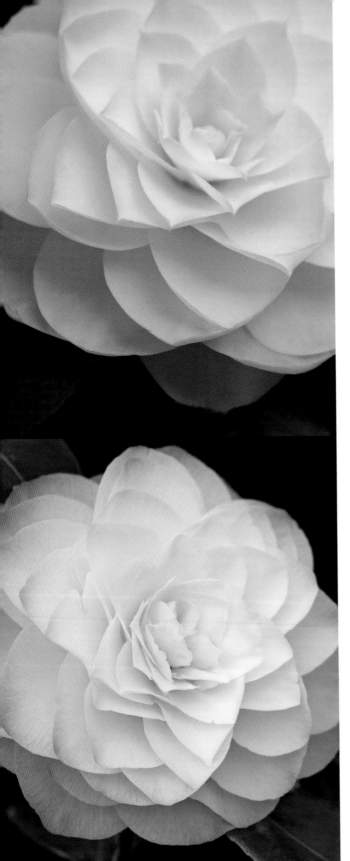

the world, valued for their glossy evergreen foliage and early flowers. They are easy to grow if given the right conditions, but many people overlook the fact that they are ericaceous and therefore need an acid soil. In the wild, they grow in woodland under a high canopy of trees that drop their leaves, creating a rich layer of leaf mould that nourishes them and keeps moisture locked into the soil, and if these conditions can be re-created, the plants will thrive. Many camellias will not tolerate extreme cold and wet, especially on poorly drained soil, but certain cultivars are known to be hardier than others. In general terms the autumn-flowering *sasanqua* types are less hardy than others, while the *williamsii* hybrids are the toughest and longest-flowering, with *C.* × *williamsii* 'J.C. Williams', 'Donation' and 'Bow Bells' (all pink) being the most widely grown. Some *japonica* cultivars are particularly hardy, including the crimson *C. japonica* 'Bob Hope' and the peachy-pink 'Berenice Boddy' (p. 65); and two lovely *reticulata* hybrids, *C.* 'Inspiration' and *C.* 'Leonard Messel', are also noted for their hardiness. In Britain, most of the *japonica* cultivars flower from January to late April, depending on where they are growing, although some early varieties — such as the deep-crimson anemone-flowered 'Takanini' (p. 69) — can flower as early as November.

Although many of the Victorian formal doubles are long gone, the spirit of the nineteenth-century camellia lives on in such flowers as the spiral-petalled

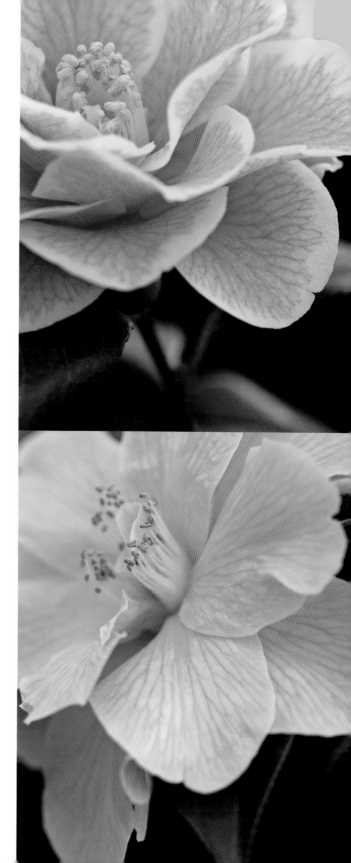

C. japonica 'Nuccio's Gem' (opposite) and the unusual
anemone-flowered *C. japonica* 'Shiro Chan' (p. 65). The
romanticized words of Samuel Curtis in the introduction
to his monograph of 1819 remind us of the dizzy heights
to which the camellia would rise in Victorian times:

> *Just as the dawn is the harbinger of the morning, and the sun
> does not at once reach its meridian glory, so the Camellias
> advance upon us in degrees of beauty … they seem to strike the
> eye with dazzling perfection, and we cannot but view with
> admiration the diversity and elegance of this beautiful family
> of plants, which the all-wise and bountiful hand of God seems
> to have formed for the delight of mankind.*

Syd. Edwards del. Pub. by T. Curtis, St Geo: Crescent July 1. 1804. F. Sansom sculp.

Dahlia

Explosive shapes and fabulous colours make the dahlia one of the most visually arresting plants we grow, so it is surprising to find that it does not have the breadth of artistic history that many other plants have. This is partly because it is a relative newcomer to our gardens, arriving via Spain from Mexico at the end of the eighteenth century (although it had been widely cultivated in Mexico for hundreds of years before that). The first known illustration of the dahlia appeared in an Aztec herbal in 1552 – a simple painting of *Dahlia coccinea* with its single orange–red flowers – and it was around this time that the dahlia was discovered by the European Francisco Hernandez de Toledo, physician to the King of Spain, who also illustrated several double-flowered dahlias in his own posthumously published herbal. Despite this initial flurry of interest, somehow the dahlia missed the boat (unlike other South American plants discovered by the Spanish at the same time, such as the passion flower and the tomato), and it was a good 250 years before the plant was successfully grown in Europe.

The first dahlias in Europe

The first dahlia species flowered in the Royal Botanic Gardens of Madrid around 1790, causing an immediate stir among the botanical fraternity of Europe. The man responsible for them, Antonio José Cavanilles, wrote about and illustrated his newly flowering plants in the first volume of his *Icones et Descriptiones Plantarum* in 1791. The first species to flower was *D. pinnata*, which he named in honour of the Swedish botanist Andreas Dahl. Two years later a second volume appeared, in which two further species were illustrated: *D. rosea* and *D. coccinea*. A frenzy of correspondence ensued, and the first dahlia seed was sent to Kew in 1798. Frustratingly, the plants raised from this seed were promptly lost without being propagated, so the race for the first British dahlia was still on.

The dahlia's introduction to Britain is widely credited to Lady Holland, a well-known and well-travelled socialite and political hostess who obtained seed of *D. pinnata* from the Royal Botanic Gardens in Madrid. The first plants flowered in her garden at Holland House in London in 1804, but a colour illustration of a different species, *D. coccinea*, had appeared the year before in *Curtis's Botanical Magazine*, indicating that Lady Holland, who had a reputation for being pushy, had been pipped to the post. In all probability, the specimens painted for the magazine were those of John Fraser, a nurseryman from Sloane Square in London, who had obtained seed from Paris in 1802. Fraser was a little-known plant-hunter who had travelled widely throughout Russia and America with his better-known father (also called John Fraser), and eventually returned to run a nursery in Kent. The *Companion to the Botanical Magazine*, edited by William Hooker between 1836 and 1837, published a retrospective 'biographical sketch' of John Fraser Sr with a short

PAGE 72
Sydenham Teast Edwards (1768–1819),
engraved by Francis Sansom
Dahlia coccinea, from *Curtis's Botanical
Magazine*, 1804
Hand-coloured engraving

Dahlia 'Acapulco'.

paragraph at the end devoted to his son: 'To Mr J. Fraser, jun., our gardens are indebted for the introduction of that splendid and highly varied genus, the Dahlia. The *D. coccinea*, a single-flowered scarlet species, was the first seen in this country, and endless are the hybrid varieties and beautiful double flowers obtained from this humble origin, by the great skill of our present Horticulturists, those "*Makers of Flowers*".' Meanwhile, Lady Holland's role in the history of the dahlia was immortalized in a ditty sent to her by her husband in a letter of 1814:

> The Dahlia you brought to our isle
> Your praises for ever shall speak;
> 'Mid gardens as sweet as your smile,
> And in colour as bright as your cheek.

A nineteenth-century obsession

After the introduction of the first species of dahlia, these dedicated 'makers of flowers' were indeed working overtime to create new varieties, realizing how wonderfully variable and versatile the plant was. Interest in the dahlia accelerated so quickly that the plant was excitedly described by the gardener and writer John Claudius Loudon in his *Encyclopedia of Gardening* of 1822 as 'the most fashionable flower in the country'. The simple, single species that had been introduced just a few years before had quickly mutated into more elaborate forms,

as seen in a painting by James Sillett dated 1823. His illustration of *Dahlia* 'Sovereign' shows a sumptuous crimson, fully double flower, much more interesting and desirable than the original species. By popular demand, the dahlia was given its badge of honour by becoming a florists' flower, one of several elite flowers that included the tulip and the carnation.

Robert Sweet's *Florist's Guide and Cultivator's Directory* (1827–32) contained colour plates of six new dahlias, showing the extraordinary progress of the genus in such a short period of time. They were listed under the name Georgina (after the German naturalist Johann Gottlieb Georgi of St Petersburg), a name used temporarily after 'Dahlia' was confused with Dalea, a group of pea-type plants. The illustrations show a number of fully double flowers, including one of the first anemone-centred dahlias, a sugar-pink confection with streaked petals known as 'Painted Lady', as well as, significantly, a dark-red globe-flowered variety annotated as *Georgina variabilis* var. *sphaerocephala*. These spherical, or 'ball', dahlias were to become the focus for amateur breeders over the next few years, as the florists toiled obsessively to produce varieties in an increasingly broad range of colours.

By 1836 an extraordinary 700 varieties of dahlia were listed in the Dahlia Register of the Royal Horticultural Society of London, and plants and tubers were changing hands for huge amounts of money. Thomas Hogg, a well-known nineteenth-century florist who produced

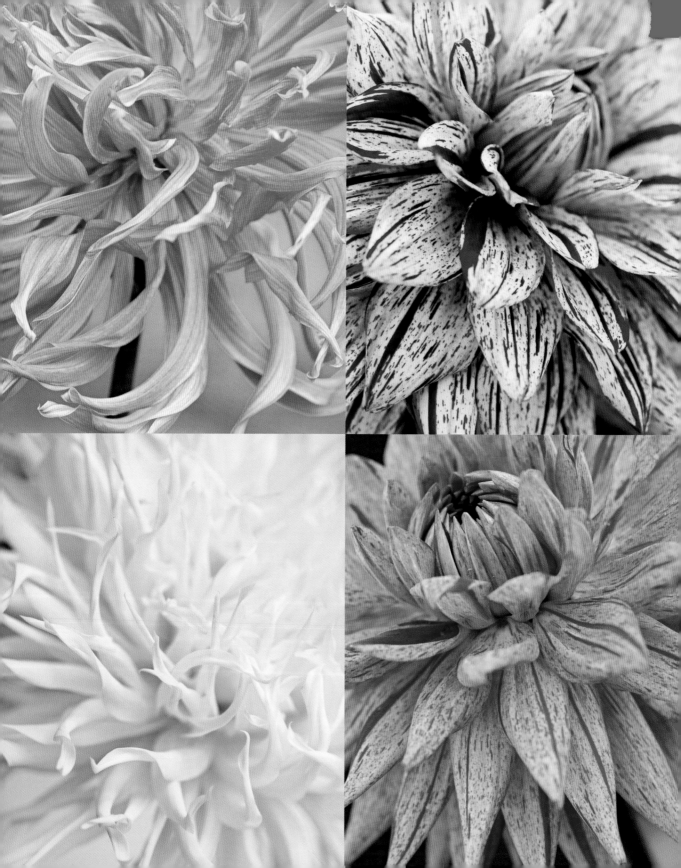

Clockwise from top left: Sarah
Mae'; 'Blackberry Ripple';
'Chantal'; 'Tsuki-yorine-shisha'.

a series of books on florists' flowers, commented on the dahlia: 'I know of no flower that has been so much improved, in so short a time, by culture, as the Dahlia; the reason is, every gardener seems to have taken it under his special care, and to have bestowed the utmost attention upon it' (*A Supplement to the Practical Treatise on the Culture of Florists' Flowers ...*, 1833). But the new flowers bore almost no resemblance to the single-flowered species that had originally arrived from abroad: these were the fashionable ball-type or show dahlias, almost unreal in their uniformity and gaudy in colour. After the ball dahlias came the pompons or Lilliputs, miniature dahlias with ball-type flowers, called *pompones* by the French because of their resemblance to the bobbles on sailors' hats.

Interest in this group of show dahlias raged for some twenty years — and then burned out. People simply became bored by the limited potential offered by perfectly spherical flowers; there was also an increasing backlash against the artificiality of the new blooms, with many people choosing to return to the simpler, single forms. In a paper presented at the National Dahlia Conference held in Chiswick, west London, in 1890, the horticulturist Shirley Hibberd retrospectively speculated on the peaks and troughs of the dahlia's popularity in the nineteenth century: 'The progress of the Dahlia as a florist's flower from 1820 to 1850 was marked by advance in every desirable quality; and with each decided gain in fullness,

smoothness, symmetry, and refinement of petal there was a corresponding advance in popularity.' He went on:

The Florist's Dahlia is in a peculiar sense the creation of the florist. Not one of the many other flowers on which he has operated with an ideal form in view, has been so distinctly modified and removed to a distance from its original state as this, and it is amazing at least, whatever else may be said about it, to see that the work of a hundred years is threatened with annihilation by the growth of a preponderating taste for the simpler forms that most truly represent nature's idea of a perfect Dahlia. But we need not fear our grand show flowers; they will always command admiration, and will be worth keeping if only to illustrate the power of man in modifying organic forms.

The arrival of the cactus dahlia

Luckily, another species of dahlia, *D. juarezii*, arrived from Mexico in about 1862 to widen the gene pool and rekindle interest in the genus. This species gave rise to the cactus dahlia, so called because of the flower's resemblance to that of the *Cereus* cactus. It was first officially illustrated in 1879 in the *Gardeners' Chronicle*, one of the many garden periodicals that were popular in England in Victorian times, but it may also have been grown and painted by Claude Monet, putting him very much ahead of his time and showing what a serious plantsman he was. His painting *The Artist's Garden at Argenteuil*

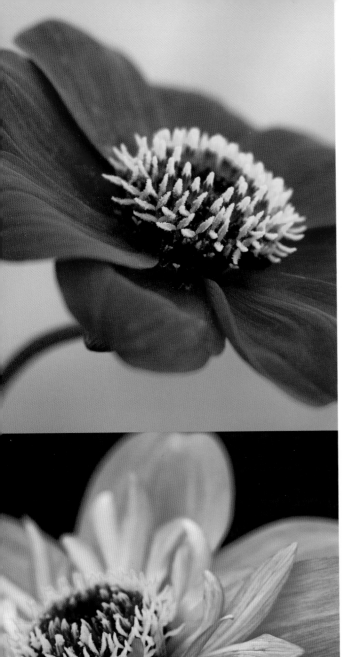

(*A Corner of the Garden with Dahlias*) of 1873 shows what looks
like a dark crimson *D. juarezii* among a cloud of other
dahlias. Other types of dahlia continued to appear,
throwing up yet more weird and wonderful forms. The
collarette dahlias — single flowers with a decorative ruff
of florets around the central eye — were first recorded
in 1899 in France, while star and orchid dahlias also
appeared around the turn of the twentieth century.

A wonderful black-and-white photograph by an
otherwise unknown gardener and amateur photographer
called Charles Jones, taken some time in the first few
decades of the twentieth century, illustrates in graphic,
close-up detail the collarette dahlia 'Pilot', but botanical
paintings of dahlias in this era are few and far between.
General artists, however, were very much drawn to the
genus, with such great painters as Auguste Renoir and
Henri Fantin-Latour producing still-life studies of
extravagant dahlias in vases. The early twentieth-century
Expressionist Emil Nolde also painted several joyfully
colourful studies of dahlias.

In the twentieth century the focus was on breeding
show dahlias, rather than producing good garden plants
that the average gardener could grow. Increasingly
outlandish varieties appeared, with monstrous flowers in
colours that would look at home on a 1950s housecoat.
The so-called dinner-plate dahlias (still grown today) had
blooms so artificially pumped up that each individual
flower required elaborate support. One of these, produced

in the 1940s and still available from nurseries today, is 'Kidd's Climax', a Giant Decorative type with creamy pink flowers more than 25 centimetres (10 in.) in diameter. Books about growing exhibition dahlias were two-a-penny, all with black-and-white photographs depicting competitive men dwarfed by their oversized dahlias.

Growing dahlias

Today dahlias are loosely arranged into ten groups according to their flower shape: Single-flowered, Anemone-flowered, Collarette, Waterlily, Decorative, Ball, Pompon, Cactus, Semi-cactus and Miscellaneous. There are hundreds of varieties from which to choose, whether your taste is for bold form and clashing colour or simple, single flowers in muted tones. Dark-flowered cultivars are particularly popular at the moment, and recent introductions include the sumptuous 'Karma Choc', a waterlily type with darkly velvety flowers suffused with crimson, and 'Trebbiano' (p. 81), a cactus variety in the same dark crimson. 'Rip City' is one of the very best semi-cactus types, a tall and extremely free-flowering variety with darkest-purple flowers suffused with crimson. For something with more punch, 'Acapulco' (p. 75) is a new cactus dahlia that has intense strawberry-red flowers with a deep-pink centre, while the extraordinary 'Lorona Dawn' has distinctive single pink flowers with decorative white ruffles and bright-yellow centres. All dahlias are

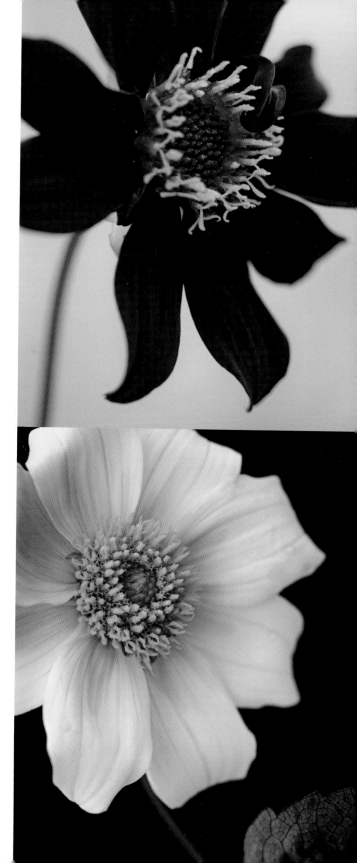

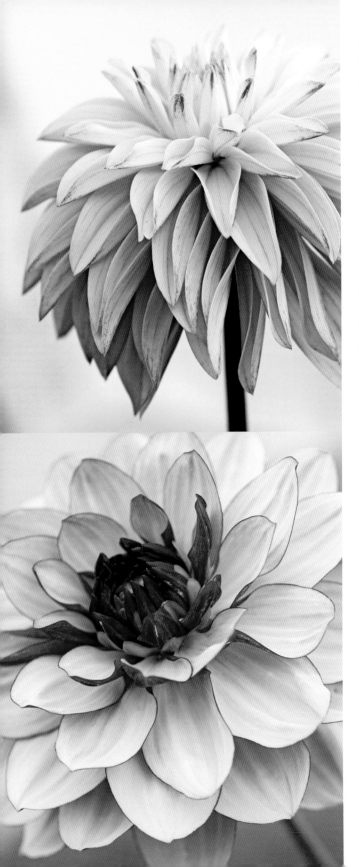

Left, from top: 'Alloway Candy';
'Hugs and Kisses'.

Opposite: 'Trebbiano'.

easy to grow if you respect the fact that they are Mexican plants and can therefore be tender in a temperate climate. They do best in an open, sunny situation in a fertile soil that does not get too dry; lift and store them over the winter, or — if you are determined to play Russian roulette — mulch them deeply to protect them from frost.

Dahlias are now firmly back in fashion after a period when they were seen as the height of vulgarity. Large, over-bred flowers in artificial-looking colours had given the dahlia a bad name, and snooty gardeners would not go anywhere near them. But thanks in part to the indomitable Christopher Lloyd, who boldly replanted the rose garden at his house, Great Dixter in East Sussex, with a colourful mix of dahlias, cannas and other exotics, dahlias have found favour again with the gardening public. In a turnaround strangely reminiscent of the nineteenth-century backlash against over-bred cultivars, it is the simple singles that are becoming popular, and such varieties as the elegant 'Bishop of Llandaff', the antithesis of the brash show varieties, have turned public opinion around. 'Dahlias spell excitement,' wrote Lloyd in *Christopher Lloyd's Garden Flowers* (2000), 'and we can all do with some of that in our lives.'

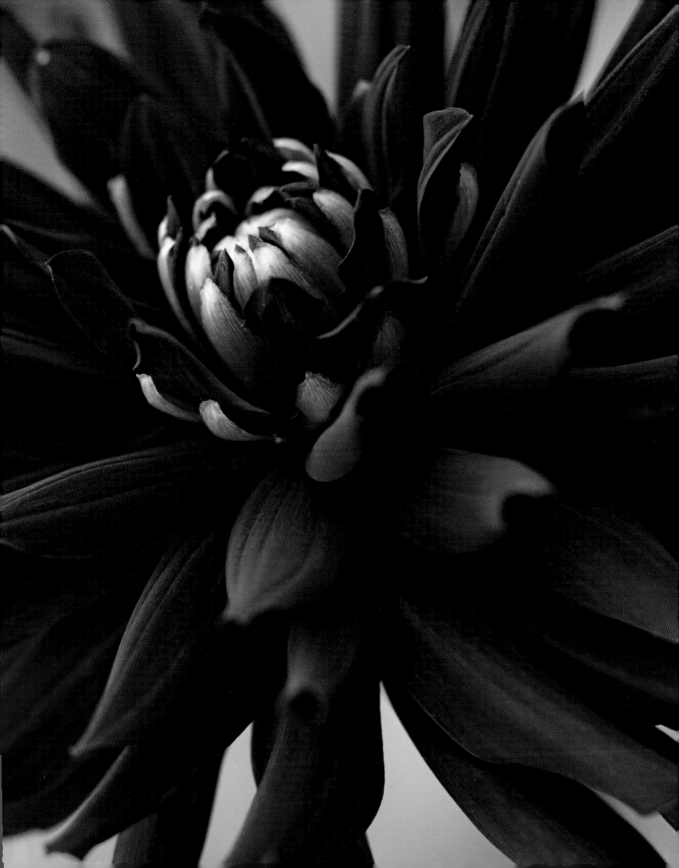

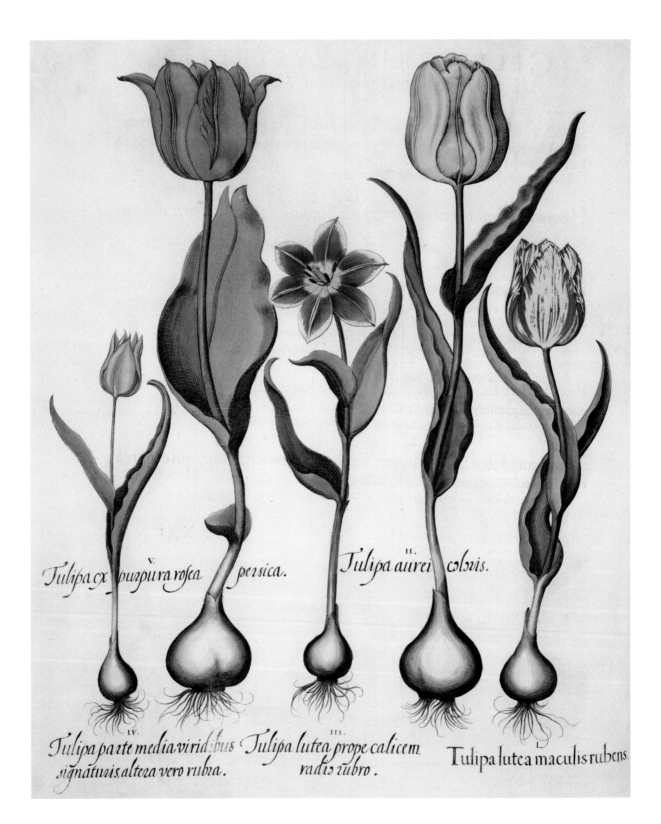

Tulipa ex purpura rosea persica.

Tulipa aurei colovis.

Tulipa parte media viridibus signaturis, altera vero rubra.

Tulipa lutea prope calicem radis rubro.

Tulipa lutea maculis rubens.

Tulip

Without doubt the tulip is the most widely depicted flower in all forms of art, a circumstance that goes hand in hand with its prodigious popularity throughout history. Tulips arrived in Europe from Turkey in the mid-sixteenth century, brought by ambassadors and travellers who fell in love with the bright colours and lily-like shape of the flowers. Ever since the first European description of the tulip, in 1561, the plant has been painted prolifically, for both botanical reference and artistic pleasure, and the wealth of visual material can help to chart the history of a plant that was once valued as highly as gold.

The tulip, which grows wild in Turkey, Iran and other parts of central Asia, was depicted in Persian ceramics as early as the eleventh century, but its apogee came with the flamboyant sultans of the Ottoman Empire, who popularized it by growing it in the gardens of their royal palaces. After conquering Constantinople (now Istanbul) in 1453, Sultan Mehmed II built Topkapi Palace in the hills overlooking the city, and laid out a series of lavish flower gardens in which the tulip featured prominently. His sixteenth-century successor Selim II, an obsessive plant-lover, ordered more than 300,000 bulbs to be dug up from the wild to fill the palace gardens. By then the tulip had become one of the most widely used cultural symbols of the Ottoman Empire, appearing as a decorative motif in many art forms, from textiles to ceramics, and from woodcarvings to miniatures.

The tulip arrives in Europe

The excitement about tulips could not be contained to the East. Word was filtering back with European travellers who noticed the proliferation of tulips growing in Turkey. Exactly when the first bulbs arrived in Europe is not clear, but one man in particular is credited with their introduction – and indeed their Western name. The Flemish diplomat Ogier Ghiselin de Busbecq (1522–1592) served as Austrian ambassador to the Ottoman Empire, spending the years between 1555 and 1562 in Turkey. As well as negotiating a border treaty over the disputed territory of Transylvania, he spent time travelling the country and sending plants and artefacts back to his patron. His famous *Turkish Letters*, written during his time there, contain specific references to the tulip, a plant he had not set eyes upon before, and a collection of bulbs was among the first shipments of curiosities that he sent back to Vienna. 'An abundance of flowers was everywhere offered to us', he wrote. 'Narcissus, Hyacinths, and those which the Turks called *tulipam*, much to our wonderment, because of the time of year, it being almost the middle of winter, so unfriendly to flowers.' In fact the Turks called tulips *lale*, not *tulipam*, and it may be that Busbecq was confused by his interpreter's description of the flower, which might well have been likened to a turban (*tulband*).

The excitement surrounding Busbecq's extraordinary bulbs spread, and soon tulips were to be seen blooming in

PAGE 82
German school (17th century)
Tulips, from *Hortus Eystettensis* (*The Garden at Eichstätt*) by Basilius Besler, 1613
Hand-coloured engraving
PRIVATE COLLECTION

Top row, from left: 'Doll's Minuet'; 'Hermitage'; 'Cummins'. Middle row, from left: 'Carnaval de Nice'; 'Monsella'; 'National Velvet'. Bottom row, from left: 'Aladdin's Record'; 'Libretto Parrot'; 'Ballerina'.

Britain, Germany, France and Austria. The first ever Western illustration of the tulip, showing a short-stemmed plant with a broad, deep-red flower, appeared in a manuscript by the Swiss botanist Conrad Gessner (1516–1565), who had seen it growing in a garden in Augsburg, Bavaria, in 1559. At first merely a curiosity grown by only a few, the tulip soon became much more widely known, thanks to the efforts of Carolus Clusius, head of the Imperial Gardens in Vienna between 1573 and 1587, and, later, founder of one of the world's first formal botanic gardens, at Leiden in Germany. Throughout his life he was known for his work distributing and propagating new bulbs collected by him or sent to him from overseas (while at the Imperial Gardens in Vienna he would have corresponded regularly with Busbecq), and tulips were a particular interest of his. He devoted thirteen pages of his *Rariorum Plantarum Historia* (1601) to them, with woodcuts showing the simple, single-coloured flowers that are the ancestors of our modern tulips.

Clusius arrived at Leiden with a sizeable collection of bulbs, the importance of which did not go unnoticed. But, far from publicizing his collection and distributing the bulbs, he kept it close to his chest, lamenting the changes that were taking place in the refined world of horticulture. Whereas previously the tulip had remained firmly in the domain of the connoisseur, with bulbs changing hands within small circles of collectors, now it was attracting the interest of a wider public who placed a higher commercial value on it, and for this reason Clusius protected his collection fiercely, refusing to part with any of his rare bulbs for any sum of money. Of course, this only served to whip people up even further, leading to a break-in at the botanical garden and the theft of most of his collection. Tulipomania had begun.

The extraordinary rise of the tulip at the beginning of the seventeenth century – and the physical changes in its appearance as natural hybrids occurred – can be charted in the art of the day. The earliest species to be grown in Europe, as shown in the botanical works of Clusius, Mathias de L'Obel and others, had simple flowers in a limited range of colours. By the turn of the century the first doubles were appearing, followed by the highly desirable 'broken' tulips, with intricately flamed or feathered petals.

As the flowers developed ever more elaborate and colourful personas, so the artist's responses changed, too. In contrast to the simple black-and-white woodcuts of the early herbals came a new style of plant album, the florilegium, containing sumptuous colour illustrations of the plethora of plants to be found in seventeenth-century gardens. The *Hortus Eystettensis* (*The Garden at Eichstätt*, 1613) was one of the earliest and finest of such publications, compiled by the apothecary and botanist Basilius Besler as a record of the collection of plants in the highly regarded botanic garden at Eichstätt in Bavaria. The large-format book contained more than 350 hand-coloured copper

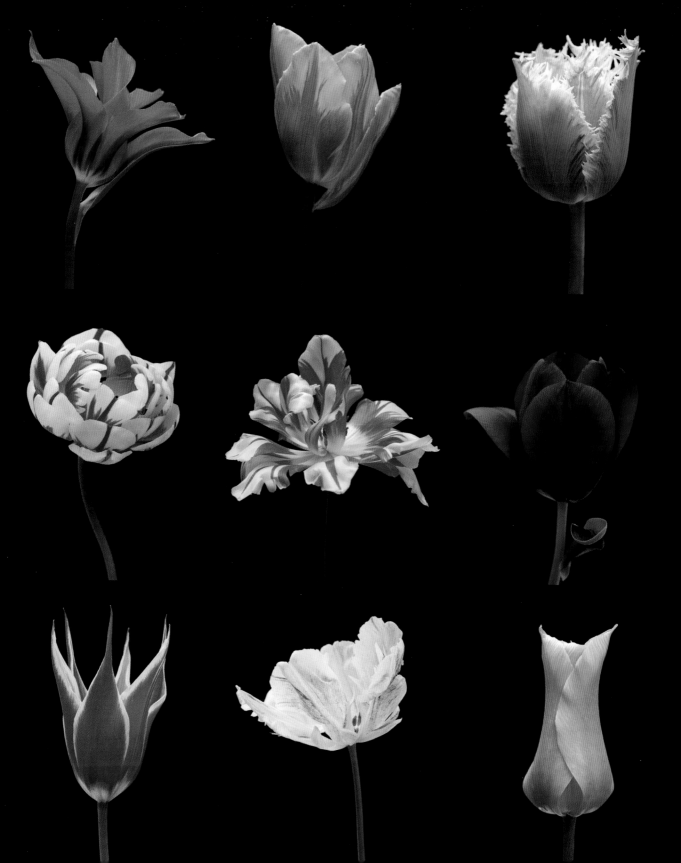

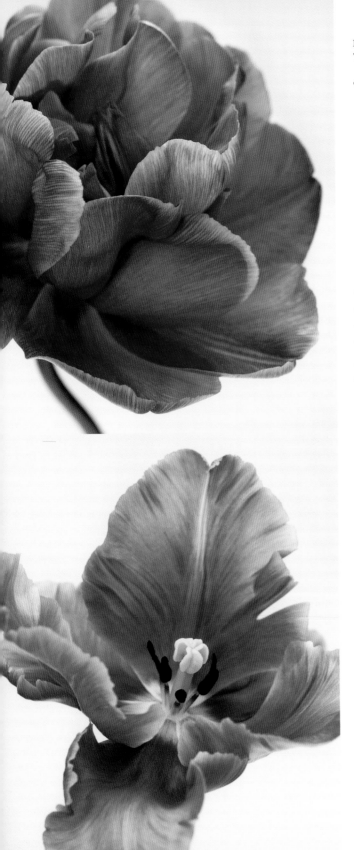

Left, from top: 'Blue Diamond';
'Blue Parrot'.

Opposite: A virus-infected tulip.

engravings of plants, including tulips (see p. 82), and these engaging images reveal immediately how irrevocably the nature of the tulip had changed in a very short time. The pictures show highly coloured tulips with striped, feathered and flamed petals that look as though they have been hand-painted with the finest of brushes. So much did people admire the elegant patterns and colours that they went to extraordinary lengths to obtain the desired effects, even scattering powdered paint around the plant in the hope that the colours would somehow pass into the flower. What no one realized at the time was that these 'broken' tulips were infected with a virus that would in time weaken the plant.

Dutch tulipomania

With desire for this new, glamorous flower growing by the minute, a few sharp individuals saw the opportunity to make a fortune, and started selling the uniquely patterned 'broken' bulbs for increasing amounts of money. In The Netherlands the market for tulip bulbs rocketed in the most extraordinary way, fuelled by traders and canny nurserymen who produced beautifully illustrated catalogues of their prize tulips. In the 1620s and 1630s, demand was such that single bulbs could fetch the equivalent of thousands of pounds today: tulips were now a commodity, sold speculatively while still in the ground, thereby creating their own unique futures

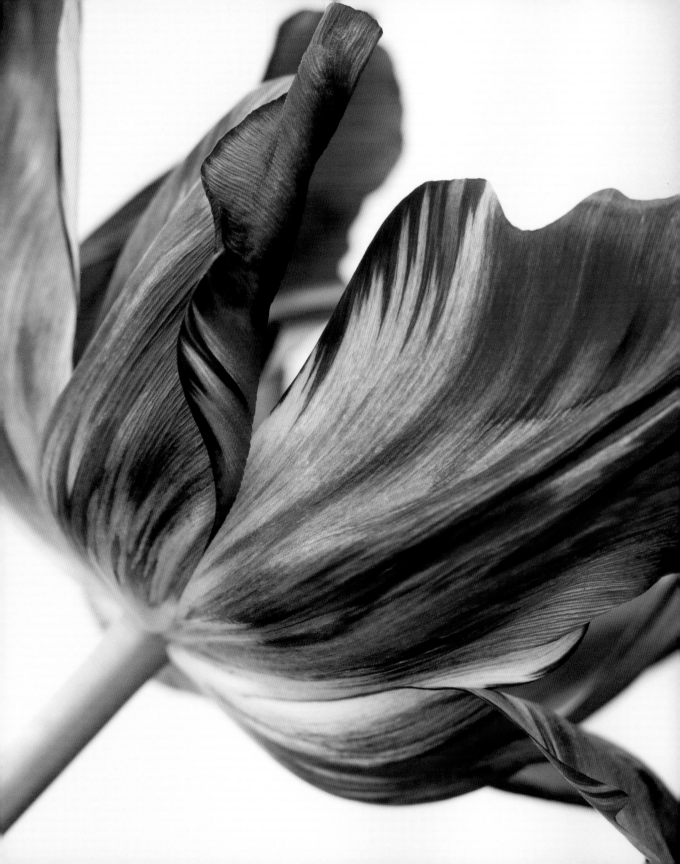

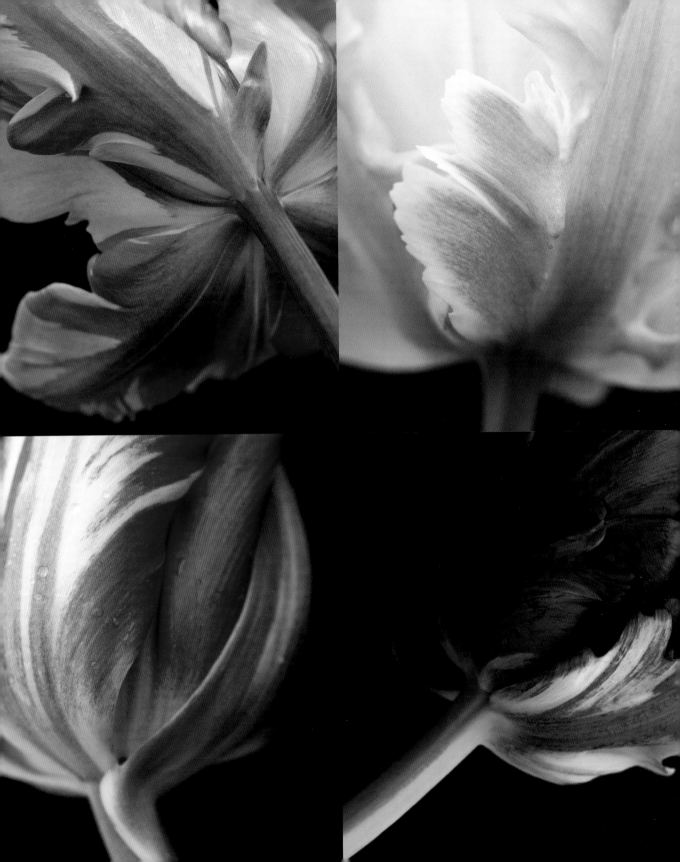

market. To counteract such activity there was a strong undercurrent of opposition from moralists, who published pamphlets and preached endless sermons against the dark evils of money-making. Artists responded, too, and several well-known satirical paintings produced during these years portray what many saw as the ridiculousness of the situation. In Jan Breughel the Younger's *Satire of the Folly of Tulip Mania* (c. 1640), you have to look twice to see that the figures in the classically beautiful setting are actually monkeys. In 1636 a frenzy of speculative buying pushed prices up still higher, until early the following year, when investors and growers had finally had enough and the market crashed. The madness that had gripped the country for so long had come to an inevitable end, and many fortunes were made or lost.

Dutch tulip fever left an enormous legacy of art. Not only painted for botanical record, the tulip was also the muse for some of the most famous artists of the day, and their still-life compositions brought art to new pinnacles of excellence during what became known as the Golden Age of Dutch painting. Ambrosius Bosschaert (1573–1621) was known especially for his still-life arrangements of flowers: lavish, richly coloured paintings that nearly always included tulips among roses, crown imperials and other newly introduced species. His *Glass with Four Tulips* (c. 1615) is a beautifully balanced composition of sumptuous, large-flowered tulips, all showing striped or flaked patterning; a rather ordinary-looking brown butterfly sits on a leaf below, its very plainness highlighting the opulence of the blooms. Slightly later, and very much influenced by Bosschaert, came Jacob Marrel (1613/14–1681), who – in addition to a very fine œuvre of still-lifes – produced his *Tulpenboek* (*Tulip Book*, c. 1640), a lavish and exclusive album of paintings showcasing some of the finest and most valuable specimens of the day. A number of these special tulip books were published in Holland at the height of tulipomania and in the years immediately afterwards, commissioned – as sales catalogues or simply as a record for wealthy collectors – from such artists as Pieter van Kouwenhoorn and Judith Leyster.

The eighteenth-century English florists' tulip

Despite the ignominious collapse of the Dutch market, the tulip lost no face, and Holland led the way in terms of bulb production and export for the rest of the seventeenth century. The raising of new varieties was centred in Flanders – spanning parts of present-day Belgium, The Netherlands and France – although this began to change in the eighteenth century, when Britain's thriving florists' societies began to make new selections. Along with the auricula and the carnation, the tulip had been one of the first flowers to be adopted by the florists in the mid-seventeenth century, and grown by a knowledgeable band of enthusiasts for exhibiting at the great Florists' Feasts. These amateur growers, although

working on a small scale, played an important part in the
development of the tulip, producing some outstanding
cultivars that rivalled the earlier European ones. Despite
the inevitable weakening of the virus-infected plants,
broken tulips continued to be the most popular, but now
the markings and colours were even more diverse.

The florists grouped the most popular late-flowering
tulips, known as 'fancies', into three categories according
to their prevailing colour: 'Bybloemens' had flowers
with a white background streaked with a very dark, rich
purple, sometimes almost brown; 'Roses' were white with
prominent red flames and featherings; and 'Bizarres'
were marked with red or maroon on a yellow background.
The most highly prized flowers were as 'bright, lively
and as opposite to nature as possible', according to the
horticultural writer William Hanbury. These gaudy
confections were illustrated in full, glorious colour in
some of the dozens of gardening magazines of the time,
among them *Curtis's Botanical Magazine* (see pp. 139, 142),
as well as in specialized florists' publications, including
Robert Sweet's *Florist's Guide and Cultivator's Directory* (1827–32).

The end of an era

During the first half of the nineteenth century the
florists' 'fancy' tulip reigned supreme. Countless tulip
shows took place around Britain, and a sharp sense
of competition (not to say obsession) coloured the
proceedings. Inevitably, though, the fire of passion
died down as industrialization brought more people
into the cities. In 1889, at the Exposition Universelle in
Paris, a Dutchman named E.H. Krelage exhibited a new
range of tulips that he had named 'Darwin'. Arranged
in a densely planted bedding scheme, these flowers
were plain 'breeders' (the tulips from which the florists
produced their fancies), and the display started a fashion
for a more prosaic class of tulip.

This development came at the right time. In the
1920s it was discovered that the florists' beloved fancy
tulip was the product of a virus caused by aphids, and
that was the final nail in the coffin for this long-admired
and mysteriously decorative flower; but the loss of the
old flamed varieties has been more than made up for by
the modern hybrids, which come in a wonderful variety
of alluring colours and interesting shapes. A small band
of enthusiasts has kept the old English florists' tulips
going, however, and in the United Kingdom the
Bybloemens, Bizarres and Roses are still prized and
exhibited at the annual show of the long-established
Wakefield & North of England Tulip Society.

Now grouped into fifteen divisions, tulips are a
diverse and endlessly alluring race, with flowers in many
different guises spanning early and late spring. Simple
cup-shaped and lily-flowered singles contrast with racy
parrot tulips and elaborately frilled peony-flowered types;
colour-saturated viridifloras are weighed up against the

large-flowered Darwin hybrids. Modern hybrid tulips are easy to grow, given reasonably well-drained soil and plenty of sunshine, but less easy to keep, as they often lose vigour after a year or two and will not increase as the species will. Planting them deeply may help, since those planted too shallowly put all their energy into producing bulblets in the warmer soil. Traditional wisdom says to plant tulips to a depth double the height of the bulb, but often it is best to go even deeper, at least 15–20 centimetres (6–8 in.), and that may encourage them to stay put for a few years.

No longer confined to the show bench, tulips are truly the people's flower, known and loved by gardeners all over the globe. Rarely has a plant had more artistic attention lavished on it, and it is this rich legacy that helps us to understand in more detail the intriguing history behind the ever-changing face of the tulip.

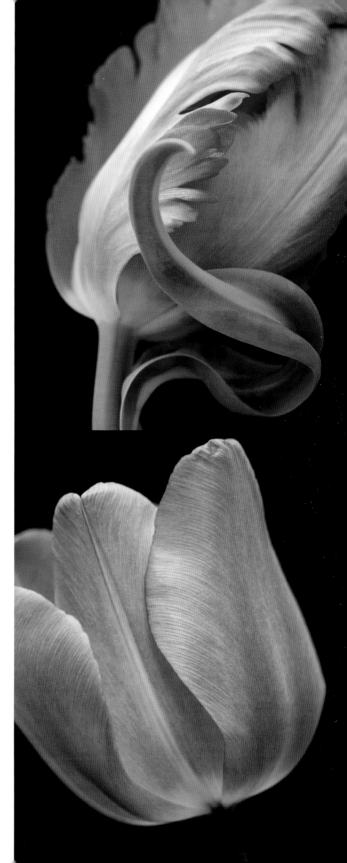

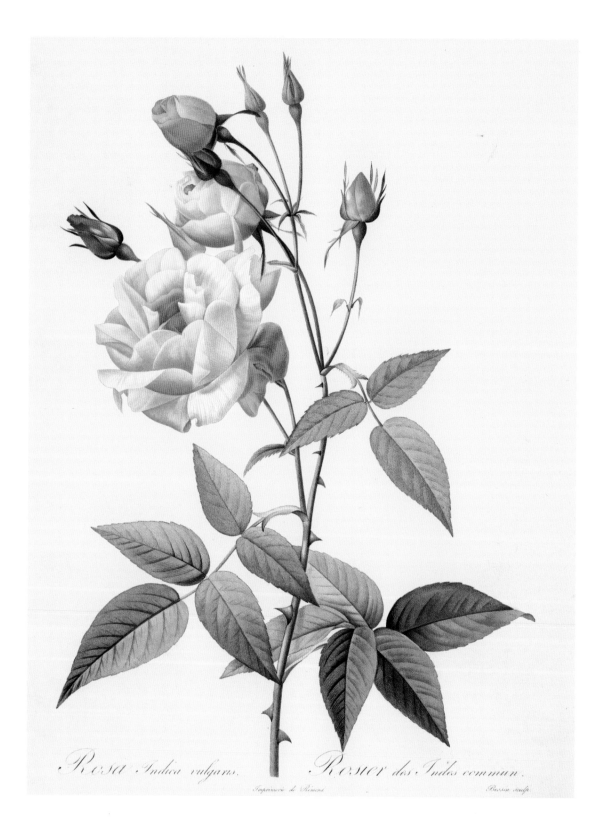

Rosa Indica vulgaris. *Rosier des Indes commun.*

Imprimerie de Remond Bessin sculp.

Rose

No flower is imbued with such phenomenal depth
of history, symbolism and cultural significance as the
rose. History, of course, is measured only from when
records began, but fossilized remains of roses have
been found dating from prehistoric times, so we can
say for sure that the plant existed millions of years ago.
It was in antiquity that the rose's relationship with
man began to blossom, as – valued for its perfume and
medicinal qualities as well as its decorative flowers – it
worked its way deep into the cultures of ancient Greece
and Rome.

Remarkably, the earliest surviving image of the rose
is more than 3500 years old. Discovered in the 1920s at
Knossos on the island of Crete, the Minoan 'Blue Bird'
fresco was painted around 1500 BC, and depicts what
is clearly a simple five-petalled rose winding around
a rock. For the Greeks, the rose was a symbol of love,
sacred to the goddess Aphrodite, but it was also associated
with death, since its flowers were woven into funeral
wreaths and its essential oils used for embalming the
dead. The Greek lyric poet Anacreon (582–485 BC)
bemoaned the fact that the flowers were used in such
a way in this poem, translated in the seventeenth century
by Abraham Cowley:

> *Why do we precious ointments shower,*
> *Noble wines why do we pour,*
> *Beauteous flowers why do we spread*
> *Upon the mon'ments of the dead?*

Nothing they but dust can show,
Or bones that hasten to be so;
Crown me with roses whilst I live.

Even at this early stage in the flower's development,
it is clear that open pollination was producing natural
hybrids that were being nurtured in gardens. Theophrastus
wrote extensively about roses, describing various different
forms: 'Among roses there are many differences, in the
number of petals, in roughness, in beauty of colour and
in sweetness of scent. Most have five petals, but some
have twelve or twenty, and some a great many more than
these.' Although it is hard to be certain which roses were
being grown by the Greeks, they are likely to be early
descendants of *Rosa gallica*, which grows wild throughout
central and southern Europe. From the earliest times,
other species and varieties would have spread gradually
over many centuries from the Middle East into Europe,
carried by kings and courtiers, immigrants and armies
to add to the richly complex melting pot of varieties.

The Romans, who were more sophisticated gardeners
than the Greeks, revered the rose even more fervently,
using it in all manner of rituals and ceremonies
(particularly in garlands), scattering the ground with
petals at banquets and even devoting a festival to the
plant. As well as using the oil in perfumes, they made
dozens of cosmetic potions out of the petals, seeds
and hips, including antiperspirant powders and even
a cure for baldness. The rose's medicinal uses were also

numerous, from purgatives to relief from toothache. Is it any surprise that this wonder-plant rose above all others in stature? It is clear, too, that while roses may have been grown more commercially by the Greeks, the Romans actually grew them in their domestic gardens, as is illustrated in Pompeiian wall paintings depicting bucolic garden scenes, on both interior and courtyard walls. One of the most charming of these murals appears in the House of the Gold Bracelet, where the central *triclinium* (dining room) is decorated entirely with a garden scene showing, among other plants, an exquisite red rose. Clearly cultivated with care, it is tied to a reed stake, on top of which perches a little brown bird, the image beautifully preserved under layers of volcanic debris since the catastrophic eruption of Vesuvius in AD 79.

Another early image of the rose appears in an illustrated version of Pedanius Dioscorides's first-century *De Materia Medica*. Published in Constantinople as a gift for Juliana Anicia, the daughter of the Western Roman Emperor Anicius Olybrius, the sixth-century manuscript, known as the *Codex Aniciae Julianae*, is preserved in the Austrian National Library, Vienna. Containing almost 400 full-page colour illustrations of plants, this priceless treasure is in effect the world's oldest work of botanical art, and owes its survival to a sixteenth-century luminary, Ogier Ghiselin de Busbecq, who is most famous for the part he played in introducing the tulip to Europe (see p. 83). In 1562 Busbecq came across the manuscript by

chance during his travels around Turkey. As he recounts in his *Turkish Letters*, he had to leave it behind, reluctantly, because of its high price:

> One manuscript I left behind at Constantinople, one much worn with age, containing the whole text of Dioscorides written in capital letters, with painted representation of plants … I wished to buy it but the price discouraged me; for it was valued at a hundred ducats, a sum for the Emperor's purse, not for mine … On account of its age the manuscript is in a bad state, the outside being so gnawed by worms, that hardly anyone finding it in the street would trouble to pick it up.

Clearly the great importance of this manuscript was not lost on him, because he managed to return seven years later and bring it to Austria. The illustrations in the *Codex Aniciae Julianae* vary in quality, but some are incredibly naturalistic and detailed for their time, including that of the rose, which shows a red *R. gallica* both in full flower and in bud, its elegantly arching stems rising from a visible root.

A medieval and Tudor icon

After the fall of the Roman empire in AD 476, and Europe's subsequent economic and cultural decline into the Dark Ages, the rose languished there for a while, to be grown only in the enclosed quarters of monastic gardens. Gradually it re-emerged, however, and in later medieval times its presence was unavoidable, in plays and such poems as the famous *Roman de la Rose* (*Romance of the Rose*),

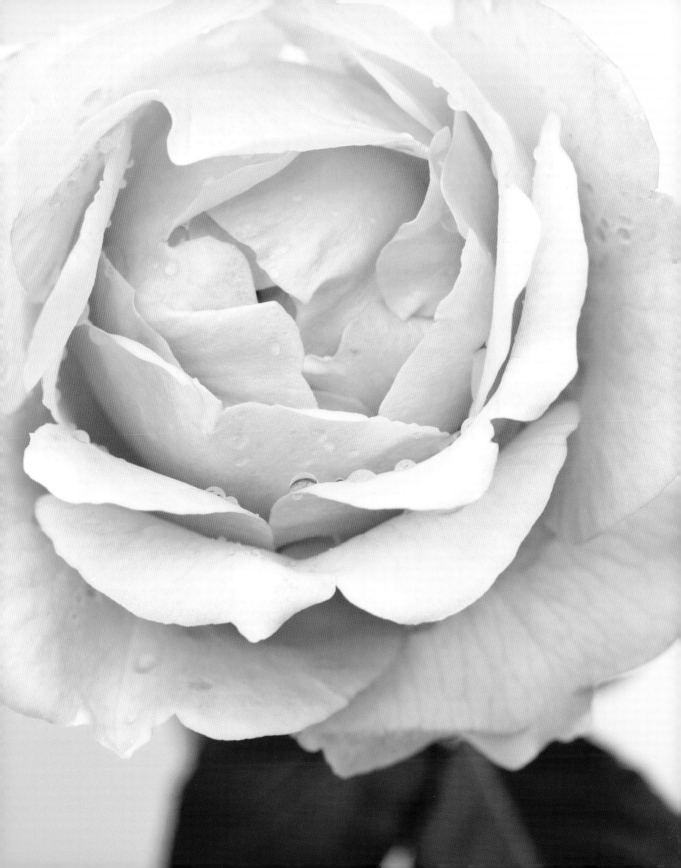

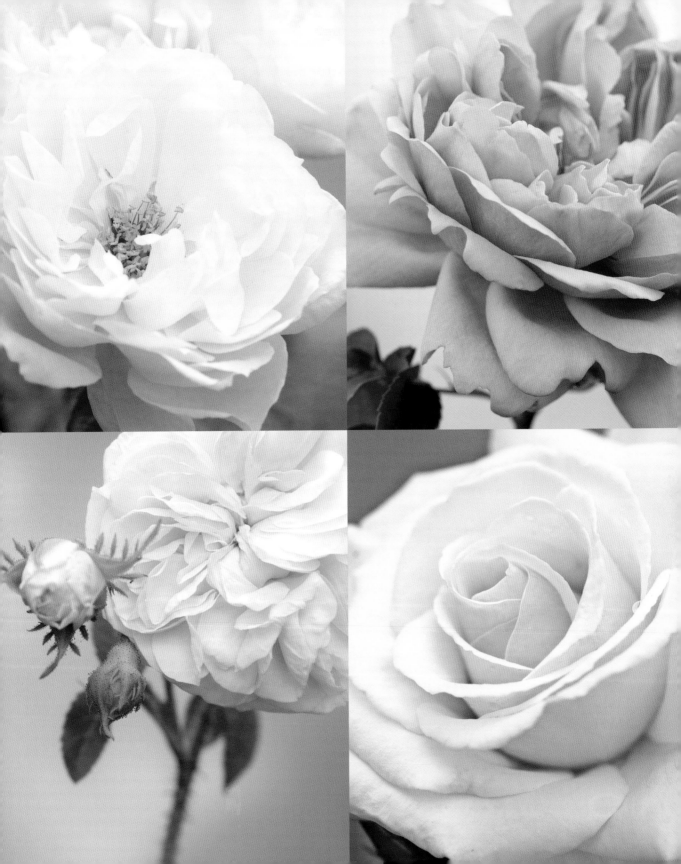

and in paintings and illuminated manuscripts, where
it was almost always pictured alongside other medieval
favourites, such as the lily and the iris. The rose's
link with monastic gardens gave it a strong Christian
symbolism, particularly associated with the Virgin
Mary, a theme that was taken up by many a Renaissance
painter. The fifteenth-century luminaries Sandro
Botticelli, Stefan Lochner and Martin Schongauer
each produced sumptuous paintings with the title
Madonna in the Rose Garden.

In Britain, the native dog rose, *Rosa canina*, would
have grown alongside other roses that had arrived
from the Continent – Albas, Damasks, Gallicas and
Centifolias – interbreeding with them to produce a
mixture of different forms that by John Parkinson's
time numbered twenty-four (listed in his herbal of
1629). By Tudor times the rose was so much part of
the fabric of British society that it became a national
symbol: the Tudor Rose, symbolizing the coming
together of the two warring houses of Lancaster and
York in a stylized merging of red and white blooms. The
rose was firmly rooted in daily life, valued particularly
for its scent, and its image was woven into tapestries,
embroidered on gowns, carved into woodwork and
immortalized in art. It was a potent and widely used
symbolic device in literature, most often representing
love and passion, but also signifying female sexuality.
Shakespeare mentions the rose more than fifty times in

his plays and sonnets, using it in many different contexts,
from the most famous quotation of all – 'What's in a
name? that which we call a rose/ By any other name would
smell as sweet' (*Romeo and Juliet*, II. ii) – to Sonnet 54,
which pays homage to the beauty of youth through the
metaphor of a scented rose:

> *O! how much more doth beauty beauteous seem*
> *By that sweet ornament which truth doth give.*
> *The Rose looks fair, but fairer we it deem*
> *For that sweet odour that doth in it live.*

In the sixteenth and seventeenth centuries more roses
began to appear in Europe, including the yellow *Rosa foetida*
from Asia, then called *R. lutea*, and the moss rose, now
known as *R. × centifolia* 'Muscosa'. The latter, which was
developed by Dutch rose-breeders in the seventeenth
century, was a sport of the Centifolia rose, distinguished by
the aromatic, mossy covering of stems and buds. It came to
Britain early in the eighteenth century, where it was first
listed in a catalogue of exotic plants purveyed by London
nurseryman Robert Furber in 1724. The first illustration
of the moss rose appeared in 1788 in the second volume of
Curtis's Botanical Magazine, with an accompanying note:

> *If there be any one genus of plants more universally admired than*
> *the others, it is that of the rose. Where is the Poet that has not*
> *celebrated it? Where the painter that has not made it an object of*
> *his imitative art? In the opinion of [the botanist Philip] Miller, the*

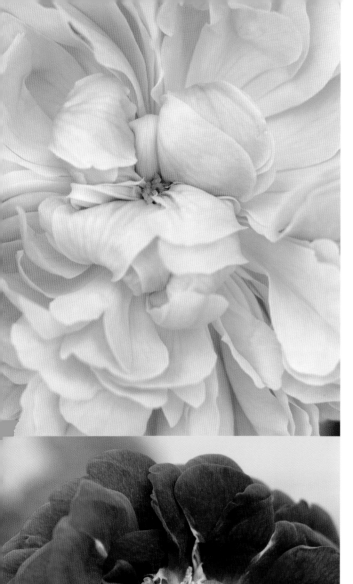

Left, from top: 'Marchesa Boccella'; 'Tuscany Superb'.

Opposite: 'William Lobb'.

Moss Rose, or Moss Province, as it is frequently called, is a perfectly distinct species; Linnaeus considers it as a variety only of the centifolia; as it is found in our Nurseries in a double state only, and as we are ignorant of what country it is the produce, the decision of this matter must be left to future observation and enquiry.

Hybridization begins

It was not until the beginning of the nineteenth century that deliberate cross-breeding began, catapulting the rose into a far more complex and exciting realm. France took the lead, launching headlong into a period of rose-mania that was famously fuelled by Josephine Bonaparte, the wife of Napoleon. However, as Jennifer Potter recounts in her historical monograph *The Rose* (2010), Josephine's contribution to the world of roses may have been somewhat exaggerated. Potter has found no evidence of a rose garden per se at the renowned Malmaison palace, and although Josephine was undoubtedly a highly knowledgeable plant-lover and collector, roses were just part of a wider and more exotic collection of species from all over the globe. The myth was undoubtedly perpetuated by the painter Pierre-Joseph Redouté's three-volume tour de force, *Les Roses* (1817–24; see p. 92), which contained 170 outstanding coloured engravings of many of the varieties known at the time. Josephine was Redouté's patron, so it would be natural to assume that many of his paintings were of roses in her collection; but in fact only a

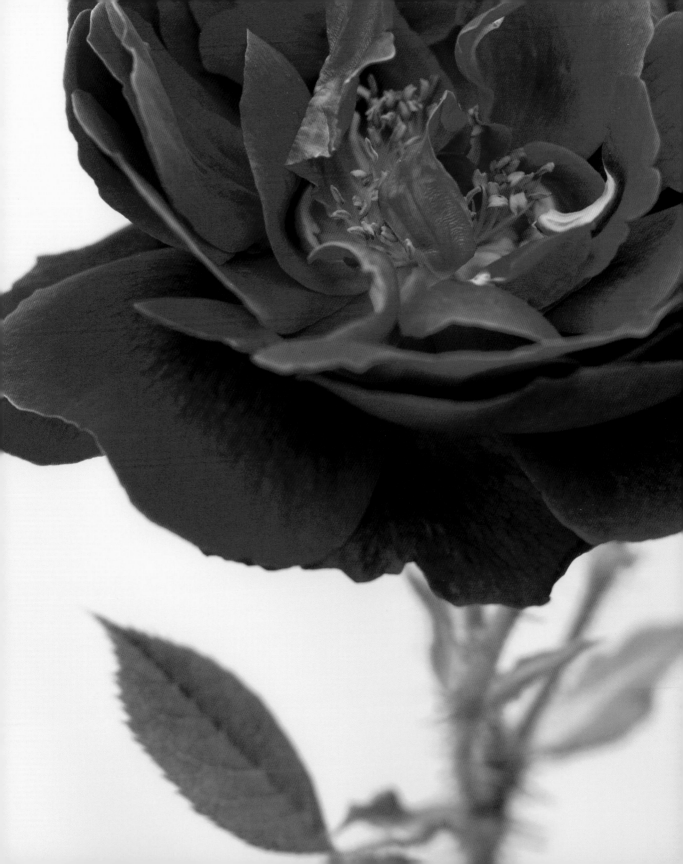

very few were recorded as having come from Malmaison. The fiction was further exacerbated by rose-breeders who seized on the chance to promote their new hybrids by adding a bit of puff about the rose-loving empress.

Les Roses used the new stipple engraving technique to which Redouté had been introduced in England, which, in his words, gave the resulting prints 'all the softness and brilliance of a watercolour'. He does not exaggerate: the incredible detail and subtle luminosity of the prints have contributed to his reputation as one of the leading botanical artists of all time. Redouté's 170 roses are predominantly pink, purple and white — the same as most of the old European varieties — but among them are a handful of new China hybrid roses that were to transform the nature of the genus during the course of the nineteenth century.

The Chinese had been cultivating roses for at least 1000 years, producing large-flowered blooms in a palette of crimson and yellow. The first Chinese species started trickling into Britain at the beginning of the eighteenth century, to appear in nursery catalogues by 1775, but progress was slow as travel in China was restricted and many of the plants collected were lost during the long voyage home. British plant-hunters, such as William Kerr and, later, Robert Fortune, were more successful, sending back such new specimens as the white Banksian rose (*R. banksiae*, named after the wife of Kerr's patron, Joseph Banks) and Fortune's Double

Yellow (now *R.* × *odorata* 'Pseudindica'), a climbing rose that Fortune described in an article as having 'a striking and uncommon appearance' (*Journal of the Horticultural Society of London*, vol. 1, 1846).

Rose specialists, particularly in France, seized on the new forms, and so began a chain of cross-breeding that would change the face of the rose forever, adding more and more branches to the already complex family tree. China roses were developed by crossing European roses with a group derived from *R. chinensis*, while Tea roses, so called because of their faint scent of fresh tea, arose from a cultivar called 'Hume's Blush Tea-Scented China', introduced by Sir Abraham Hume in 1810. These groups in turn gave rise to the hybrid China, Portland, Bourbon and Noisette groups, and finally the Hybrid Perpetuals, which, with their longer flowering periods and larger flowers, dominated nursery catalogues in the second half of the nineteenth century. The Hybrid Perpetuals were then crossed with the older Tea roses, so the Hybrid Tea group was born — and so on. The experimentation, it seemed, was unstoppable, occurring now in France, Britain, the United States and elsewhere around the world.

The twentieth century onwards

In Britain the fashion for ever more elaborately coloured and unnatural-looking hybrids was eventually

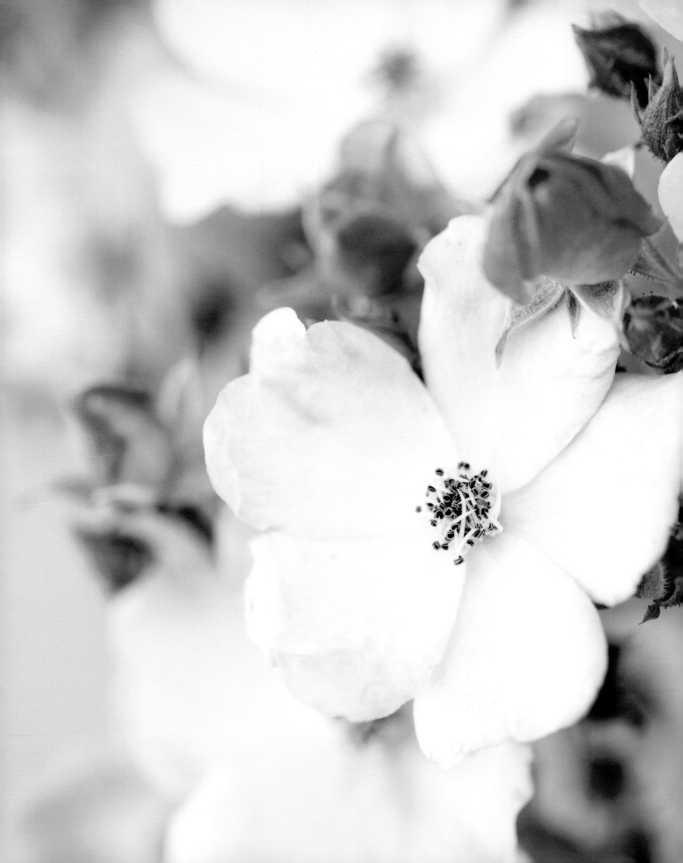

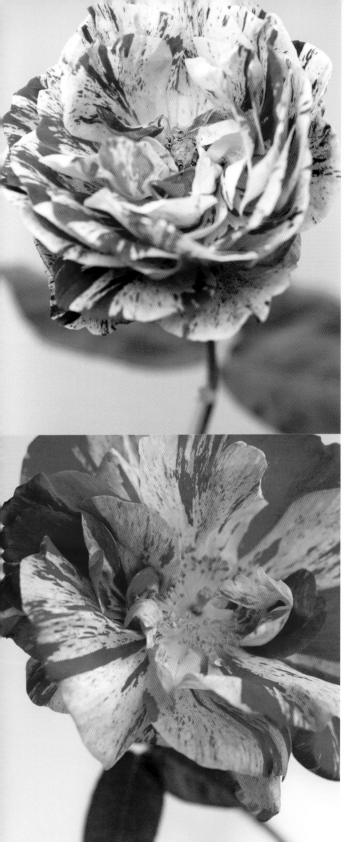

challenged towards the end of the nineteenth century,
with such leading figures as Gertrude Jekyll singing the
praises of the older, more natural-looking forms. The
plantswoman Ellen Willmott produced her monograph
The Genus Rosa in parts between 1910 and 1914, in which
the roses, superbly illustrated by the renowned landscape
painter Alfred Parsons, are almost all species or old roses.
Vita Sackville-West voiced her opinion in typically blunt
style in her column in *The Observer*: 'Conventionally
minded people remark that they like a rose to be a rose,
by which they apparently mean an overblown pink, scarlet
or yellow object, desirable enough in itself, but lacking
the subtlety to be found in some of these traditional roses'
(28 May 1950); and Graham Stuart Thomas, one of the
twentieth century's most influential plantsmen, published
his book *The Old Shrub Roses* in 1955. But, despite all this,
breeding continued relentlessly, bringing yet more
groups to the stage: the Polyanthas, with their clusters
of small flowers, and the more showy Floribundas, the
result of crossing Polyanthas with Hybrid Teas, were
all the rage in the 1940s and 1950s, while Hybrid Teas
themselves remained resolutely popular because of their
long flowering time.

Then, in the 1960s, one British breeder revolutionized
the rose industry by producing a cultivar called 'Constance
Spry', the result of a cross between an old gallica rose and
a modern floribunda. Inspired by a book on old roses,
David Austin set out to cross old roses with new forms,

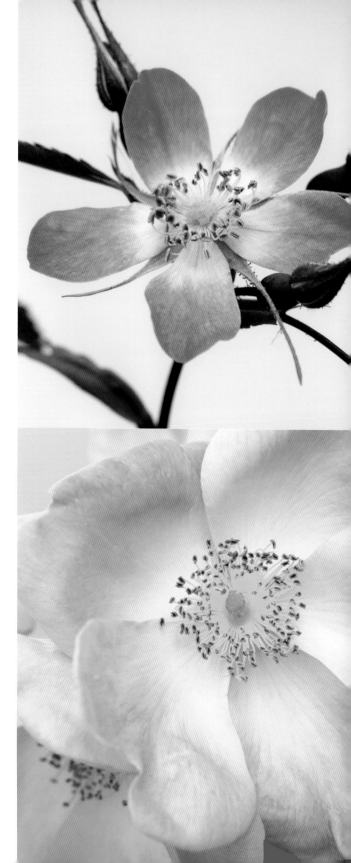

producing his hugely successful range of 'English' roses. Combining many of the best characteristics of the old varieties, including their scent and flower shape, with the colour range and repeat-flowering habit of modern hybrids, these exceptional roses are known and grown all over the world, and have brought the rose back full circle by linking it directly with some of the most venerable varieties. Vita Sackville-West would have approved. In *The Observer* in May 1950, she concluded her quest to convert her readers to old-fashioned roses: 'I could go on for ever, but always I should come back to the idea of embroidery and of velvet and of the damask with which some of them share their name. They have a quality of their own; and from the gardener's point of view they give little trouble … Have I pleaded in vain?'

Helleborus niger,
Orientalis, amplissimo
folio, caule proealto,
flore viridi, Itineris
Tournefort.

Hellebore

Bright as the silvery plume, or pearly shell,
The snow-white rose, or lily's virgin bell,
The fair Helleborus attractive shone,
Warm'd every Sage, and every Shepherd won.

Erasmus Darwin, 'The Loves of the Plants' (1791)

The hellebore is a tricky plant to study in botanical art, for although its origins are truly ancient, its role as a decorative plant did not burgeon until the twentieth century. Portraits are therefore few and far between before then, yet a proliferation of illustrations in sixteenth- and seventeenth-century herbals show that it has been a well-known cultivated plant for hundreds if not thousands of years, grown not for its ornamental values but for its medicinal properties.

Today it is the so-called Oriental hybrids (*Helleborus × hybridus*) that reign supreme, grown for their exquisite flowers that appear, as if by magic, very early in the year. The name is misleading: although a single species hails from China, the geographical origins of the plant are mainly in Europe – from Britain in the north to Greece and Italy in the south, and Croatia and even Russia in the east – where it has been collected from the wild and used to produce the vast number of variants we know today. Genetically unstable, with huge variability in appearance within the species, hellebores are a hybridist's dream. Their propensity to change and cross-fertilize has been used to great advantage by breeders, who seize on unusual characteristics to select

new plants, with the result that the range of hellebores now available is truly astonishing. Their graceful, nodding flower heads come in almost every colour imaginable, and may be spotted, blotched, freckled or bi-coloured, single, double or anemone-centred, each with its own distinct personality. From delicate apple-greens and primrose-yellows to delicious strawberry-pinks and the darkest, most sumptuous velvety maroons, the colours might have been mixed on an artist's palette.

The hellebore's medicinal roots

The true story of the hellebore begins long before the emergence of the decorative hybrids we know today: in antiquity it became one of the most powerful and widely used plants in herbal medicine. Both Pliny the Elder and Pedanius Dioscorides wrote at length about the hellebore in the first century AD, and even before that, the Roman writer Cato referred to the hellebore in his manuscript *De Agricultura* (c. 200 BC), describing how its roots could be steeped in wine to make a purgative, or ground up and scattered on the soil around vines to produce a medicinal vintage. The plant we now know as the Christmas rose or black hellebore (*Helleborus niger*) is the most closely related to the plant used in antiquity, known in the past as *H. officinalis*. Confusingly, its flowers are white: the name comes from the black root, the part of the plant used in medicine. Containing powerful compounds that can be

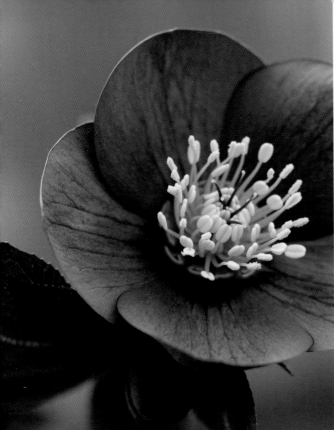

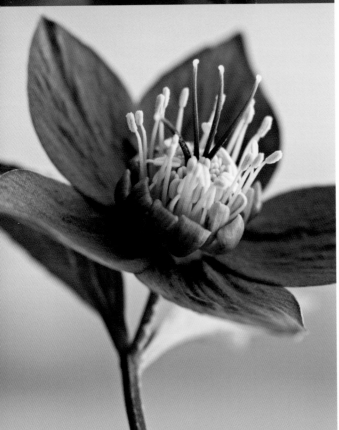

fatally poisonous in large quantities, the root was used for a range of ailments, including depression and other mental illnesses. In his *Natural History*, Pliny attributed the plant's discovery to the mythical soothsayer and physician Melampus (*c.* 1400 BC), who was said to have first noticed its effect on goats, and subsequently cured the mad daughters of the king Proetus by giving them his goats' milk.

Hellebores were represented in all the early herbals, with varying accuracy. One of the earliest paintings appeared in a version (held in the National Library of Russia in St Petersburg) of Matthaeus Platearius's twelfth-century *Book of Simple Medicines*, published in about 1470. It has charming illustrations by the French illuminator Robinet Testard, who worked as an artist and illuminator in the court of Charles Angoulême in Cognac, and was responsible for the illumination of some of the most exquisitely decorated books of hours of the age. Labelled 'Consiligo', one of the ancient Greek names for the hellebore, the painting depicts a remarkably realistic *H. viridis* in seed, alongside a flowering bur reed (*Sparganium*) and a wild strawberry plant. The realism of this drawing was, unfortunately, exceptional for this era; plant illustrations tended to be copied from volume to volume down the centuries, so that inevitable inaccuracies crept in.

Two sixteenth-century herbals that broke the mould were written respectively by Otto Brunfels and Leonhart Fuchs, who both employed good draughtsmen to draw

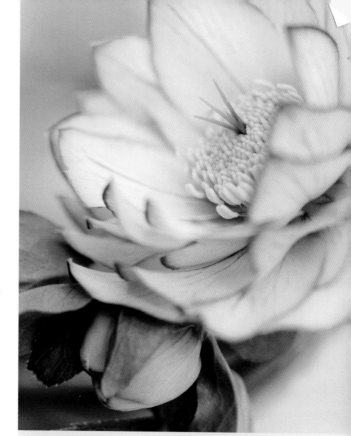

All the photographs in this chapter depict seedlings of *Helleborus* × *hybridus*.

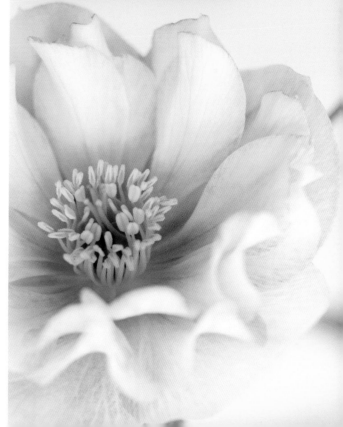

directly from the plants. In Brunfels's *Herbarium Vivae Eicones* (*Living Plant Images*) published in Strasbourg between 1530 and 1536, there is a splendid woodcut of *H. viridis* by Hans Weiditz (*c.* 1495–1537), who was a well-known caricaturist as well as a talented botanical artist.

The physician and herbalist John Gerard illustrated three kinds of hellebore in his herbal of 1597: the 'true black hellebore', *H. niger*, which – although not a British native – was widely known by the seventeenth century; what he called the false or bastard hellebore, *H. viridis*; and the 'beare-foot' hellebore, which is what we now call the stinking hellebore, *H. foetidus*. Gerard also noted another name for this plant, 'Ox-heele', relating to its common use as a cure-all for cattle and other animals. *H. viridis* and *H. foetidus* grow wild in Britain, particularly in light woodland on chalky ground, and the three listed by Gerard were the only hellebores to be widely cultivated in Europe for at least the next 250 years. Writing at length about the plant's medicinal properties, Gerard warned that it should be prescribed only to 'robustious and strong bodies', and noted: 'A purgation of Hellebor is good for mad and furious men, for melancholy, dull and heavy persons, for those that are troubled with the falling sickness [epilepsy], for lepers …' A contemporary of Gerard, Robert Burton, also referred to the hellebore as a cure for depression in his work *The Anatomy of Melancholy* (1621):

Borage and Hellebor fill two scenes,
Soveraign plants to purge the veins
Of melancholy, and chear the heart,
Of those black fumes which make it smart;
To clear the brain of misty fogs,
Which dull our senses, and Soul clogs.
The best medicine that e'er God made
For this malady, if well assaid.

The hellebore in seventeenth- and eighteenth-century art

Over the next few hundred years, the hellebore genus remained static in terms of hybridization, and artists therefore had little to inspire them beyond the three well-established species mentioned above. Some managed to produce outstanding works of art, however, including two French artists, Nicolas Robert (1614–1685) and Claude Aubriet (1665–1742), both of whom were employed at the court of Louis XIV. In Robert's portrait of *H. niger*, it is the slightly pink-tinged flowers that draw the eye, while in Aubriet's (p. 104), it is the glossy, textured leaves that form the centrepiece. Later, Georg Dionysius Ehret (1708–1770) produced a very fine painting of the Christmas rose, complete with a yellow winter aconite and an out-of-season butterfly in the background.

Another eighteenth-century artist who painted the hellebore in all its forms was Elizabeth Blackwell

(1707–1758). Her *Curious Herbal* (1737–39), aptly named for the intriguing tale behind its publication, contained, as the title page proclaimed, 'five hundred cuts, of the most useful plants, which are now used in the practice of Physick'. Blackwell was a Scottish artist who had the misfortune to marry a rogue and fraudster. Her husband, Alexander Blackwell, who was practising illegally as a doctor in Aberdeen, was subsequently forced to flee the city; he set up a publishing firm and printing press in London, and in due course found himself incurring fines for flouting trade rules. In 1734 he was sent to debtors' prison and Elizabeth found herself destitute. Determined to make ends meet and raise the money to get her husband out of prison, she decided to produce a herbal that would include recently introduced species from the Americas, and she worked day and night for some years to illustrate her 500 chosen plants, engraving the copper plates and colouring each print by hand. As she had no botanical training, she took the finished drawings to her husband's cell for him to annotate each plant. With its highly accomplished illustrations, the *Curious Herbal* was well received, and Elizabeth was able to buy her husband out of prison with the profit from its sales. But the happy ending she so deserved was not to be: her husband went to Sweden, where he talked his way into the court of Frederick I as chief physician, but was eventually sentenced to death for conspiracy in 1747. Elizabeth's astounding tenacity was immortalized in her

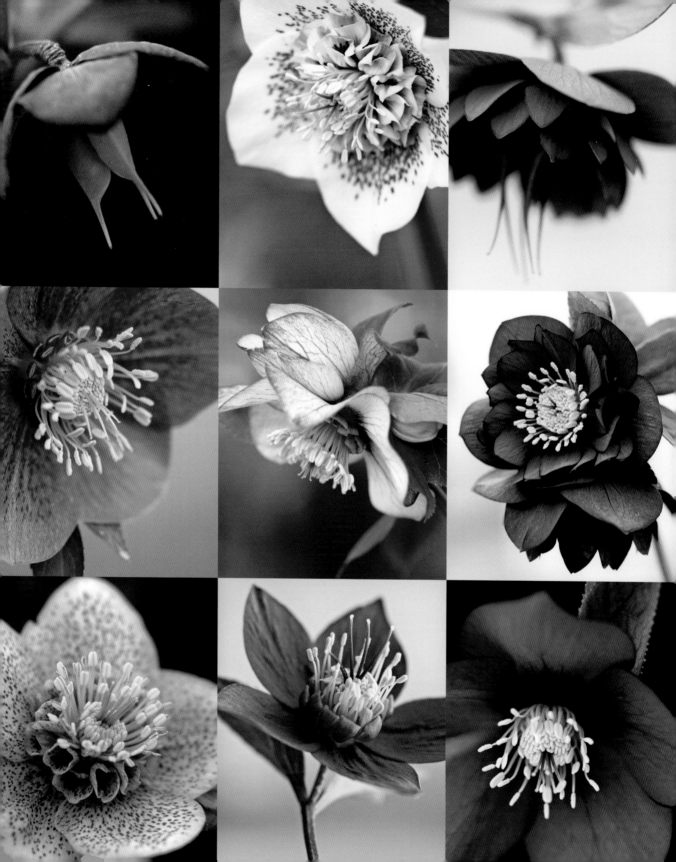

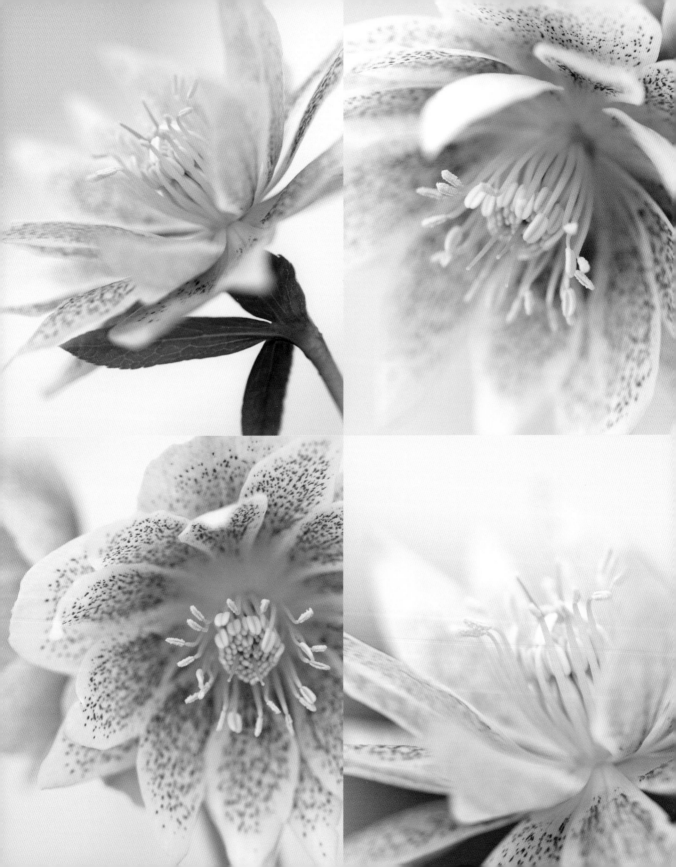

herbal, a copy of which is held in the British Museum, and in which illustrations of what she notes as *H. major* (probably *H. niger*), *H. minor* (*H. viridis*) and the Helleboraster (*H. foetidus*) can be seen.

The first hybrids

It was Germany that sparked the first interest in hellebore hybridization, with such nurserymen as Max Leichtlin (1831–1910) leading the way. Working with new species from Russia, these pioneering plantsmen soon found that they could obtain a wide range of colours with interesting markings, and the modern hellebore, in all its many guises, was born. Meanwhile, in Britain, a few horticultural pioneers were starting to realize the versatility of the genus. One such enthusiast, who corresponded with German hybridizers and obtained some of their plants, was the gardener and writer Canon Henry Ellacombe (1822–1916), who had a well-known garden at his vicarage in Bitton, near Bristol. It was a renowned plantsman's garden, stocked with a rich mix of plants, and hellebores were one of his passions. In his book *In a Gloucestershire Garden* (1895), he wrote presciently about the plant:

> *Of the Christmas rose proper there are several varieties, chiefly differing in the size of the flowers and their suitableness to different localities; and there are many species. We have two in England, both of which grow in the Gloucestershire woods,* H. foetidus *and* H. viridis, *and both worth growing in the garden, especially*

H. foetidus, *for its handsome and lasting foliage. For the same good character I grow and admire* H. argutifolius *from Corsica, which looks more like a dwarf large-leaved holly than a Christmas rose. I also grow and am fond of the many hybrids raised about thirty years ago (chiefly at Berlin) between* H. guttatus *and* H. abschasicus.

At the end of the section on hellebores, he added a heartfelt and appreciative postscript about these winter-flowering beauties: 'Every day will unfold some new treasure; but few though they are, they are very lovely, and almost because they are so few they are very dear to us, and we may well be thankful for them.'

Hellebore hybridization continued apace throughout the twentieth century, although interrupted by the two world wars, and such figures as the horticulturalist Helen Ballard (1908–1995) produced an ever-increasing gene pool of forms. Since about 1980 the range of hybrids has widened, with breeders producing the most exquisite flowering plants in a seemingly unending variety of colours – from deep, luscious plum and buttercup-yellow to slate-grey and purple–black, some with extravagant double flowers or 'anemone' ruffles, others beautifully marked with spots or blotches. Hellebores are notoriously difficult to propagate vegetatively (by division), but on the other hand they cross-pollinate with the greatest of ease, so most hellebore breeding today concentrates on seed-raised plants, which can be extremely variable. As a result, named cultivars are relatively few, and the emphasis is

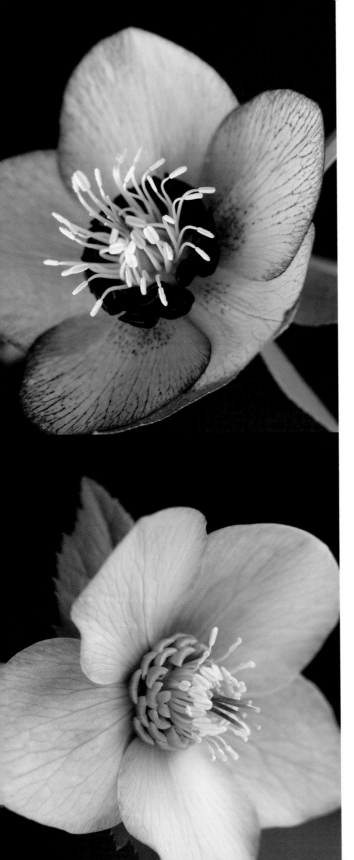

instead on named groups of hybrids, often referred to by colour, shape or markings. The delightful Bradfield Star hybrids, for instance, bred by Roger Harvey at Harvey's Garden Plants in Suffolk, have charming, narrow-petalled flowers in white, carmine-pink or white with red spots. The Ashwood Garden hybrids from Ashwood Nurseries in the West Midlands embrace a mouth-watering range of colours, including pinks, greens and apricots, and are particularly noted for their doubles, especially the dark forms, some of which are almost black with a beautiful pearly iridescence.

Growing these rewarding, easy plants can be addictive. Tough and adaptable, they are reasonably tolerant of most soil conditions and can be planted in sun or shade. Their pet hate is prolonged damp, so heavy soil must be improved with plenty of grit and organic matter. Once established, the plants need little care throughout the year, although in late summer, when the new buds are forming, it is advisable to mulch with a thick layer of well-rotted compost or manure, perhaps mixed with a few handfuls of bonemeal. The only other task is to snip off old leaves that look tatty or mottled, to prevent the spread of black spot, and also (for tidy-minded people) to cut off the flower heads as they fade, to prevent hundreds of seedlings popping up around the plants. But for some, watching them mix up and seed around is part of the fun of growing these characterful plants.

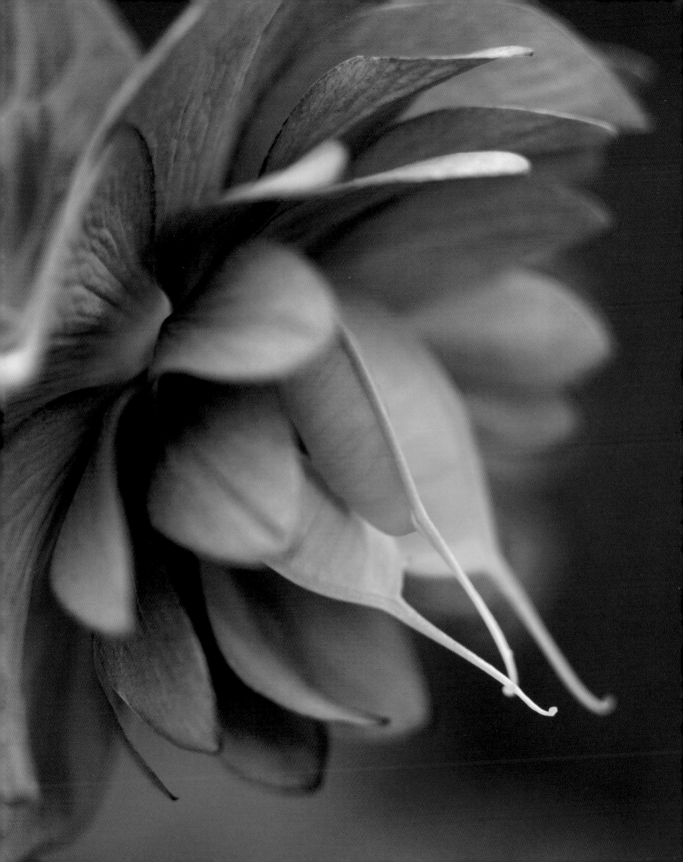

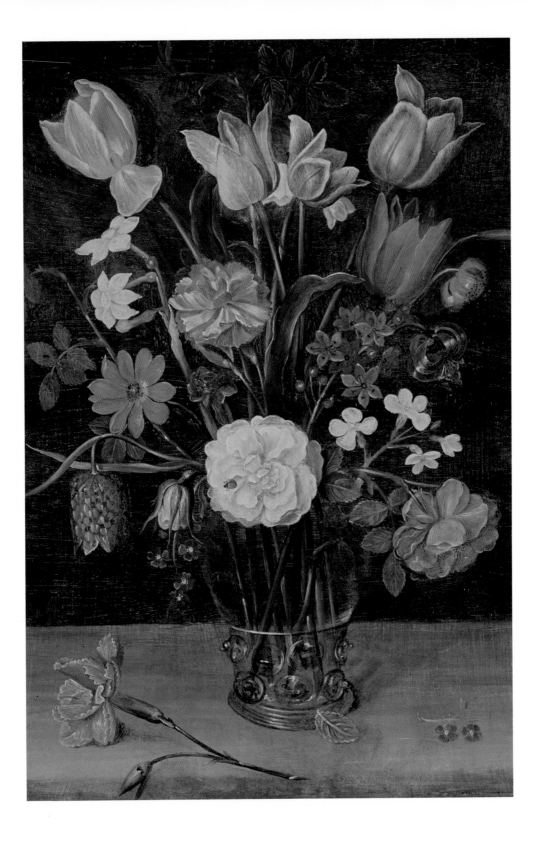

Carnation and Pink

For various colours Tulips most excel,
And some Anemonies do please as well,
Ranunculus in richest Scarlet shine,
And Bears-ears may with those in beauty joyne,
But yet if ask and have were in my power,
Next to the Rose give me the Gillyflower.

John Rea, *Flora, seu, de Florum Cultura*
(*Flora, or, Regarding the Growing of Flowers*), 1665

Delicate, clove-scented pinks and their larger cousins, carnations (or gillyflowers), of the genus *Dianthus*, have one of the most richly illustrated histories of all plants, stretching back as far as medieval times, when they began to be seriously cultivated in Europe. Since the fifteenth century these well-loved flowers have been painted repeatedly, both for education (in the botanists' herbals) and, more significantly, for decoration, and they can still be seen in early works of art, from the exquisite books of hours, where blood-red carnations symbolized Christ's resurrection, to some of the most iconic works of Renaissance art. Sandro Botticelli's painting *Primavera* (c. 1478) depicts the serene figure of Flora, goddess of flowers, dressed in a flowing white gown decorated with cornflowers and rose-pink dianthus. According to Christian legend, carnations and pinks sprang up on the ground where Mary's tears had fallen after she had seen Jesus carrying the cross, and the flowers often appear in paintings of the Virgin Mary and baby Jesus. Raphael's serene *Madonna dei Garofani* (*Madonna of the Pinks*, c. 1506–1507) depicts a tender Mary gazing down at the baby Jesus holding a double stem of pinks, while in Albrecht Dürer's *Maria mit der Nelke* (*Mary with the Carnation*, 1516), the portrait of mother and son shows her holding a deep-pink carnation, prominent against the white of her throat. In these paintings, the carnation seems to be a symbol of deep and enduring love; in later years, it came to represent betrothal and fertility.

In Tudor times, the dianthus was frequently represented in tapestry and needlework, to be seen in the elaborate millefleurs backgrounds of all the great Flemish and French wall-hangings. The beautiful *Lady and the Unicorn* tapestries, produced in France in about 1500, illustrated each of the five senses. In the panel representing scent, the Lady stands in the centre weaving a crown out of scented carnations, while a mischievous monkey holds a stolen flower up to his nose to smell it. Scatterings of pink and white dianthus flowers are also identifiable in the early sixteenth-century Dutch tapestry *The Three Fates*, where the figures stand against an intricately woven background of hundreds of different colourful flowers.

The reign of the carnation

Although both the garden pink (derived from *Dianthus plumarius*) and the carnation (from *D. caryophyllus*) were

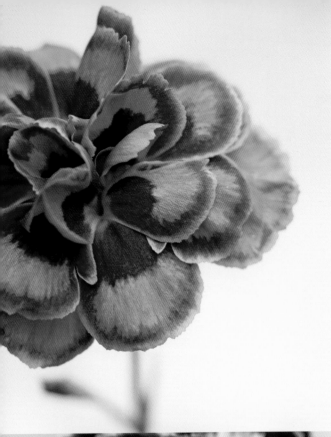

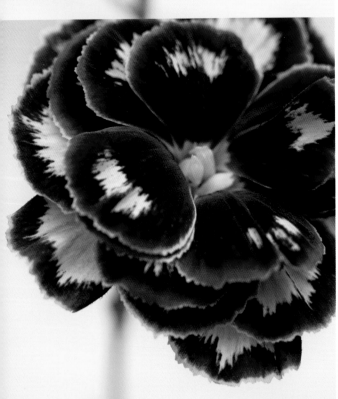

PAGE 114
Ambrosius Breughel (1617–1675)
Still Life with Spring Flowers, date unknown
Oil on panel
PRIVATE COLLECTION

cultivated from medieval times (and wild forms known much earlier than that), it was the carnation that attracted the most attention initially because of the natural hybrids it produced. Although deliberate hybridization was not understood until the eighteenth century – when, as we will see, the carnation played a crucial part in the first such experiment – natural crosses would have occurred when people started building up collections, and all over Europe seed of the most interesting crosses would have been saved and grown on. Striped (or 'flaked'), bi-coloured and double flowers were pounced on, appealing to the Elizabethan fascination with all things bizarre, and were soon available in so many different forms that in his herbal of 1597 John Gerard wrote: 'There are at this day under the name of *Caryophyllus* comprehended divers and sundry sorts of plants, of such various colours, and also several shapes, that a great and large volume would not suffice to write of every one.' But for all the passion that was incited by these new plants, there was also a small but vociferous group opposed to what they perceived as artifice rather than nature. William Shakespeare voiced his opinion through the character of Perdita in *The Winter's Tale* (1611), who shows her distaste for 'carnations and streak'd gillyvors,/ Which some call nature's bastards' (IV. iii).

Around this time, the dianthus flower burgeoned in another art form: embroidery. As is evident in many Elizabethan and Jacobean portraits, clothing was lavishly embellished with embroidered flowers, and the carnation

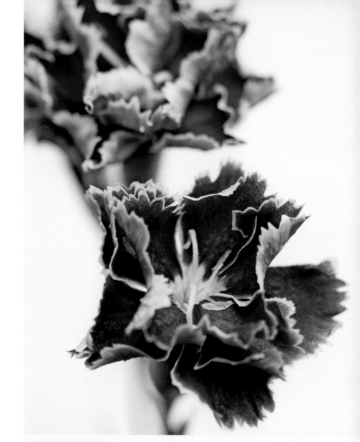

appeared repeatedly as a stylized motif, often edged with silver or gold thread, on gowns, doublets, nightcaps and other items. Hand in hand with this feeling of opulence and wealth, the carnation was fast becoming the flower of the aristocracy. The passion for it resulted in many new varieties — many of them named after royalty — and by the end of the seventeenth century more than 360 cultivars could be named, many of which were listed in the second edition of the botanist John Rea's *Flora, seu, de Florum Cultura* (1676). Rea provides persuasive descriptions of their attractions, waxing lyrical about their 'delicate variegations and pleasing scents to vie with any species whatsoever … the single colours little esteemed in comparison of those striped, flaked or powder'd upon white or blush with darker or lighter red, crimson or carnation, sadder or brighter purple, deeper or paler scarlet'.

A seventeenth-century florists' flower

Along with the tulip, the carnation was one of the first flowers to be adopted by the elite florists' societies in the seventeenth century; the pink, as we shall see later, was not deemed special enough to become a florists' flower until the eighteenth century, when new, more exciting forms began to appear. The carnation was a particular favourite among florists, and many of these enthusiasts raised new varieties themselves, bringing their best creations to the feasts to compete for sought-after prizes.

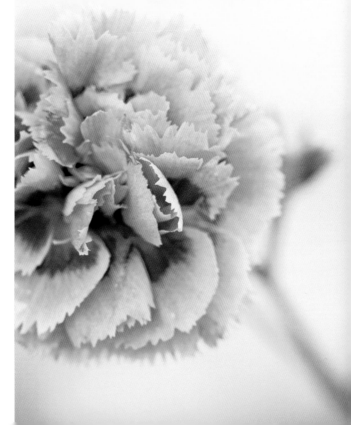

An unnamed seedling.

The types of carnation selected by the seventeenth-century florists are shown in the florilegium compiled over thirty years by Alexander Marshal, containing detailed botanical watercolours of some sixty of the most popular carnations of the time. These small, dainty flowers in varying shades of pink and red invariably have fringed petals, and a few show the 'flaked' or striped markings that were to become so fashionable. Many of them have French names, hinting that new varieties were flooding in from the Continent.

Meanwhile, in contrast to Marshal's detailed botanical studies, on the European mainland the Dutch masters were busy immortalizing the beauty of these flowers in a more gratuitous, decorative way. When studying the wonderful still-life flower paintings of the period, it is rare to find one that does not include carnations. A particularly fine example is Ambrosius Breughel's undated *Still Life with Spring Flowers* (p. 114), a delicate composition of blooms set against a dark background with a pure-white carnation standing out in the centre of the painting, a red-and-white flaked bloom above it, and a fringed pink carnation lying in front of the vase on the table. With their symbolism of marriage, carnations and pinks were also frequently included in portraits of women, who were depicted holding up a single bloom. In Rembrandt's haunting portrait *Woman with a Pink* (early 1660s), the woman's face and the flower are illuminated in a pool of light against a sombre backdrop.

The eighteenth century and the rise of the pink

In Britain, the eighteenth century was a time of intense, unprecedented interest in plants and gardens. New plant material was flooding in, not only from Europe but also from further afield. Seed of numerous American plants was sent to the cloth merchant and gardener Peter Collinson by the great American plant-hunter John Bartram (1699–1777), and Joseph Banks circumnavigated the globe with Captain Cook to bring back astonishing new plants from Australia, New Zealand and the South Pacific.

In this context, it is not surprising that a natural curiosity about how plants reproduced led to an illicit experiment to make the first artificial hybrid: a cross between a carnation and a sweet william (*Dianthus barbatus*). Known as 'Fairchild's Mule' after its creator, nurseryman Thomas Fairchild (?1667–1729), this hand-pollinated hybrid demonstrated the understanding of a plant's sexual reproductive system, and was therefore highly contentious in its contradiction of the Christian belief in the Creation. Fairchild, himself a practising Christian, lived in guilt for the rest of his life, and was not to know what a ground-breaking effect his potting-shed venture would have on the future of horticulture.

The eighteenth century also saw the rise in popularity of the garden pink. Although pinks had been known and loved from medieval times, they seem to have been

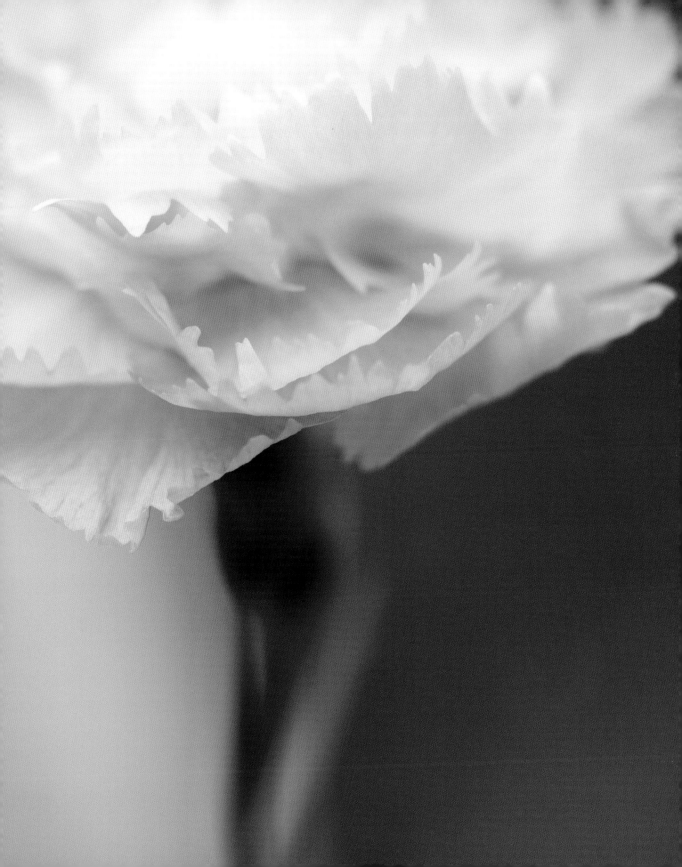

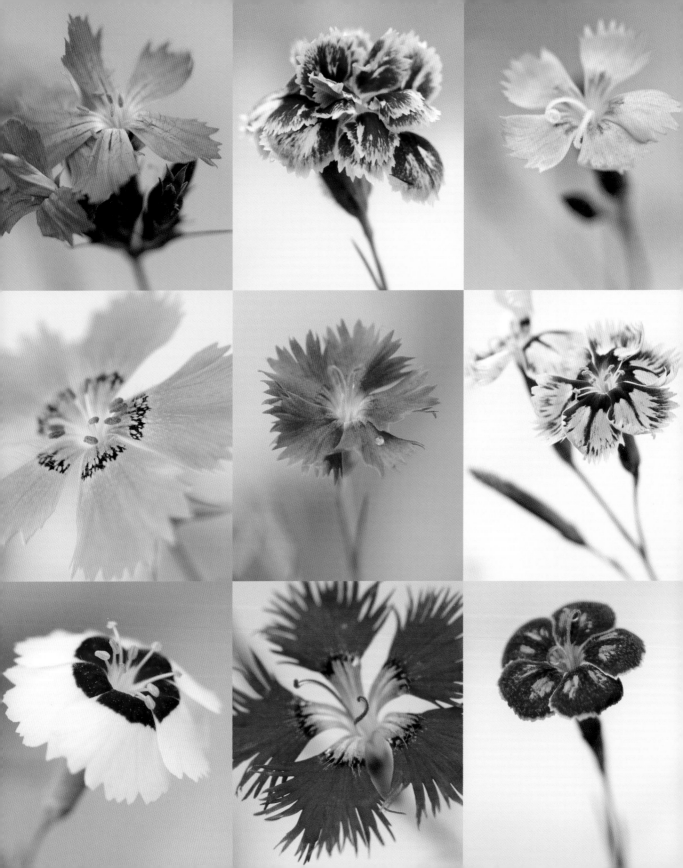

dismissed by some people as a more 'common' flower than the sophisticated carnation, although they were clearly valued for their scent. In 1597 Gerard distinguished between carnations and pinks, saying that the latter were 'not used in Physicke, but esteemed for their use in Garlands and Nosegaies', while in 1625 Francis Bacon wrote about the pink in his essay 'Of Gardens': 'In May and June come pinks of all sorts, especially the blush pink … the breath of flowers is far sweeter in the air (where it comes and goes like the warbling of music) than in the hand.' The pinks were so named not because of their colour but because of their serrated petals, a name derived from a usage of the word that is not often heard nowadays, but survives in 'pinking shears'. In fact, the colour 'pink' came afterwards, leading to the conclusion that it must have been named after the flower.

For many years only a handful of improved forms appeared. It was not until the end of the eighteenth century that pinks were accepted into the inner circle of the florists' societies, and then only because of the appearance of chance seedlings showing decorative edging in contrasting colours. Plantsmen seized on this characteristic, and before long many new varieties of what became known as 'laced' pinks were appearing. One area particularly noted as a melting pot for laced pinks was Paisley, near Glasgow, where local weavers formed a large and thriving florists' society. Some of the best illustrations of the new laced varieties appeared in Robert

Sweet's *Florist's Guide and Cultivator's Directory* (1827–32), which contained – in addition to tulips, auriculas and other popular florists' flowers – eighteen colour plates of pinks. A good fifteen of these were laced varieties, including the sumptuous *D.* 'Davey's Bolivar', a white-flowered cultivar with dark-maroon lacing, and the more subtle 'Barratt's Conqueror', both of which disappeared from cultivation many moons ago. Sweet's guide, with its colour plates based on originals by Edwin Dalton Smith, shows very clearly the type of flower that was in fashion at the time.

As well as the elaborately laced pinks, carnation flowers had morphed into large-bloomed monstrosities, with the bizarres (striped) and the picotees (edged) being the most popular. A description of the carnation 'Erasmus' in the *Florist's Guide* sums up the desire for over-the-top colour: the blooms were 'yellow tinged with green at the base, edged with a lively purple, and striped down the centre'.

Nineteenth-century Malmaisons

Carnations once again stole the limelight in the nineteenth century, with the introduction of the perpetual flowering varieties and, later, the large, blowsy Malmaison carnations that were so revered in Edwardian times. The perpetual flowering carnation was the forerunner of the gaudy, scentless flowers that are at the centre of commercial cut-flower breeding today. The heavily scented Malmaison

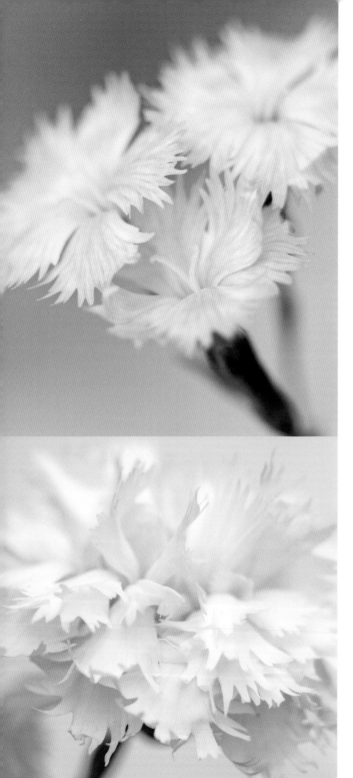

Left, from top: *Dianthus petraeus*;
D. 'Mrs Sinkins'.

Opposite: *D. superbus*.

carnation, on the other hand, first bred in France in 1857, is enjoying a marked revival in popularity. In Edwardian times it was the high-society flower, gracing the buttonholes of the rich and famous at society events, and famously dyed green by Oscar Wilde. All the well-heeled estates throughout the United Kingdom grew these flamboyant flowers, but the fashion was to be short-lived, cut down in its prime by the First World War. Despite the brevity of the Malmaison's heyday, it still seems strange that few, if any, contemporary paintings of them were made. Only photographs remain in old copies of the *Gardener's Chronicle*, and these have been invaluable in the recent reintroduction of the Malmaison hybrids by horticulturist Jim Marshall, who discovered several old cultivars in a Scottish garden in the early 1990s and has since built up a sizeable National Collection.

There has been a revival in the popularity of these traditional flowers in recent years, particularly the scented Malmaisons and old-fashioned pinks. While the Malmaisons are half-hardy and best grown under glass, the pinks are easier, tougher plants that can be grown outside, thriving in an open, sunny position in well-drained soil, and traditionally grown as an attractive, scented edging for borders. One of the most tenacious and famous of the old pinks is *D.* 'Mrs Sinkins' (left), a blowsy white double with fringed petals and a very sweet clove scent. It was named after the wife of the man who first raised it, in 1868, John Sinkins of Slough. The

dark-maroon-and-white 'William Brownhill' is another old favourite. There are also many modern cultivars that capture the essence of the old-fashioned pink but flower for even longer; among them is the lovely 'Laced Monarch' (p. 116), with its deep-pink flowers and maroon lacing. It is such improved forms that are bringing these sweet-scented favourites back into mainstream gardening, for, as Vita Sackville-West enthused in her column in *The Observer* in December 1949, 'there are few plants more charming, traditional, or accommodating'.

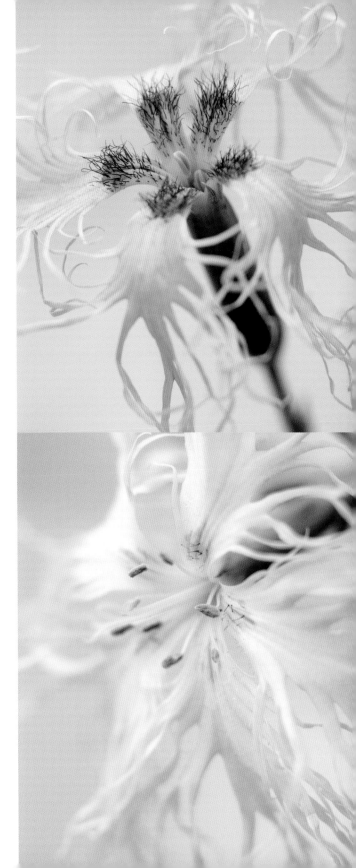

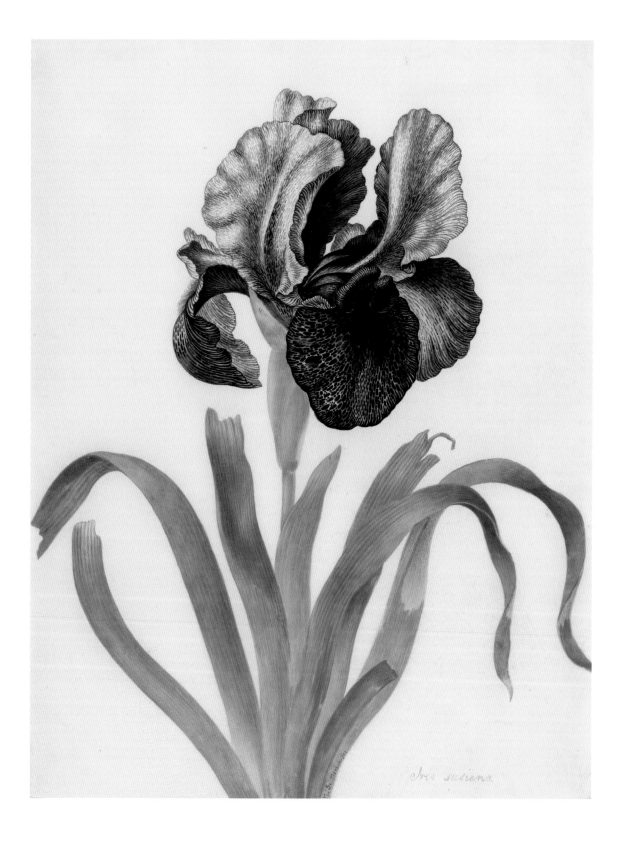

Iris susiana

Iris

There is something wonderfully abstract about the iris, as such artists as Georgia O'Keeffe have shown. O'Keeffe (1887–1986) produced several iris portraits (including the famous *Black Iris*, painted in 1926), magnifying the blooms to present her own bold interpretations of form and colour. 'Nobody sees a flower — really,' she wrote in the catalogue that accompanied her exhibition of 1939, 'it is so small — we haven't time … So I said to myself — I'll paint what I see — what the flower is to me[,] but I'll paint it big and they will be surprised into taking time to look at it.' With their abstract shapes and flamboyant hues, the modern cultivars of bearded iris particularly lend themselves to such treatment, their intriguing colour blends and sculptural, ruffled petals a gift for the colourist painter.

The origins of the iris

This perception of modernity belies the ancient origins of the iris. Named after the Greek messenger to the gods, who descended from the heavens to Earth on a rainbow, the iris was certainly cultivated by the ancient Greeks and Egyptians. The oldest known representation of the flower in art is in a fresco at the Minoan palace of Knossos on the island of Crete (*c.* 1550 BC), where it appears as a stylized motif in an image of the 'Priest-King'. The iris also appears in stone wall-carvings in the Egyptian temple of Amun-Re at Karnak, dating back to the reign of

Pharaoh Thutmose III (1479–1425 BC), an obsessive plant-lover. In ancient times the iris was grown primarily for its medicinal value. Pedanius Dioscorides mentioned two types in his first-century manuscript *De Materia Medica*, referring to the use of the rhizomes as a purgative, among other things, and offering a recipe for a curative elixir made from the ground root mixed with vinegar. The Romans used the rhizomes to spice their wine, and also made a powder that was used in cosmetics and perfumes. Later, this powder became known as orris root, derived from such species as *Iris germanica* and *I. pallida*, which have sweet, violet-scented roots, and from the white-flowered *I.* 'Florentina', named after the city in which the first commercial cultivation of orris took place, in the Middle Ages. Orris was widely used in Elizabethan times in facial cosmetics and to powder wigs, and even today the essential oils from orris root are used as a base note in perfumery.

Because of its medicinal uses throughout history, the iris was widely depicted in early herbals, from the first printed volumes of the fifteenth century with their crude black-and-white woodcuts to pioneering works by such sixteenth-century luminaries as Leonhart Fuchs and Otto Brunfels in Germany and William Turner and John Gerard in Britain. Fuchs's *De Historia Stirpium* (*On the History of Plants*, 1542) led the way in terms of illustration, with hand-coloured woodcuts that represented each plant as faithfully as possible. Employing three illustrators — one to draw the plant 'from nature', one to transfer each

PAGE 124
Maria Sibylla Merian (1647–1717)
Iris susiana, date unknown
Watercolour on vellum
FITZWILLIAM MUSEUM, UNIVERSITY
OF CAMBRIDGE

Iris 'Millennium Falcon'.

drawing to the woodblock, and another to do the cutting – Fuchs took pride in the authenticity of his illustrations, as he explains in his preface: 'As far as concerns the pictures themselves, each of which is positively delineated according to the features and likeness of the living plants, we have taken peculiar care that they should be most perfect; and, moreover, we have devoted the greatest diligence to secure that every plant should be depicted with its own roots, stalks, leaves, flowers, seeds and fruits.' His herbal illustrates more than 500 plants, including an elegantly drafted *I. germanica* with velvety, dark-purple flowers.

The iris was also a favourite with artists of the day, and was portrayed with amazing accuracy and naturalistic flair by such painters as Albrecht Dürer. His elegant, beautifully executed portrait of the iris, a study of the plant that would later be included in his religious masterpiece *Madonna with the Iris* (1508), conveys his natural affinity with plants. With its three standards and three falls (see below), the tripartite shape of the iris lent itself to religious iconography, symbolizing the Holy Trinity, and it found its way into some of the most famous religious works of art of the fifteenth and sixteenth centuries, from the simple vases of irises and columbines in Hugo van der Goes's Portinari altarpiece (*c.* 1473–78) to the waterside clumps in the first version of Leonardo da Vinci's *Virgin of the Rocks* painting (1483–86).

The fleur-de-lys

The iris genus is huge and rambling, with about 300 species growing in many different regions of the northern hemisphere, although only two (*I. pseudacorus* and *I. foetidissima*) are truly native to Britain. It was not until the sixteenth century that species from further afield began to spread through Europe. In France, Germany, Austria, Holland and Britain, botanists began to make collections of different plant genera, creating accidental hybrids that further broadened the spectrum of plants available. When John Gerard produced his herbal in 1597, he illustrated more than ten types of rhizomatous iris, or 'Floure de Luce', as he called them. The derivation of this name, to this day immortalized in the fleur-de-lys symbol, is lost in the mists of time, although there are several possible explanations. What is certain is that the symbol – a stylized flower – began to be used as a heraldic motif in the twelfth century, when Louis VII was the first French king to use it on his coat of arms. An enjoyable, if fanciful, tale attributes the name to a specific incident involving the king: while fleeing his enemies, he was attempting to cross the River Lys when he noticed a deer crossing further downstream. Knowing that the river must be shallow at that point, he and his men followed suit and escaped peril. Reaching the other side, he picked an iris flower (probably that of the yellow flag iris, *I. pseudacorus*, which is found near water) and held it aloft as a symbol of life.

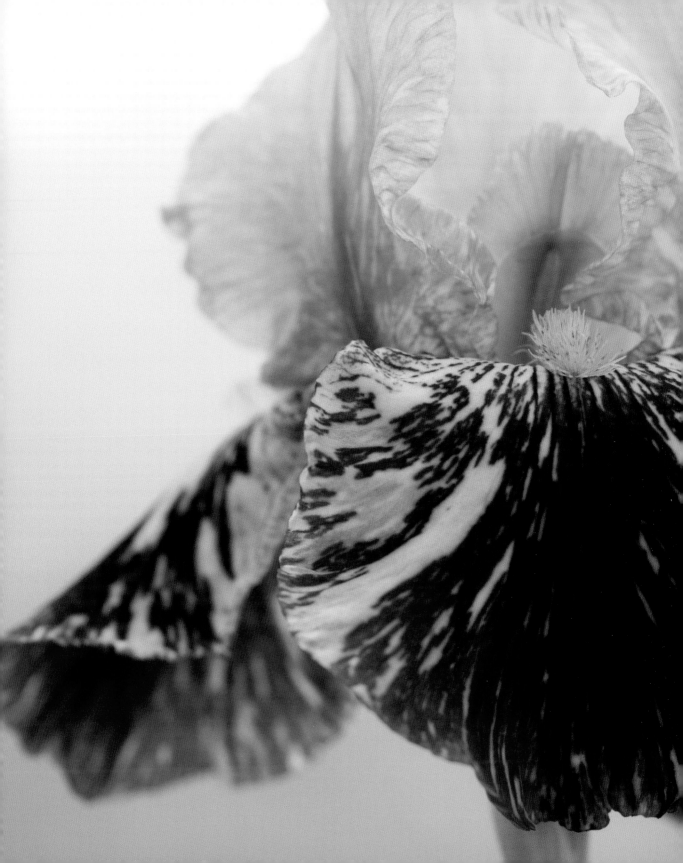

Some believe that the name is derived from 'fleur de
Louis' or 'Loys', but whatever the origins, there is no
doubt that the symbol represents an iris rather than a lily,
as is sometimes mistakenly thought.

New species of iris in Europe

Throughout the sixteenth, seventeenth and eighteenth
centuries increasing numbers of iris species circulated
Europe, including the Siberian irises, the Mediterranean
Spurian irises and *I. susiana* from Turkey. The last, known
as the mourning iris on account of its unusual, almost
sinister-looking grey-tinged flowers, arrived in Europe in
the second half of the sixteenth century, probably thanks to
the efforts of the tireless Ogier Ghiselin de Busbecq (see
p. 83), who sent back countless varieties of Turkish plants
to his homeland. A wonderful miniature by Jacques Le
Moyne de Morgues painted in about 1585 signifies the
recent arrival of *I. susiana* in European gardens: the serene
figure in *A Young Daughter of the Picts* stands naked, her entire
body tattooed with intricate floral blooms including a
flower that looks much like *I. susiana* on each knee.

A century later, the same iris was painted by one of
the most interesting and talented botanical painters of the
time, the German Maria Sibylla Merian (1647–1717).
Merian was the stepdaughter of the artist Jacob Marrel,
who nurtured her burgeoning artistic talent from an
early age. Intensely religious and fiercely independent,

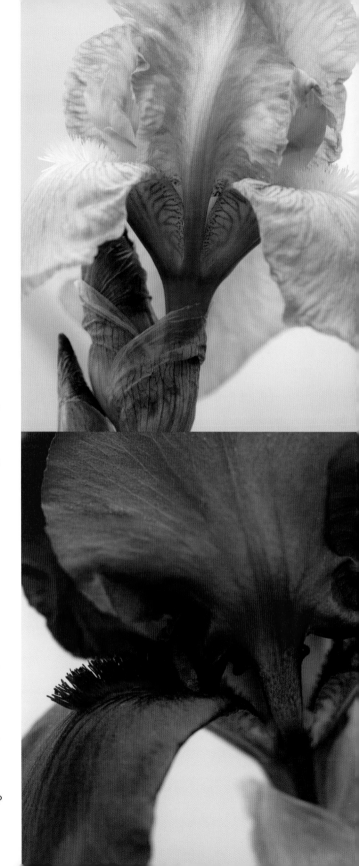

Merian painted plants, insects and animals in a style that was crisp, clear and brutally honest. Rather than portraying plants in a divine state of perfection, as did many other artists, she embraced their imperfections, illustrating fading flowers and leaves half eaten by caterpillars. In her portrait of *I. susiana* (p. 124), now held in the Fitzwilliam Museum in Cambridge, the glossy, intricately patterned single bloom stands out in contrast to the untidy-looking leaves.

Another iris that captured the European imagination in the nineteenth century was the delicate, water-loving Japanese iris, *I. ensata*, which had been cultivated in its native country for centuries. Along with the chrysanthemum, it was seen as a national flower, and accordingly it is well represented in Japanese art. The Dutch botanist Engelbert Kaempfer had been the first European to see and describe the Japanese iris at the end of the seventeenth century, but it was not until the 1860s that the species was officially introduced to Europe, by Philipp Franz von Siebold (1796–1866). A German physician who worked for the Dutch military, Siebold was posted to Japan in 1823 and there amassed a collection of more than 1000 native plants. By all accounts he was a larger-than-life character, blatantly ignoring protocol by setting up home with a Japanese woman and subsequently having a child with her. He was later exiled from the country on suspicion of spying after he acquired secret maps of Japan and Korea. Remarkably, he was able to ship

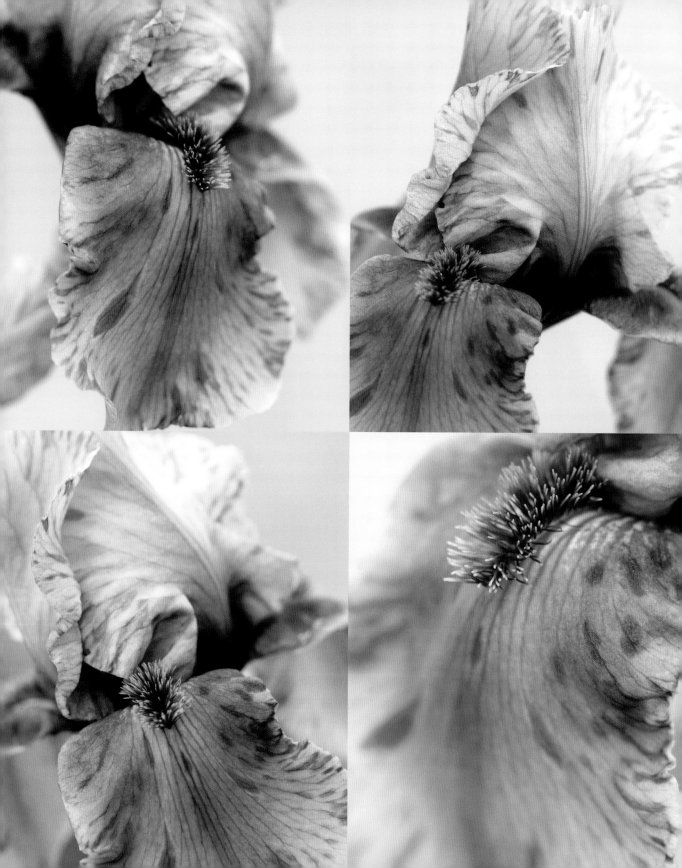

living plant material back with him, and his substantial plant collection survived. His *Flora Japonica*, published in 1835, contains an illustration of *I. ensata*.

Modern bearded irises

The modern hybrids of what are now known as bearded irises were born in the nineteenth century, and these large-flowered, blowsy garden plants are still by far the most popular irises grown today. The first named hybrid was produced in France in 1822, and soon nurserymen in Belgium, Germany and France were following suit, producing ever more interesting colour mixes and crosses. Coinciding with the excitement and acceleration of these developments in the plant's history, perhaps the most enduring artistic images of the iris belong to the Impressionists. Claude Monet's garden at Giverny in France was bursting with irises, both in the borders and around the pond, and he painted them repeatedly in their garden setting, capturing the mood of the place in hazy blue tones. 'My garden is my most beautiful masterpiece', he wrote, and throughout his forty-odd years living at Giverny he shared the intimacy of his beautiful garden in dozens of paintings. Vincent van Gogh was similarly drawn to the plant. One of his most famous paintings is simply entitled *Irises* (made in 1890, just after he had admitted himself to a mental asylum in France), and portrays an attractively haphazard arrangement of blue irises in an earthenware vase against a golden–yellow backdrop. Perhaps more than any botanical study, these emotion-filled paintings capture the essence and romance of the iris.

The twentieth century saw more improvements to the bearded iris, and now it was the turn of the Americans to take the baton, conjuring up apparently limitless new colours and shapes, with such additions as ruffling, veining and patterning. Today, bearded or Pogon irises are the most frequently grown group of irises in Britain, popular because of their large, showy early summer flowers in an irresistible spectrum of colours, from lustrous near-black to pure virgin white, with many mixed and blended combinations in between. The only colour not represented is true red, and that is not for want of trying.

Part of the attraction is the flower's intriguing shape: in addition to the three upright 'standards' and the three lower 'falls', there are curious tufts of fine hairs like small caterpillars (the 'beard') on the standards. Bearded iris cultivars are divided into various groups according to height, colour and markings, including Selfs, which are all one colour; Bicolours, with standards and falls in different colours; and Plicatas, more exotic in character, some with ruffled petals and different layers of colour with delicate stippled or veined markings. The tall bearded cultivars, which grow 75–110 centimetres (2½–3½ ft) high, are easily the

most popular, but intermediate, dwarf and miniature varieties are also available, some of which reach only 20 centimetres (8 in.) tall. Developed from southern European species, bearded irises need plenty of sun to thrive, and are traditionally grown on their own in narrow borders, where their rhizomes are not shaded by other plants. However, these versatile creatures are happy in almost any open, dry, well-drained situation, and can be grown with other sun-loving plants, such as cistus, lavender, rosemary and santolina. Most bearded irises flower from late April to June, and although the large flowers can be short-lived (both in hot, sunny springs, when they come and go rather quickly, and in wet or windy weather, when their large flowers can be damaged), the thick, sword-like leaves provide additional interest both before and after flowering.

It is impossible to end without introducing the contemporary American artist George Gessert (born 1944), a painter and printmaker who breeds irises as an art form in the way the artist Edward Steichen experimented with delphiniums. Gessert is interested in the aesthetics of plants and the way in which human preferences affect the evolution of certain species, and his work, in the realm of what is described as 'bio art', examines the overlap between art and genetics. His artistic hybrids have been exhibited as installations along with documentation of the breeding process. In the introduction to his book *Green Light: Toward an Art of Evolution* (2010), Gessert writes: 'Bio art registers a cultural shift away from dualistic views of the world, in which art and nature are separate, toward nondualistic, ecological constructs that merge the two.' Selecting only the plants that are aesthetically pleasing to him, he demonstrates how humans can manipulate or even control nature and essentially turn plant forms into living works of art.

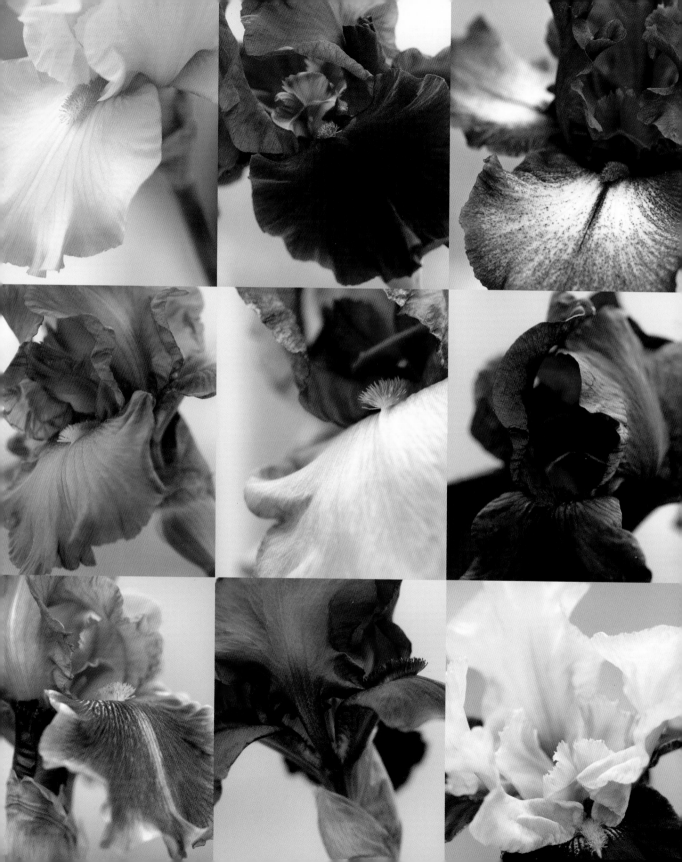

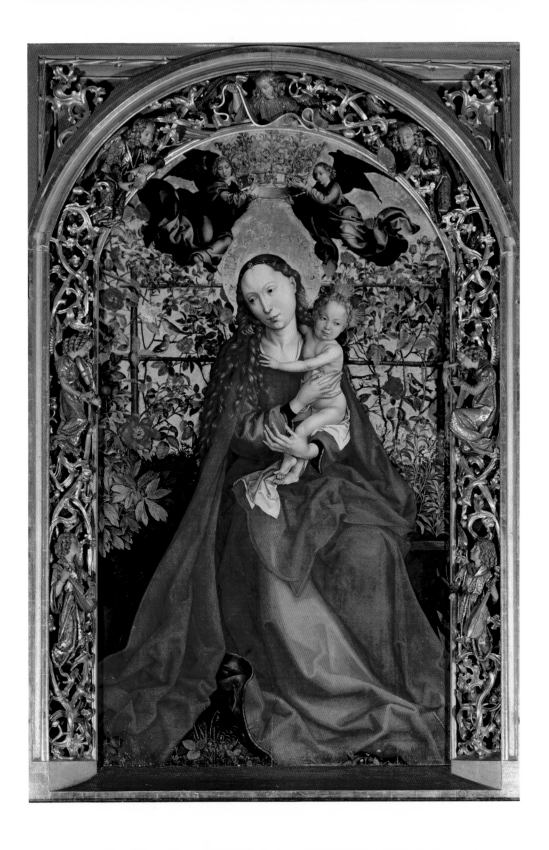

Peony

Known as the 'queen of flowers', the peony is one of the most opulent and flamboyant of all plants, and there is nothing more uplifting in spring than to see its exotic blooms emerging from glossy round buds, their petals like crushed silk against a rich green canvas of ferny leaves. Now grown primarily for its ornamental value, the peony was once one of the most important medicinal plants, its roots used as a cure-all for a range of symptoms, from jaundice and 'falling-sickness' (epilepsy) to the curse of nightmares.

Two species of herbaceous peony grow wild in southern Europe – *Paeonia officinalis* and *P. mascula* – and these have been cultivated from very early times, being mentioned in the first-century *De Materia Medica* by Pedanius Dioscorides. It is from Greek mythology that the peony takes its name, commemorating Paeon, physician to the gods. The story goes that the Greek god of healing and Paeon's former teacher, Asclepius, became jealous of the success of his pupil when Paeon healed Hades of an injury caused by one of Hercules' arrows. Asclepius plotted to murder Paeon, but was outwitted by Hades, who turned Paeon into a plant so that he would not be recognized. Other legends surround the plant, too. Pliny the Elder, for example, claimed that peony roots should be dug up only at night, because by day the plants were protected by woodpeckers that would peck out your eyes if they caught you. Perhaps this was a ruse to prevent people digging up the precious medicinal roots.

The real home of the ornamental peony in the glamorous guise we know today is China (and parts of Mongolia and Russia), where further herbaceous species and tree peonies grow in the wild. Peonies have been used in traditional Chinese medicine from time immemorial, and also cultivated as ornamental plants from at least the fifth century AD. Records show that the Chinese tree peony (including the species *P. suffruticosa*, *P. lutea* and *P. delavayi*) was grown at the time of the Sui Dynasty (581–618), and soon afterwards found its way to Japan, where it was given royal status. The other Chinese species that became pivotal in the creation of today's hybrids was *P. lactiflora*, a herbaceous peony with scented flowers, and both this and the tree peony have been central to Chinese culture for thousands of years. Since the time of the Ming Dynasty (1368–1644) the flower has been eulogized in poetry and prose, and depicted in all sorts of art forms, from paintings and manuscripts to silk textiles and Ming vases. It became a national flower in 1903.

In medieval Europe, being first and foremost a medicinal plant, the peony was found in all the herbals. One such manuscript was the *Herbarium of Apuleius Platonicus*, a fifth-century Latin herbal that remained the standard reference text on medicinal plants for hundreds of years. An eleventh-century version is preserved in the Bodleian Library in Oxford, and contains a remarkably clear drawing of a peony – one of the oldest existing European illustrations of the plant. More cartoon-like than

Martin Schongauer (1440–1491)
Virgin of the Rose Bower, 1473
Oil on panel
ST MARTIN, COLMAR, FRANCE

realistic, the image nevertheless gives an idea of the shape and form of the flower and leaf, and is accompanied by lengthy notes. In direct contrast to this crude illustration is Martin Schongauer's lovely *Study of Peonies* (1472), in which a lustrous red *P. officinalis* is painted in remarkably realistic detail. Schongauer (1440–1491) was a forerunner of Albrecht Dürer and Leonardo da Vinci, both of whom became known for their passion for painting direct from nature, and this painting was a study for a later work, *Virgin of the Rose Bower* (1473; p. 134), which depicts a resplendent Mary and baby Jesus surrounded by roses and a prominent peony, its large, single red bloom matching the red of Mary's gown.

From the Middle Ages onwards double forms of the two European species were grown, and these more decorative flowers appear regularly in the paintings of the seventeenth-century Dutch flower painters, in elaborate arrangements with tulips, roses, lilies and other fashionable flowers of the day. Ambrosius Bosschaert's *Still Life with Flowers in a Wan-Li Vase* (1619) contains two double peonies, one white, one red, standing out clearly against the dark background. Doubles were obviously prized, but red and white was the limit of the colour range available in Europe at the time, and it was to be another 200 years before that range expanded. Little did seventeenth-century European gardeners know that a vast cornucopia of elaborate, exquisitely coloured peonies, already being cultivated in China and Japan and painted

by such seventeenth-century Chinese artists as Yun Shouping (1633–1690), was waiting to be found by European explorers.

The Chinese peonies arrive in Europe

It was not until the end of the eighteenth century that the Chinese peonies began to be imported into Europe. Joseph Banks (1743–1820), who spent his latter days as George III's unofficial director of the Royal Botanic Gardens at Kew, was instrumental in introducing both the *lactiflora* species and the tree peony to Britain. In 1787 he commissioned Alexander Duncan, a surgeon in the British East India Company, based in China, to send back forms of the peony everyone was talking about: *P. suffruticosa*, or the 'Moutan', as it was known in China. Two years later the first tree peonies flowered at Kew.

One of the first colour engravings of the new plant appeared in *Curtis's Botanical Magazine* (pp. 139, 142) in 1808, in a plate by Sydenham Teast Edwards. According to the accompanying text, the provenance of the tree peony was 'among the mountains in Northern China, whence it was brought into the Southern provinces, and cultivated with the same range as Tulips have been in Europe, and with a similar effect of producing numerous varieties, some of which, from their beauty and rarity, have been known to sell in China for a hundred ounces

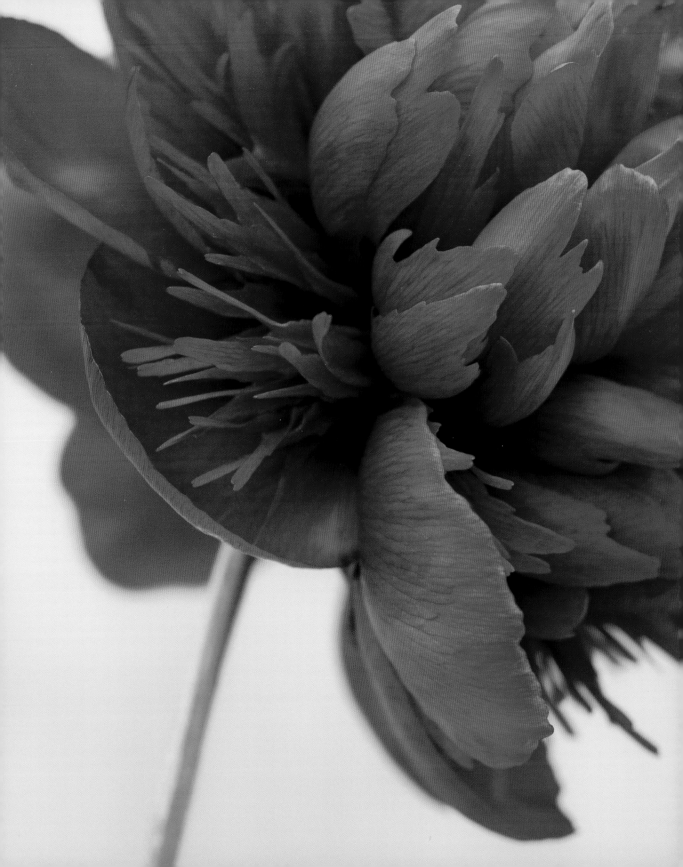

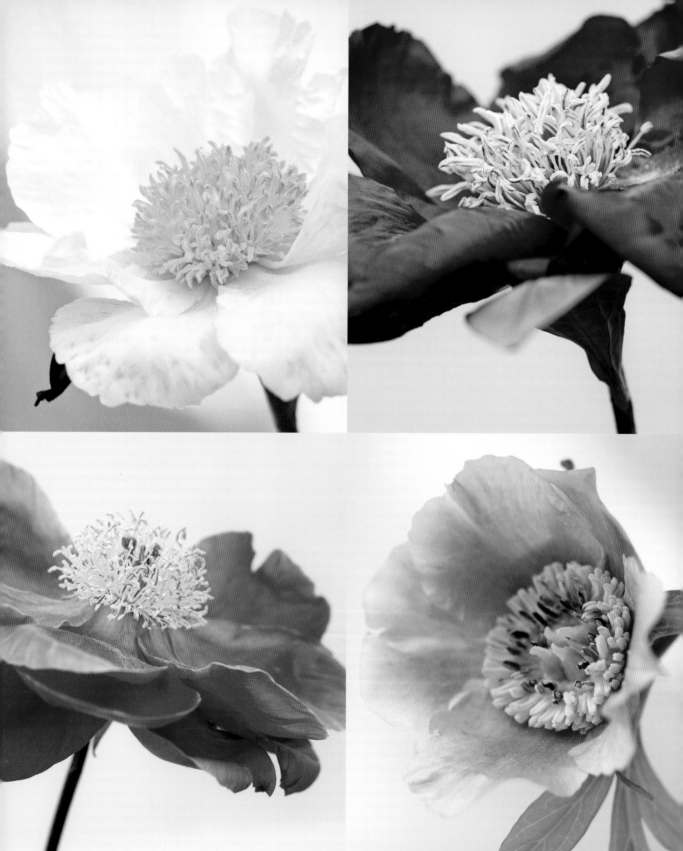

Clockwise from top left: *P. lactiflora*
'Shaylor's Sunburst'; *P. lactiflora*
'Lord Kitchener'; *P. veitchii*;
P. lactiflora 'Bethcar'.

of gold'. A few years later Pierre-Joseph Redouté painted the Moutan peony for the lavish *Description des plantes rares cultivées à Malmaison et à Navarre* (1813), made for the Empress Josephine Bonaparte, a keen plantswoman who actively sought out new plants for the royal gardens at Malmaison. Two different forms of the tree peony are portrayed, and the images of voluptuous double pink flowers, their petals elaborately frilled, must have captured the attention of many a botanist and plant-lover, hinting at the varieties that were to come.

However, it was *P. lactiflora* that was to be responsible for the ultimate success and popularity of the genus, introducing a much wider colour range as well as more elaborate double forms. Discovered by the German naturalist Peter Pallas (1741–1811) and sent to Banks at Kew in 1784, *P. lactiflora* was already widely grown in many different forms in China and Japan. Seeing the potential of these more variable forms, French botanists first seized the chance of working with the plant, and of them Nicolas Lemon was one of the earliest. His most successful cultivar, *P. lactiflora* 'Edulis Superba', produced in 1824, has large, showy double flowers in lipstick pink, and is as popular today as it was when it first appeared. Other French nurserymen producing new hybrids at the time include Victor Lemoine, after whom the *P. × lemoinei* hybrids are named. Such cultivars as the pink *P. lactiflora* 'Sarah Bernhardt' (p. 142) and white *P. lactiflora* 'Duchesse de Nemours' (p. 143), both of which are still grown

today, quickly found their way to England. The latest must-have varieties were painted there by such artists as Clara Maria Pope, who produced eleven watercolour illustrations of peonies in 1821–22, showing the new white and pale-pink doubles that soon became talking points in botanical circles.

The interest of British gardeners had been piqued, and soon it was the turn of British nurserymen to try their hand at breeding from *P. lactiflora*. James Kelway (1815–1899) led the way, succeeded by his son and grandson, and Kelways is still the leading peony nursery in Britain. By 1884 it could offer more than 100 cultivars, and by 1904 it had grown to be one of the largest growers of peonies in Europe, employing almost 400 staff and offering 294 cultivars, including the famous *P. lactiflora* 'Kelway's Glorious'.

Curtis's Botanical Magazine

Throughout the nineteenth century new species were being discovered by some of Britain's best-known plant-hunters, including Robert Fortune and Ernest Henry ('Chinese') Wilson. Most of these species were documented in the leading botanical publication of the day, *Curtis's Botanical Magazine*. Launched in 1787 by William Curtis (1746–1799), the magazine aimed to provide up-to-date information on 'the most ornamental foreign plants ... accurately represented in their natural Colours'.

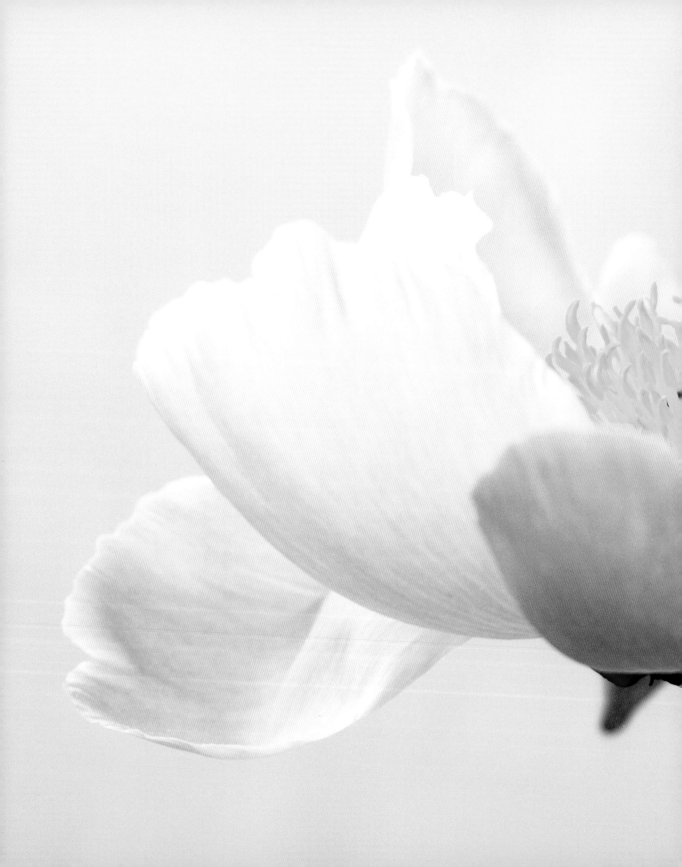

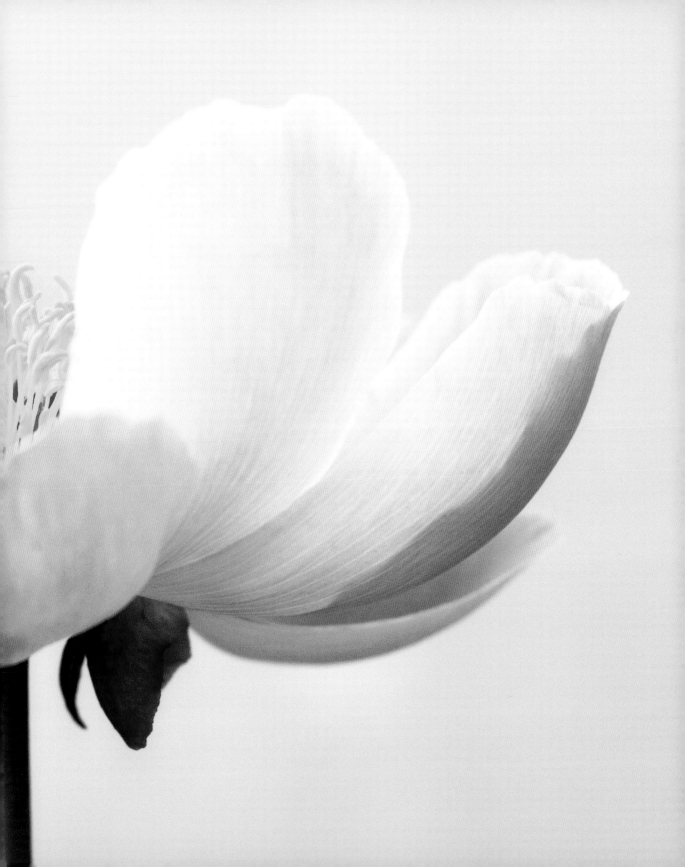

Curtis had tapped a rich vein, obviously learning from the financial failure of a previous publication, *Flora Londinensis*, that the gardening public was hungry for information about the new, exotic plants that were flooding in from abroad, rather than the more prosaic varieties on the doorstep. How right he was: the magazine thrived, largely thanks to its collection of brilliantly executed botanical illustrations, and enjoyed a circulation of about 3000 copies in its early years.

Curtis died in 1799 but the magazine continued, taken over by his friend John Sims, and later by William Hooker – and indeed it lives on today as the world's longest-running botanical publication. Various artists have been associated with it over the centuries, including Sydenham Teast Edwards, who produced about 1700 illustrations from the age of nineteen before finally deserting the magazine to set up a rival publication (the *Botanical Register*) after several of his illustrations were credited to another artist. Later in the nineteenth century Walter Hood Fitch was the main contributor; he worked for the magazine for an astonishing forty-three years and produced a remarkable 10,000 illustrations, including fine studies of *P. emodi* (1868), which had recently been introduced from the Himalayas, and *P. wittmanniana* (1882), the first pale-yellow peony to arrive in Europe.

The twentieth century onwards

During the early twentieth century new species of peony were still being discovered. Two new yellow species, *P. lutea* and *P. mlokosewitschii* (commonly known as 'Molly the witch', for obvious reasons), arrived around the turn of the century, and were illustrated soon after their introduction in *Curtis's Botanical Magazine*. After the devastation of the First World War, peony-breeding dwindled in Britain, but it was taken over in about 1920 by the Americans, of whom Charles Klehm and Arthur Saunders were the most influential hybridizers of peonies. The peony had suddenly become hugely fashionable with the establishment of the American Peony Society in 1903, and it has remained so; the focus of current peony-breeding is there rather than Europe. In Britain, the heyday of hybridization is long over, and very little breeding takes place there, partly because of the range of excellent old varieties that still exist, and partly for commercial reasons, as peonies take many years to flower and increase.

Kelways nursery still has the largest range of both tree peonies and herbaceous cultivars, with such old favourites as the delicate pale-pink *P. lactiflora* 'Kelway's Fairy Queen' (1927), the blush-pink *P. lactiflora* 'James Kelway' (1900) and the single deep-pink *P. lactiflora* 'Bethcar' (1926; p. 138) sitting alongside newer cultivars, including the very popular *P. lactiflora* 'Bowl of Beauty' (opposite) and *P.* 'Buckeye Belle', both raised in the 1950s. In addition, more recent herbaceous cultivars are becoming available from the

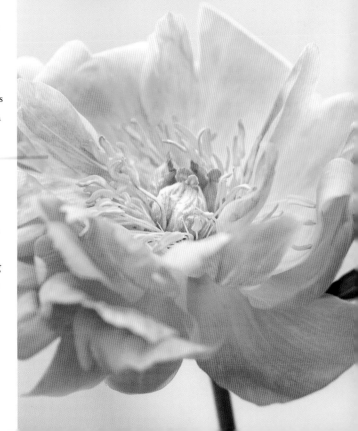

Opposite: *P. lactiflora* 'Lemon Queen'.

Right, from top: *P. lactiflora* 'Cheddar Gold'; *P.* 'Coral Charm'.

United States, including the new coral-coloured peonies, such as *P.* 'Coral Charm' (right). For those who prefer a more natural look, some of the species themselves are equally rewarding, with smaller, simpler flowers that usually appear earlier than those of the hybrids. *P. mlokosewitschii*, which has recently risen in popularity, is one of the first to flower, in late April or early May. The shoots emerge pinky-bronze, eventually forming a 1-metre-high (3 ft) mound of handsome green leaves topped by pale-yellow flowers. Another favourite is the delicate *P. tenuifolia*, which has fine, feathery foliage rather than the typical, more substantial peony leaf. It is smaller in stature than many peonies, but its strong, rich colours — glossy crimson-and-gold flowers set against rich green foliage — mean that it more than holds its own in a border. Herbaceous peonies, traditionally grown in a mixed border, are extremely hardy and adaptable to most conditions, although they resent having wet feet, so need a well-drained, fertile soil that errs towards alkaline. Some of the species peonies seem to thrive better in cool shade, but most peonies grow best in full sun, where they will flower freely over a period of approximately two weeks. The flowers may be fleeting, but the plants themselves generally have a long life if they are given the right growing conditions, coming back year after year to reward you with their sensuous blooms. 'They are so long-lived', wrote Vita Sackville-West in her column in *The Observer* in September 1949, 'that once you have established a clump (which is not difficult) they will probably outlive you.'

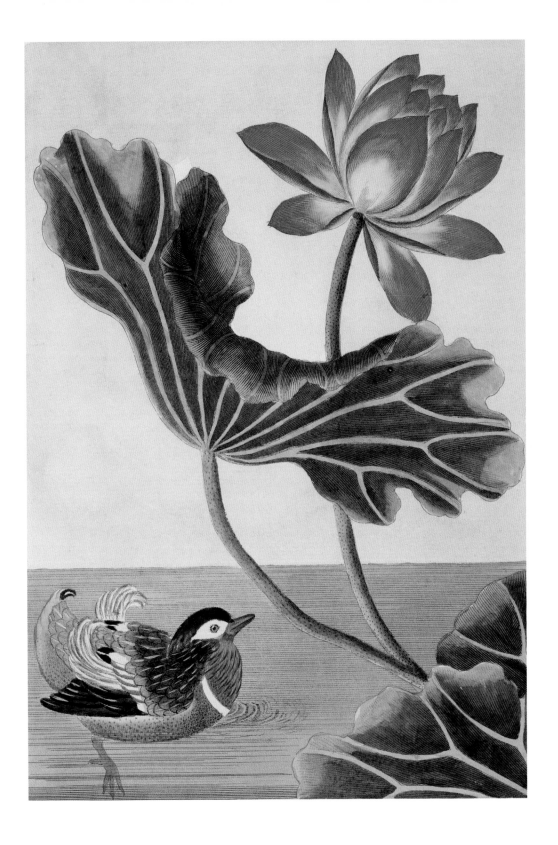

Waterlily

Emerging from the depths like a watery goddess, the waterlily is a fascinating plant that has achieved almost mythical status in many cultures. The sacred lotus, *Nelumbo nucifera*, has been a divine symbol in India and China since ancient times, representing the virtues of sexual purity and divine beauty, and in art, many deities of Asian religions are depicted standing on a lotus flower. The flower also symbolizes human enlightenment, beginning life as it does as a humble seed in the mud, later to rise upwards, eventually opening its flowers in a show of pure, unblemished beauty. One of the most striking images of the Asian lotus is a painting by the Frenchman Pierre-Joseph Buc'hoz (1731–1807) for the *Collection precieuse et enluminée ...* (1776), depicting a magnificent deep-red lotus flower perfectly balanced by a highly decorative Chinese duck (opposite).

The Asian lotus is just one of several genera belonging to the waterlily family; in the West, the most commonly cultivated genus is the *Nymphaea* (named by Theophrastus after the water nymphs of Greek mythology), the history of which stretches back many thousands of years. The American waterlily, *Nymphaea odorata*, was used in medicine by the Native Americans, while the blue waterlily, *N. caerulea*, was first cultivated in ancient Egypt, where it was sacred, its flowers used in religious rituals and its seeds taken as a narcotic and aphrodisiac. Interestingly, the opposite effect was obtained from the two European species, white *Nymphaea alba* and yellow *Nuphar lutea*, which were used to control rather than enhance sexual desire.

Described by Pedanius Dioscorides in the first century AD, the European waterlily was used in medicine from antiquity until the nineteenth century. In his herbal of 1597, John Gerard eloquently described the uses of the waterlily:

> The Physitions of our age do commend the floures of the white Nymphaea against the infirmities of the head which come of a hot cause: and do certainly affirme, that the root of the yellow water lily cureth hot diseases of the kidneys and bladder, and is singular good against the running of the reines [uncontrolled discharge of bodily fluids]. The root and seed of the great water lilie is very good against venery of fleshly desire, if one do drinke the decoction thereof, or use the seed or root in powder in his meates, for it dryeth up the seed of generation, and so causeth a man to be chaste.

Because of their wide use in medicine, European waterlilies appear in many medieval and Renaissance herbals. One of the earliest colour illustrations of *Nymphaea alba* is to be found in a fifteenth-century version of Matthaeus Platearius's *Book of Simple Medicines* (see p. 106). Each beautifully composed page typically contains three plants, charmingly painted in jewel-like colours by Robinet Testard and framed by a single painted line. The waterlily is given pride of place on its page, with one flower in full bloom and one in bud, its large leaves partially hiding the plumed thistle pictured with it.

The other European waterlily, *Nuphar lutea* (then known as *Nymphaea lutea*), was illustrated in an edition

of 1570 of the Italian physician Pietro Mattioli's *Discorsi* (*Discourses*), a commentary on the writings of Pedanius Dioscorides. Mattioli sold a staggering 30,000 copies in various editions published between 1554 and 1585. The predominant illustrative technique for these books of the sixteenth and seventeenth centuries was the woodcut, a line drawing carved into a block of wood and coloured by hand after printing. Many earlier herbals had used the woodcut in a fairly crude way to recycle botanical illustrations again and again, but Mattioli and his contemporaries Otto Brunfels and Leonhart Fuchs commissioned artists to work from the plants themselves, with increasingly detailed and realistic results.

The discovery of new species

The next chapter in the history of the waterlily can be told through the pages of Britain's leading horticultural publication, *Curtis's Botanical Magazine* (see pp. 139, 142). Although still known primarily as a medicinal plant, the waterlily was coming under new scrutiny in Europe as previously unknown species arrived from abroad, and these soon found their way on to the pages of this highly respected periodical. In the first decade of the nineteenth century alone, four exotic waterlilies, all new to British cultivation, were illustrated in full-colour plates by Sydenham Teast Edwards: the American species *Nymphaea odorata* and *Nuphar advena*, the Egyptian *Nymphaea caerulea* and

the Indian *Nymphaea rubra*. The last two, with their exotic colouring, must have made people realize that there was more to the genus than the familiar plain white and yellow forms. In 1847 yet another waterlily – the giant *Victoria amazonica*, then named *V. regia* after Queen Victoria – was published in the magazine, accompanied by several colour illustrations by Walter Hood Fitch, showing the plant in its setting as well as close-ups of its bud, bloom and seed pod. This was by far the most exciting yet, with leaves 1.8 metres (6 ft) across and blooms larger than dinner-plates, and the plant was deemed important enough to have an entire issue devoted to it:

It has always been our endeavour to commence a New Year in this Magazine with some eminently rare or beautiful plant; but never had we the good fortune on any occasion to devote a Number to a production of such pre-eminent beauty, rarity, and we may add celebrity, as that now presented to our Subscribers; worthy, as we have no doubt they will agree with us in thinking, to occupy the entire Number. Seldom has any plant excited such attention in the botanical world; the interest being specially enhanced by the name it is privileged to bear ... It is true that the Victoria has not yet produced its blossoms in England; but we have growing plants in the Royal Gardens of Kew, which germinated from seeds brought from Bolivia ... These have hitherto made satisfactory progress; although we have our fears that the plant being possibly annual and the season late (December), they may not survive the winter; or, at any rate, may not produce perfect flowers. Many are the disappointments and delays of Science!

'Almost Black'.

Disappointment certainly reigned because, try as they might, the gardeners at Kew were unable to coax this monster of a plant into flower, and it was to be two years before it happened. The man to take credit for this was Joseph Paxton, the famous head gardener to the Duke of Devonshire at Chatsworth in Derbyshire, and it was there that the sensational event happened, in November 1849, drawing crowds from near and far. The plant, grown from a single seed sent from Kew, prompted the construction of another of Paxton's famous glasshouses, the eponymous Victoria Regia House, where the plant thrived for many years. A new fashion for growing tender water plants was begun, and breeding started immediately. Paxton was again in the lead with his cultivar *Nymphaea* 'Devoniensis', named in honour of his employer, and a former gardener at Chatsworth, Eduard Ortgies, takes credit for the second cultivar, *N.* 'Ortgiesiano-rubra', which was first described and illustrated in the Belgian horticultural periodical *Flore des serres et des jardins de l'Europe* (*The Flowers of European Glasshouses and Gardens*), published between 1845 and 1888.

Latour-Marliac and Monet

Only the wealthiest gardeners could afford to build the glasshouses and warm pools that were required to grow the exotic tender species, however, so inevitably the next quest was to broaden the colour range of the hardy waterlilies. Early experiments in both Europe and America were mostly unsuccessful, and it seemed at first that hybridizers were seeking the impossible. But then, after many years of trial and error, the French nurseryman Joseph Bory Latour-Marliac (1830–1911) turned expectations upside down by producing a range of colourful yet hardy hybrids, which he launched to great acclaim at the Exposition Universelle in Paris in 1889. It had taken a decade of intensive work to get to this point, as he described in an article in *The Garden* in 1893:

> About the year 1879 I commenced the work in earnest by crossing the finest types of hardy and tropical Nymphaeas which I had in cultivation here [at his nursery in Lot-et-Garonne]. These early attempts were at first negative in their results, but soon afterwards I scored an unexpected success in obtaining a hybrid with deep red flowers … In the year 1889 the Universal Exhibition was held at Paris, and my small collection of hybrids timidly took the road to the metropolis, to see if possibly they might attract some notice from amateurs in the midst of the plant wonders there. Their graceful elegance, however, was appreciated, and they came back radiant with the distinction of a first prize.

The result of Latour-Marliac's work changed European waterlily cultivation forever, as can be seen in the beautiful array of colours we know today, from deep, rich plum to the palest ethereal pink. Many of his hundred or so introductions are still available, including the very first to be introduced, *Nymphaea* 'Marliacea Chromatella',

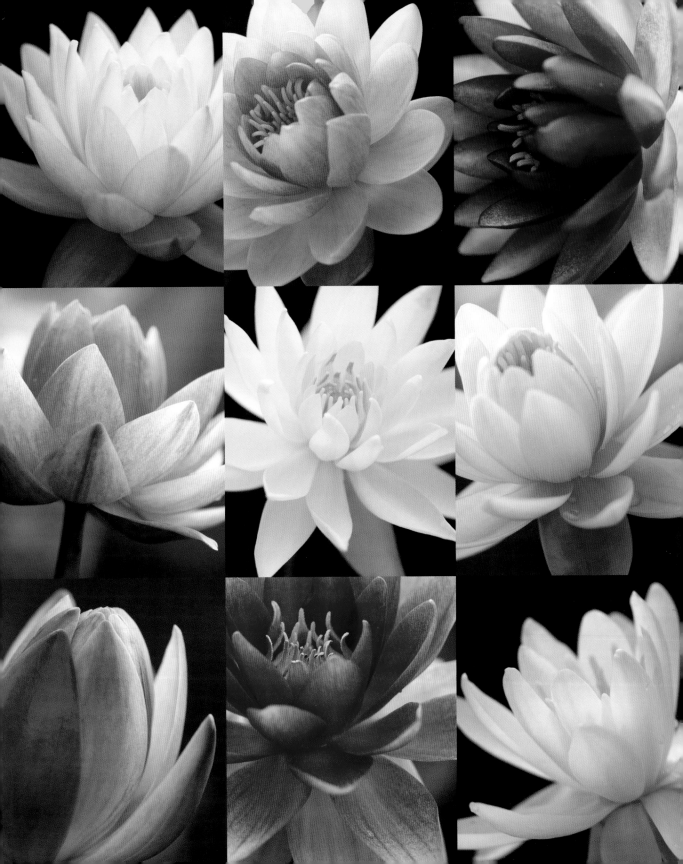

which has large cup-shaped primrose-yellow flowers with golden stamens. He guarded his hybridization secrets closely, reputedly offering to reveal all to an American waterlily enthusiast for no less than £1000. Needless to say, the sum was never met and the exact science behind his success remains a mystery. However, it was at the Paris Exposition Universelle that he received a visitor who was to become one of his greatest advocates, and the one artist above all others with whom the waterlily is associated.

Claude Monet (1840–1926) was captivated by the sight of Latour-Marliac's new waterlily cultivars blooming in the water gardens in front of the Trocadero, and immediately resolved to expand his garden at Giverny by buying an adjacent meadow, where he set to work to create a new *jardin d'eau*. Several years later he placed an order for some of Latour-Marliac's waterlilies, and as his water garden developed he obsessively followed news of every hybrid that was produced, even visiting Latour-Marliac's nursery to see the source of his inspiration. He was so passionate about these beguiling flowers that he painted them over and over again. 'I had planted [the waterlilies] for the pure pleasure of it,' he wrote, 'and I grew them without thinking of painting them … And then, all of a sudden, I had the revelation of the enchantment of my pond. I took up my palette.'

The waterlily became the most painted plant in Monet's garden, and is immortalized in hundreds of celebrated oil paintings, many of them monumental in scale, showing the flowers both close up and as part of a wider pond setting that the artist described as a 'mirror of water'. Among the most famous is the series of paintings known as *Les Grandes Decorations*, which is housed in specially designed elliptical rooms at the Musée de l'Orangerie, Paris, in a display of extraordinary luminescence and colour. 'These landscapes of water and reflection have become an obsession for me', Monet wrote to a friend in 1909. 'It is beyond my strength as an old man, and yet I want to render what I feel.'

The waterlily today

Latour-Marliac's invaluable work lives on in the range of excellent cultivars that he developed. There are far too many to mention, but favourites include the beautiful *Nymphaea* 'Marliacea Carnea', which has huge pale-pink flowers with sulphur-yellow stamens, and *N.* 'Caroliniana Perfecta' (1893; opposite), a very popular variety with flowers in a delicate salmon-pink. Other well-loved stalwarts are *N.* 'Darwin' (1909; opposite and p. 155), with opulent, peony-like pink blooms, and *N.* 'Sirius' (1913), which has star-shaped purple–red flowers. For smaller ponds, *N.* 'Pygmaea Rubra', with small, starry flowers that open pink and age to red, and the pale-yellow *N.* 'Pygmaea Helvola' will both thrive in just 15 centimetres (6 in.) of water. The United States has been the source of many new cultivars in recent years,

Left, top and bottom:
'Pink Sensation'.

Opposite: 'Darwin'.

in a range of startling colours, from the pure-pink
N. 'Perry's Strawberry Pink' (p. 149) to the sumptuous
dark-purple N. 'Almost Black' (p. 151).

When selecting waterlilies, the first consideration
should always be the size and depth of the pond, with
colour the next criterion, followed by flower size and
shape; individual flowers may be rounded or ball-shaped,
open and plate-like, or delicately stellate. Finally, the
leaves, or lily-pads, should not be overlooked, as they
can provide a focal point in themselves: the Latour-
Marliac introduction N. 'Arc-en-ciel' is grown primarily
for its striking leaves, which are blotched in bronze,
cream and purple. Growing waterlilies is easy if the plants
are given the conditions they need: plenty of sunlight, a
position in still water away from any currents (avoiding
the direct flow of fountains or waterfalls) and a reasonably
shallow planting position. A lack of flowers can be put
down to any one of these conditions being compromised.
But if they are happy, established waterlilies will provide
a succession of blooms from June to September, each
lasting for three to five days in sunny weather. Pushing
up from the murky depths of a pond, the flowers open
with the morning sun and close in the evening, and
then disappear under the surface again, adding to their
mysterious charm.

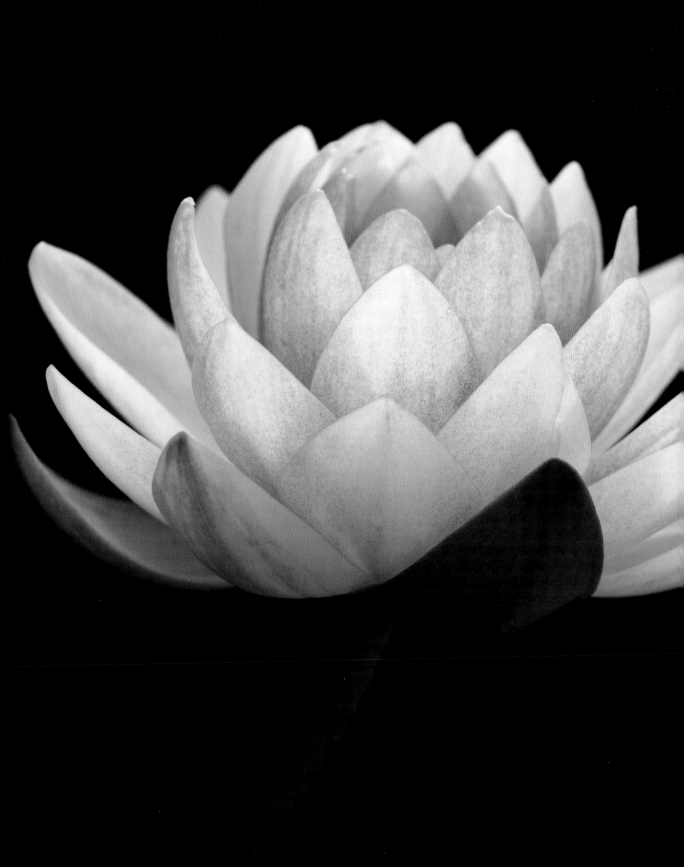

Select Bibliography

Beck, Christabel, *Fritillaries*, London (Faber and Faber) 1953

Blunt, Wilfrid, and Stearn, William T., *The Art of Botanical Illustration*, London (Collins) 1950; Woodbridge, Suffolk (Antique Collectors' Club) 1994

Colston-Burrell, C., and Knott Tyler, Judith, *Hellebores: A Comprehensive Guide*, Portland, Ore. (Timber Press) 2006

De Bray, Lys, *The Art of Botanical Illustration*, London (Quantum Books) 2005

Duthie, Ruth, *Florists' Flowers and Societies*, Aylesbury, Buckinghamshire (Shire Books) 1988

Fearnley-Whittingstall, Jane, *Peonies, The Imperial Flower*, London (Weidenfeld & Nicolson) 1999

Fisher, John, *Mr Marshal's Flower Album: Paintings from the Royal Library, Windsor*, London (Victor Gollancz) 1985

Guest, Allan, *The Auricula: History, Cultivation and Varieties*, Woodbridge, Suffolk (Garden Art Press) 2009

Halda, Josef, *The Genus Paeonia*, Portland, Ore. (Timber Press) 2004

Hobhouse, Penelope, *Plants in Garden History*, London (Pavilion Books) 1992

Hughes, Sophie, *Carnations and Pinks: The Complete Guide*, Marlborough, Wiltshire (The Crowood Press) 1991

Jefferson-Brown, Michael, *Narcissus*, Portland, Ore. (Timber Press) 1991

Köhlein, Fritz, *Iris*, Portland, Ore. (Timber Press) 1987

Lawton, Barbara, *Magic of Irises*, Golden, Col. (Fulcrum Publishing) 1998

Page, Martin, *The Gardener's Guide to Growing Peonies*, Newton Abbot, Devon (David & Charles); Portland, Ore. (Timber Press) 1997

Pavord, Anna, *The Tulip*, New York and London (Bloomsbury) 1999

Potter, Jennifer, *The Rose: A True History*, London (Atlantic Books) 2010

Read, Veronica M., *Hippeastrum: The Gardener's Amaryllis* (Royal Horticultural Society Plant Collector Guide); Portland, Ore. (Timber Press) 2004

Rice, Graham, and Strangman, Elizabeth, *The Gardener's Guide to Growing Hellebore*, Newton Abbot, Devon (David & Charles) 2005

Rix, Martyn, *Art in Nature: Over 500 Plants Illustrated from Curtis's Botanical Magazine*, London (Studio Editions) 1991; published in the United States as *Art in Nature: Classic Botanical Prints from the Eighteenth to the Twentieth Century*, New York (Rizzoli) 1991

Rowlands, Gareth, *The Gardener's Guide to Growing Dahlias*, Newton Abbot, Devon (David & Charles); Portland, Ore. (Timber Press) 1999

Russell, Vivian, *Monet's Garden: Through the Seasons at Giverny*, London (Frances Lincoln) 1995

Stebbings, Geoff, *The Gardener's Guide to Growing Irises*, Newton Abbot, Devon (David & Charles); Portland, Ore. (Timber Press) 1997

Trehane, Jennifer: *Camellias: The Gardener's Encyclopedia*, Portland, Ore. (Timber Press) 2007

Willes, Margaret, *Pick of the Bunch: The Story of Twelve Treasured Flowers*, Oxford (Bodleian Library) 2009

Index

First published 2012 by

Merrell Publishers Limited
81 Southwark Street
London SE1 0HX

merrellpublishers.com

British Library Cataloguing-in-Publication data:
Foster, Clare.
Painterly plants.
1. Flowers in art. 2. Botanical illustration. 3. Plant varieties –
Pictorial works. 4. Flower gardening – Pictorial works.
I. Title II. Ruber, Sabina.
635.9'0222-dc23

ISBN 978-1-8589-4555-2

Produced by Merrell Publishers Limited
Designed by Nicola Bailey
Project-managed by Rosanna Lewis
Indexed by Vanessa Bird
Printed and bound in China

Horticultural names have been checked against the Royal
Horticultural Society's Horticultural Database, available at
rhs.org.uk.

Jacket, front: A virus-infected tulip (page 87)
Jacket, back: *Rosa* 'Scepter'd Isle' (page 95)
Frontispiece: *Nerine* 'Crystal Palace'
Pages 10–11: Nerine buds

PICTURE CREDITS
Bibliothèque du Museum d'Histoire Naturelle, Paris,
France/Giraudon/The Bridgeman Art Library: 42; Fitzwilliam
Museum, University of Cambridge, UK/The Bridgeman Art
Library: 124; Giraudon/The Bridgeman Art Library: 134;
© John Mitchell Fine Arts/The Bridgeman Art Library: 114;
Linnaean Society, London/The Bridgeman Art Library: 7;
Natural History Museum, London, UK/The Bridgeman
Art Library: 34, 104; © Newberry Library/Superstock: 62;
Private Collection/The Bridgeman Art Library: 92; Private
Collection/The Stapleton Collection/The Bridgeman Art
Library: 52, 82; Royal Botanic Gardens, Kew: 72; The Royal
Collection © 2011 Her Majesty Queen Elizabeth II/The
Bridgeman Art Library: 12; © The Royal Horticultural Society:
24; The Stapleton Collection/The Bridgeman Art Library: 146.

AUTHOR'S ACKNOWLEDGEMENTS
Painterly Plants started life as a series in *House & Garden* magazine,
and I should like to thank the Editor of *House & Garden*, Susan
Crewe, for unfailingly supporting all my creative ideas. My
thanks also to all those specialists who read through each article
or chapter, in particular Michael Marriott of David Austin Roses
and Christine Skelmersdale of Broadleigh Bulbs. The RHS
Lindley Library in London is a fantastic resource, both for
horticultural information and for art, and I should like to thank
the staff there for all their help. Finally, a big thank-you to my
friend Tamsin Lovatt, who, despite working fourteen-hour days
in her organic kitchen garden, still found time to read through
and comment on the draft manuscript.

PHOTOGRAPHER'S ACKNOWLEDGEMENTS
First, I should like to thank everyone at *House & Garden* for
running the Painterly Plants series from which this book grew,
especially Clare for her brilliant writing. Many people in the
growing and nursery world have given me their time, space and
plants, enabling me to capture these beautiful images; it has
been a real pleasure. A big thank-you to Gerrit Preijde, who
opened up the Dutch bulb world for me – magic! Also to
Les Allen for auriculas; Jacques Amand for fritillaries; Myra
Carmichael, who holds the National Collection of nerines;
Sophie Hughes for dianthus; Kelways for paeonia; Kenchester
Water Gardens for nymphaea; Michael Marriott at David
Austin Roses; Basil Smith for hellebores; Trehane Nursery for
camellias; Jill and Allen Whitehead at Aulden Farm for irises;
and everyone who so kindly let me raid their gardens in search
of specific 'missing' flowers. I am grateful to Hugh Merrell,
Claire Chandler, Rosanna Lewis, Nicola Bailey and Amanda
Mackie at Merrell for making this such a pleasurable experience.
And, last but not least, two very special people, whose friendship
has meant a lot to me and who have been very much in my
thoughts: Michael and Megan. Oh, and my husband, Paul,
for everything.

ISBN 978-1-8589-4555-2

9 781858 945552